Diana

A Princess Remembered

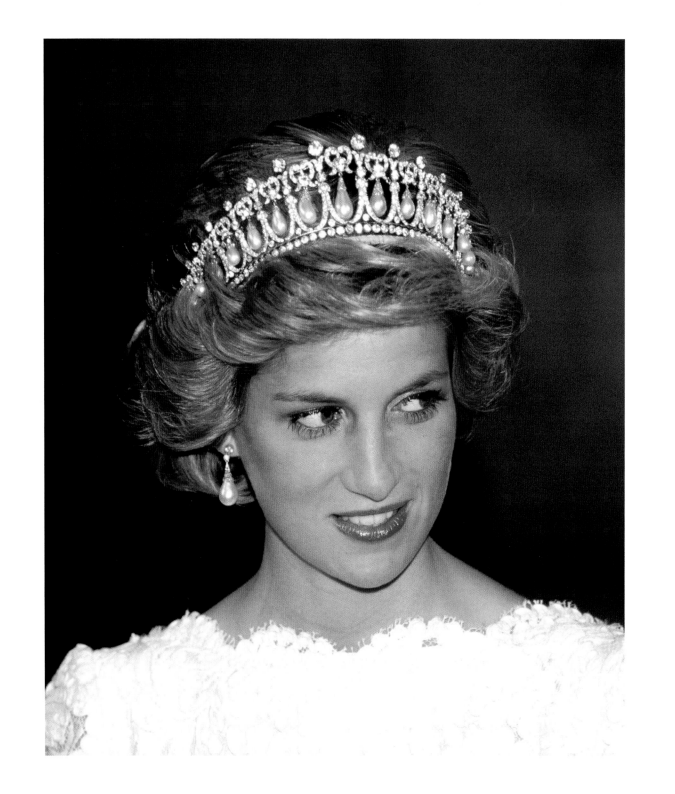

Diana
A Princess Remembered

Glenn Harvey

southbank publishing

First published in 2006 by Southbank Publishing,
21 Great Ormond Street, London WC1N 3JB

www.southbankpublishing.com

© Glenn Harvey 2006

The right of Glenn Harvey to be identified as the
author of this work has been asserted in accordance
with the Copyright, Designs and Patents Act 1988.

A CIP catalogue record for this book is available
from the British Library.

ISBN 10: 1 904915 18 3

ISBN 13: 978 1 904915 18 8

2 4 6 8 10 9 7 5 3 1

Title by Zoe Beth Torjussen

Design by George Lewis
Printed and bound in Italy by Lego Spa, Vicenza, Italy

For Laurie, Alex, Holly,
Dean, Mum and Dad.

Acknowledgments

For friendship and support, Simon Bridge, John
Edwards, Arthur Edwards, David Levenson, Lionel
Cheruault, Mark Tattershall, Adrian Smith, Caron
Curnow, Emma, Alex Cohen, Tim Graham, Frank
Barratt, George Lewis, Roger Eldridge, Jaqui Ann
Wald, Roy and Don, and Paul Torjussen for your
great vision.

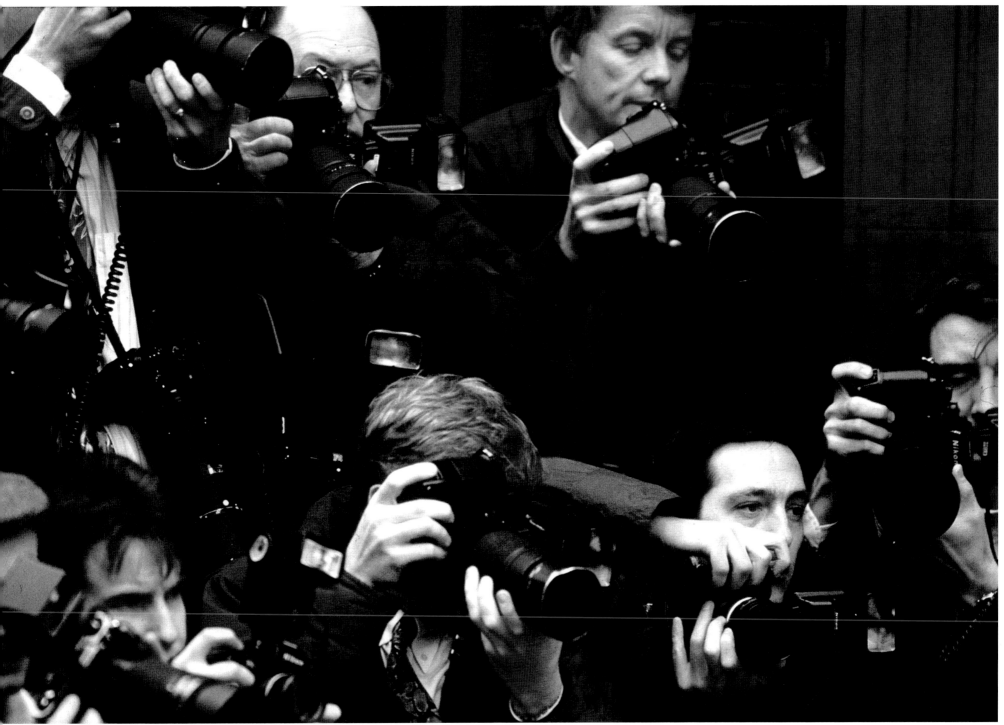

Contents

Brazil 8, Indonesia 18, Hong Kong 24, Italy 30, Australia 40, Japan 48, Egypt 52, Germany 60, Nigeria 70, India 80, Canada 94, England 98, Skiing 110, USA 116, Hungary 126, France 134, Spain 140, Czechoslovakia 146, Pakistan 152, Nepal 162, Oman 168, Thailand 172, Scotland 178, Bahrain 182, Caribbean 188.

Introduction

Princess Diana was an icon of the twentieth century. With one of the most recognised faces of all time, millions of people from around the world were captivated by her. Diana spread her charm and elegance everywhere she went.

This book is a celebration of Princess Diana's travels, where she achieved so much, uniting people and spreading peace and happiness.

So why all the euphoria? People were captivated by her beauty and presence – the sheer delight on the faces of the children and adults who met Princess Diana tell the story. Across the world, children and adults alike waited in the blazing heat or searing cold just for the chance to glimpse a living icon. To so many, Princess Diana was special, somebody different, and that is why they wanted to see her.

Princess Diana charmed everyone with her infectious sense of humour. She had a rare and unique ability to walk into a room full of stuffy dignitaries and instantly transform the tense, nervous atmosphere to scenes similar to a school playground, with all present laughing and joking like children.

There were no barriers to the Princess; she spanned all cultures, religions and social classes. She touched and embraced unfortunate people with old and new deadly diseases, often helping, in one moment, to dispel the unfounded myths and rumours surrounding the disease they suffered from.

Presidents, emperors, kings, tribal and religious leaders relished the chance to welcome the Princess into their world and be photographed together as friends.

These rare and often previously unpublished photographs were taken in locations around the world. Some of Diana's most revealing and unguarded moments, captured on a world stage, act as a fitting tribute to the memory of an international Princess.

I had the privilege of accompanying Princess Diana on visits to so many countries and to see at first hand the impact she had on the thousands she met.

This is what I witnessed.

Glenn Harvey

Brazil
1991

Jumping off the press bus the majestic image of Christ towered above the world's media assembling in the coach park. But before any of us had the photo in the camera there were at least a thousand steps up to the top, or that's what it might as well have been. With all my heavy camera equipment over my shoulders I scaled the first steps, being closely followed by the other pressmen. The race to the press enclosure was on. If your position in the press pen is not in the right place you may as well be back England watching on television when the photo opportunity begins.

Halfway up the Corcovado mountain I felt a tug on my shoulder and immediately felt relief from the camera weighing down my body. A boy had grabbed my £3,000 camera with its lens and was running away with it. We had all heard and been warned previously about the poor street children of Rio with their formidable reputation for street crime. I had no chance of catching him as he disappeared into the distance.

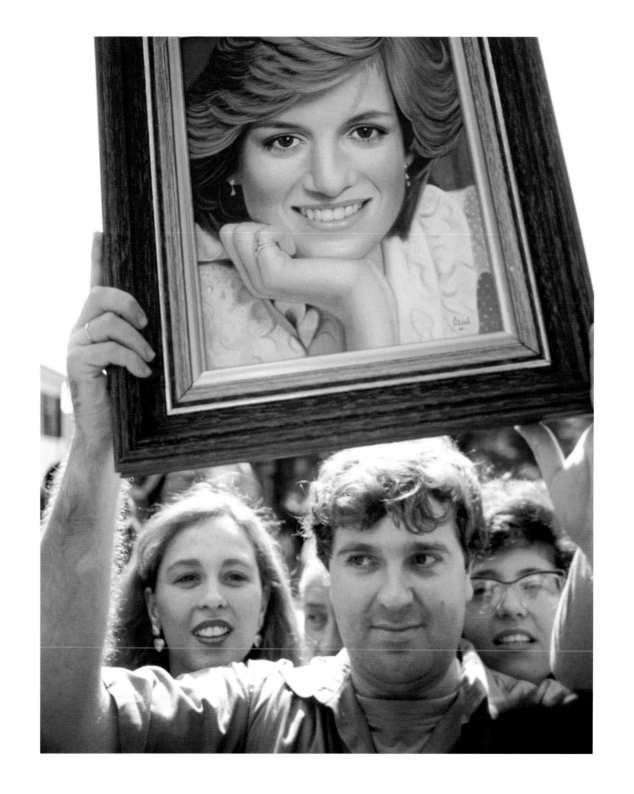

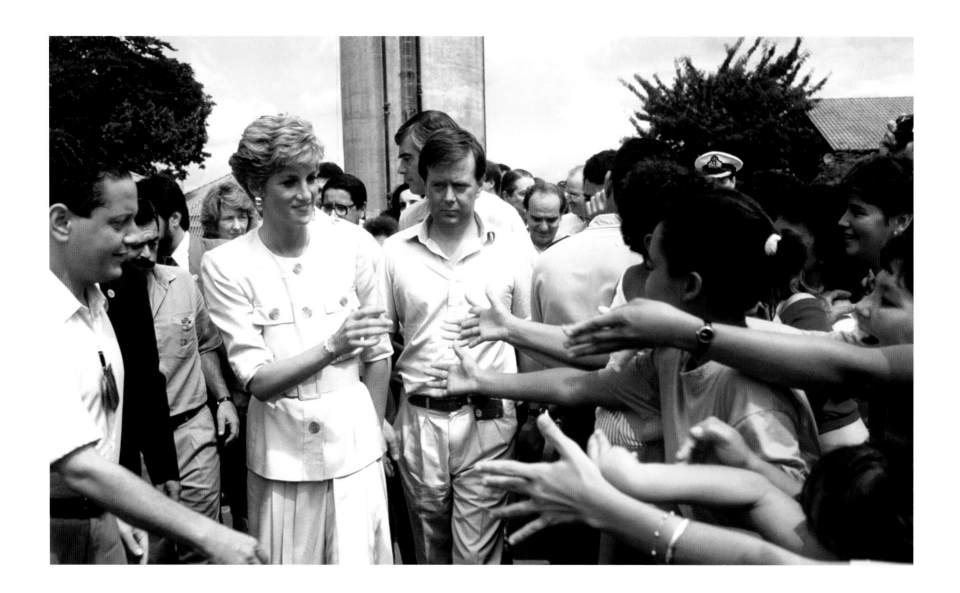

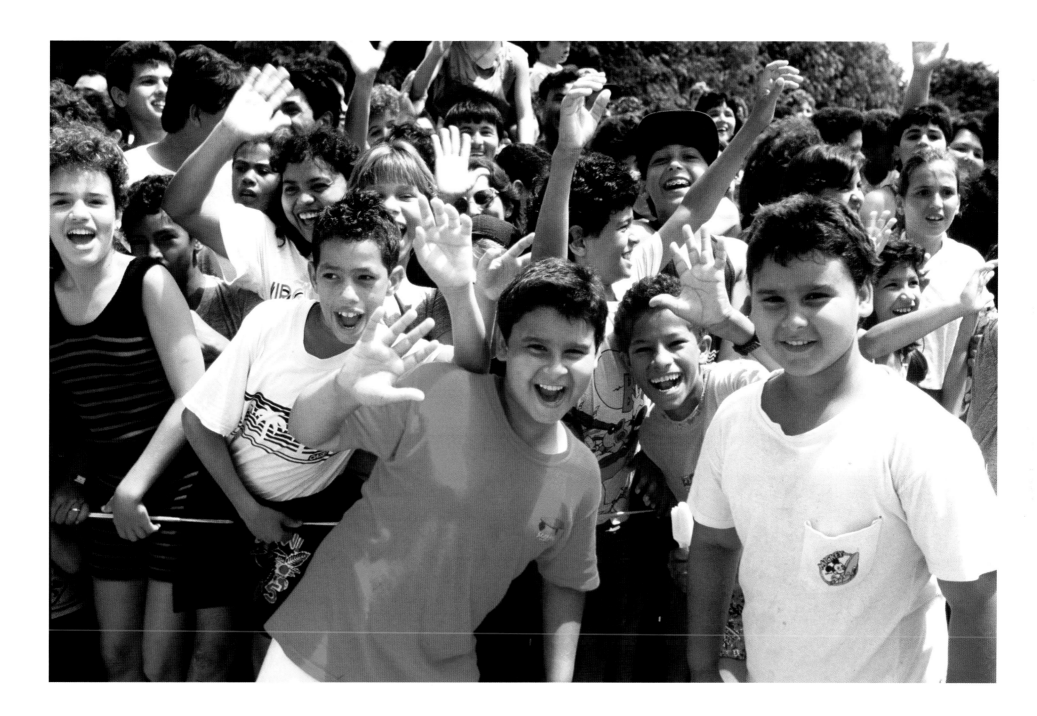

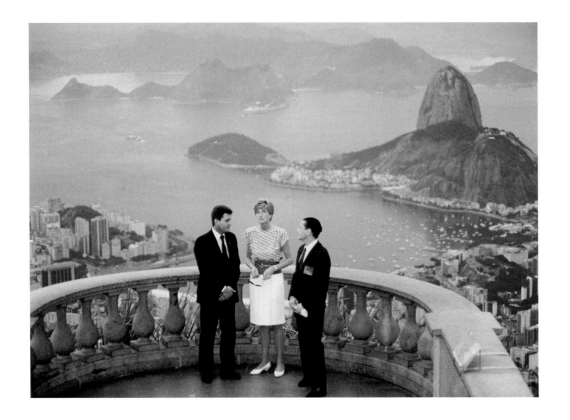

Reaching the top and gasping heavily for some breathable air I collapsed into a space behind a small roped area. The climb was over and so I thought was my life. I sat desperately sucking in the 'thin air', beneath the 38-metre concrete Jesus

'Excuse me, sir,' a small voice said cheerily. It was the boy standing proudly in front of me. In his hands held out before him was my camera. His smile was as wide as the Copacabana beach. The boy had seen me struggling up the mountain with my equipment and helped me out. So much for the Rio kids' reputation we were warned about, I thought. I offered the boy some money in return for his kind favour but he seemed offended at my offer and ran off skipping into the crowd.

With the help of the boy I had managed to get into a prime position to take one of my best photographs. Every time I look at it I think of the kind nameless boy with a grin as huge as his gesture.

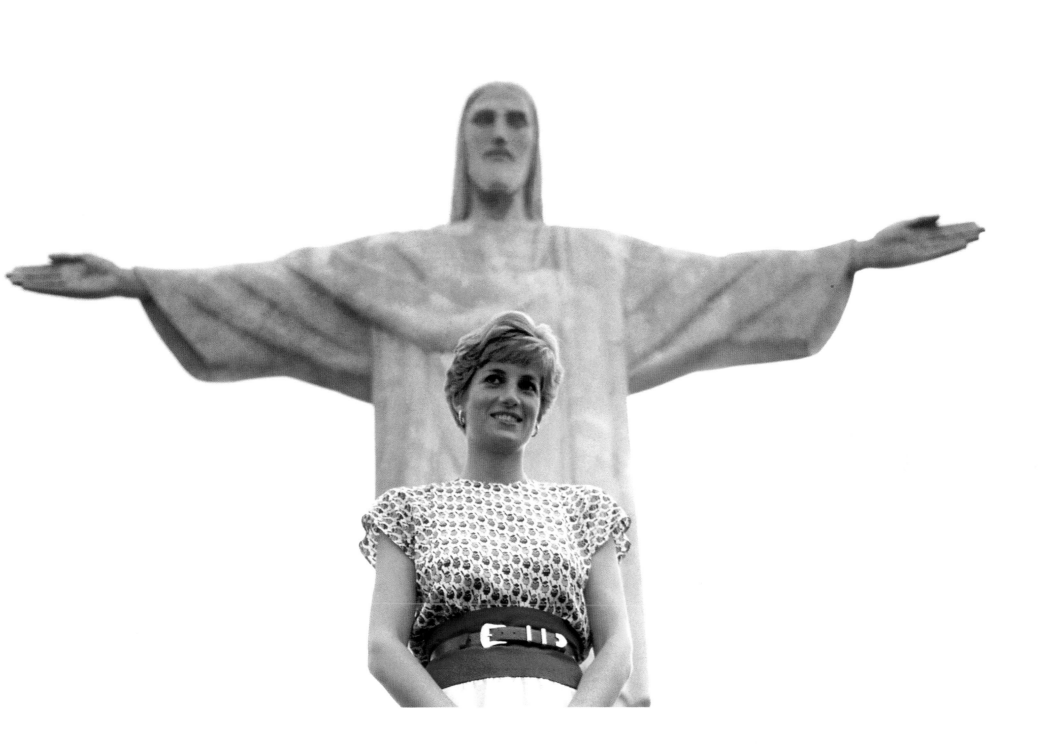

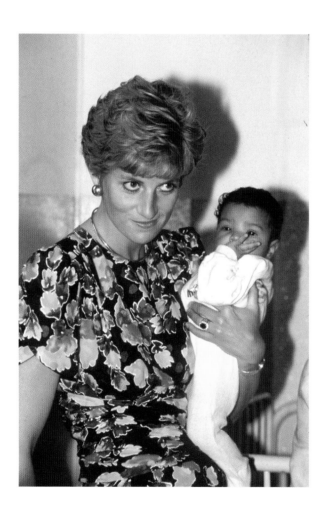

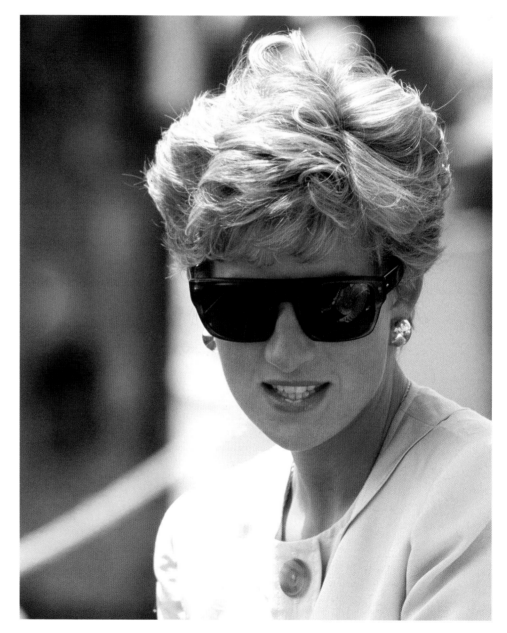

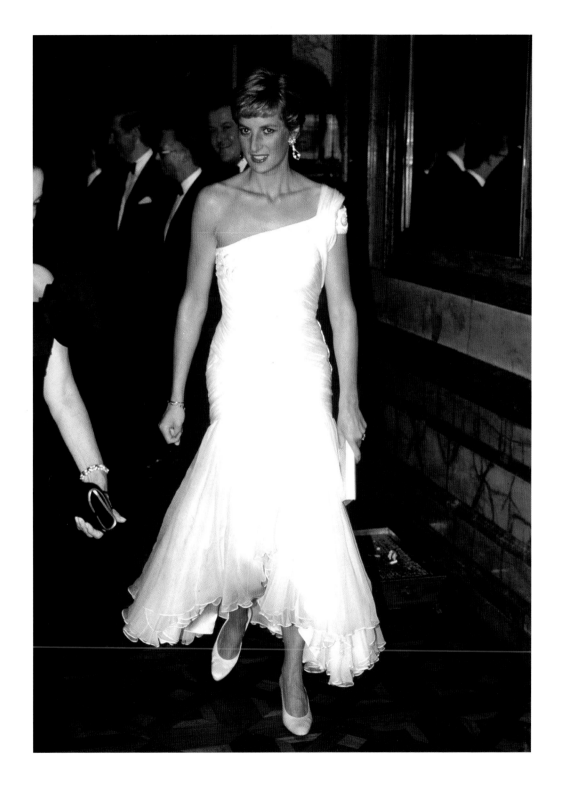

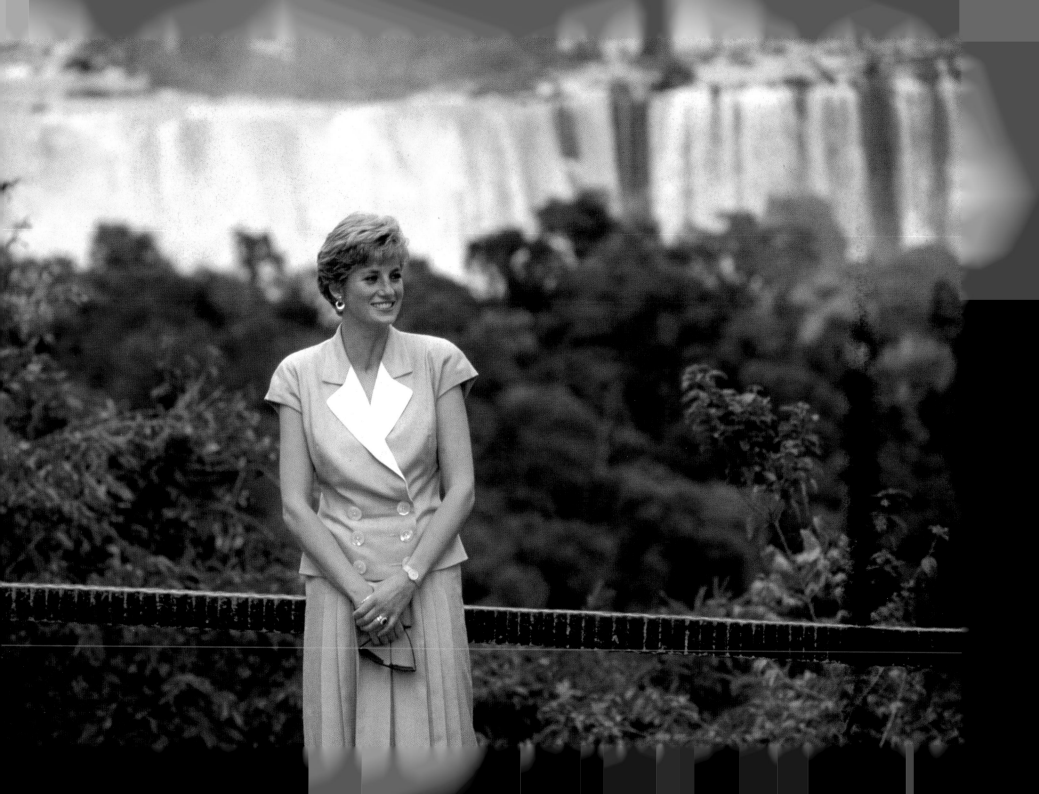

Indonesia 1989

Despite waiting for hours in the Jakarta heat, this good-natured crowd still had time for a smile when the authorities decided to put the media between them and Diana, totally blocking their view. This photograph for me sums up the warmth of the Indonesian people, not only to Diana but to all of us who were visiting their country and also standing in their way. I'm glad to say the press were moved out of the way before Diana arrived at the venue but not before a great deal of very friendly and light-hearted banter had taken place.

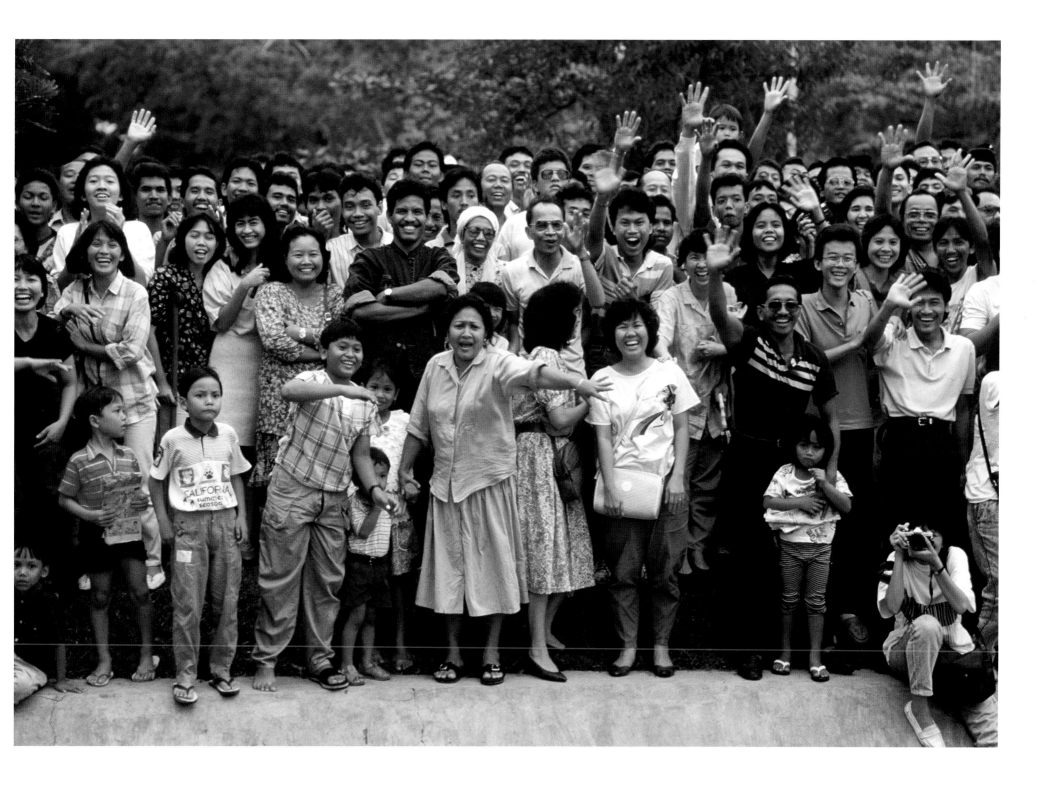

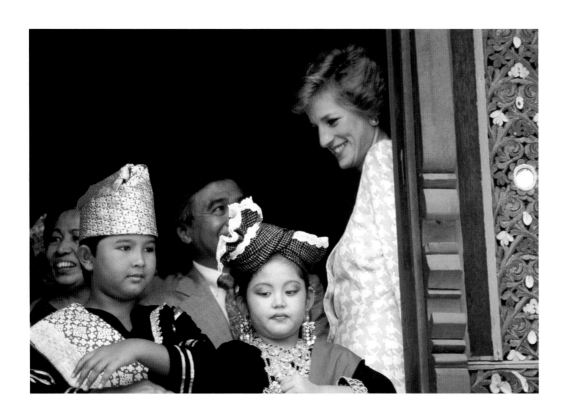

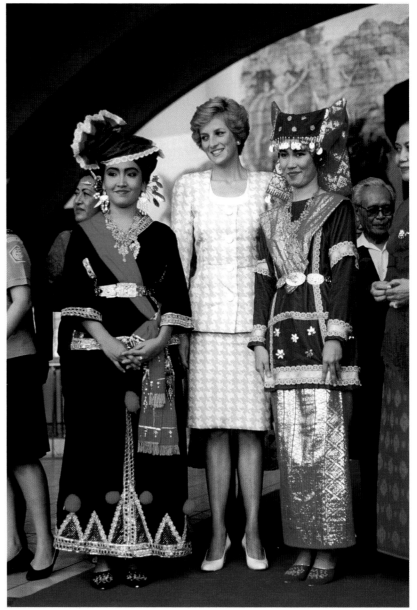

After meeting some of the patients of the leprosy hospital in Jakarta, Diana invited herself to a game of bowls. Princess Diana had the ability to instantly lift the mood amongst all around her as she moved on from the serious and difficult issues surrounding leprosy. Inevitably a somber moved had descended upon the gathering and her attention to the game was a very successful attempt to lift the spirits. Indeed, so much so Diana revealed a great talent for the game with a very deft bowling action.

Some of the magnificent national costumes of Indonesia are paraded for the royal guests in Jakarta. Diana is for once outshone in the fashion stakes.

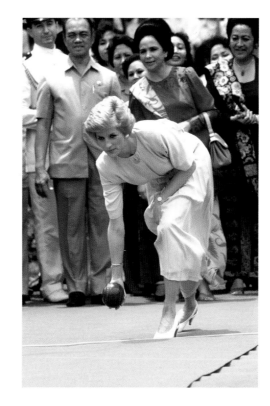 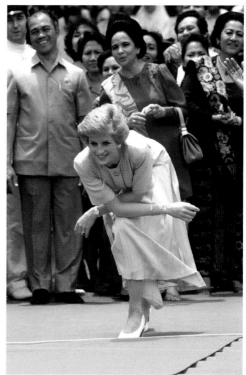

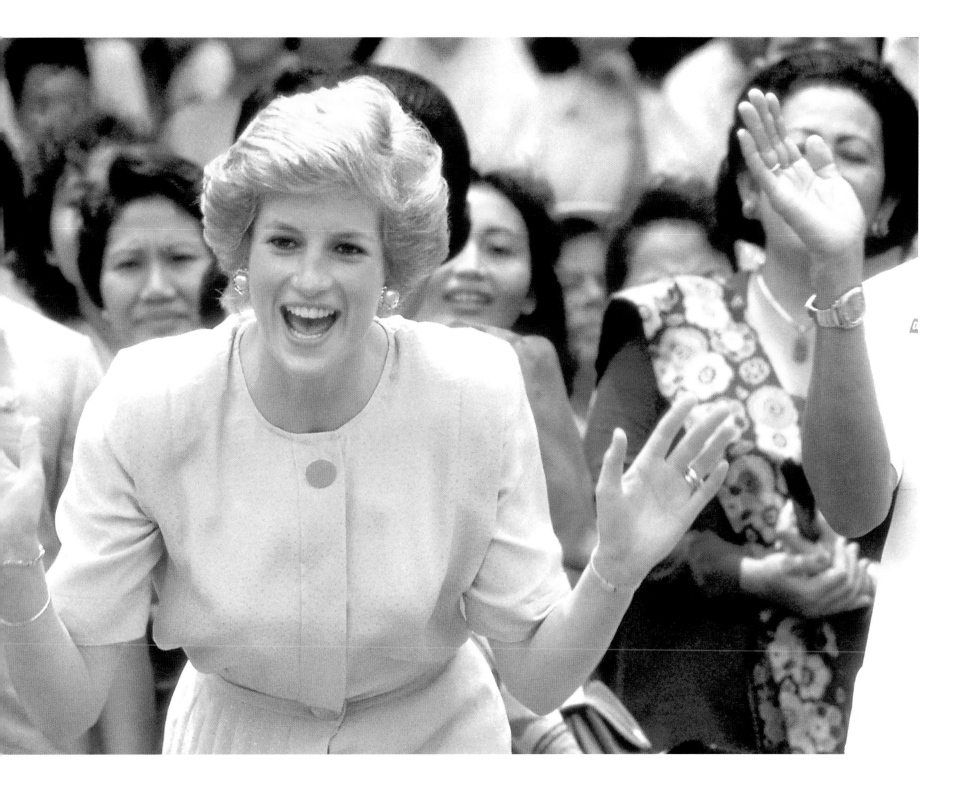

Hong Kong
1989

Diana boards a boat for a night tour around Hong Kong harbour. After a successful visit to Indonesia this Asian tour had landed in Hong Kong. The Princess looked confident and stunning. She was beaming with beauty and glamour as she arrived at a Kowloon Gala in full evening wear. Diana was ready to wow Hong Kong as she had wowed the crowds of Indonesia.

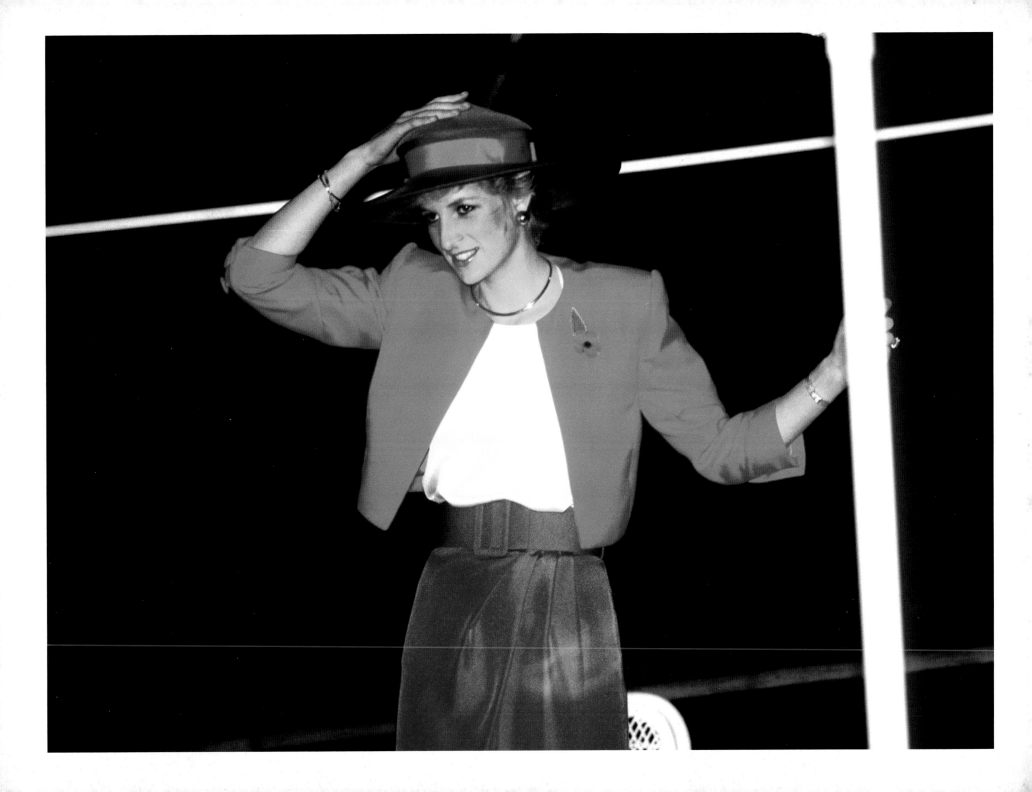

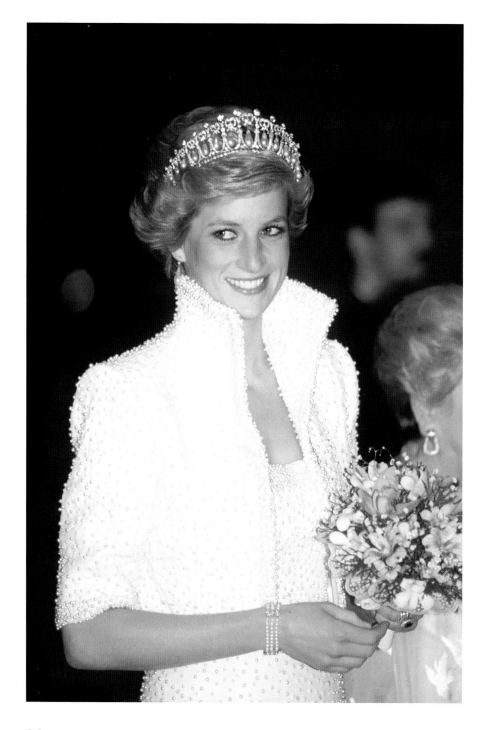

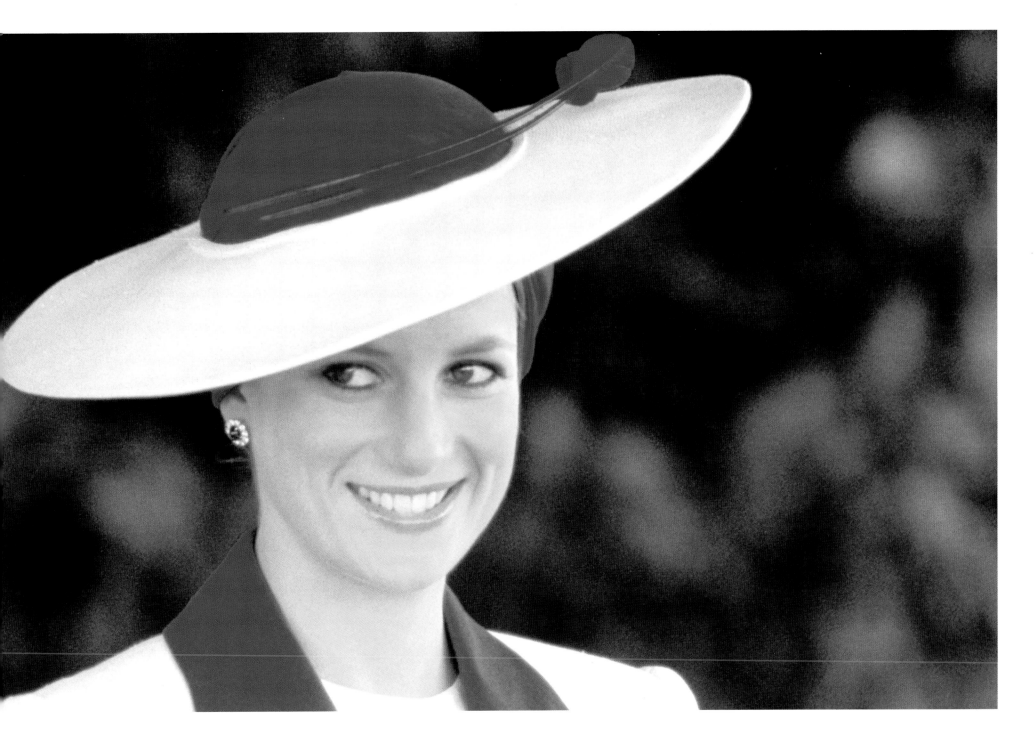

27 Hong Kong

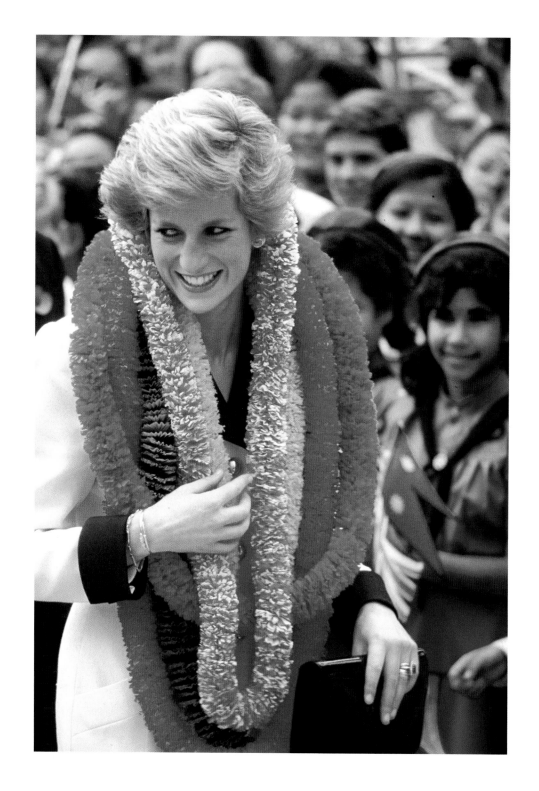

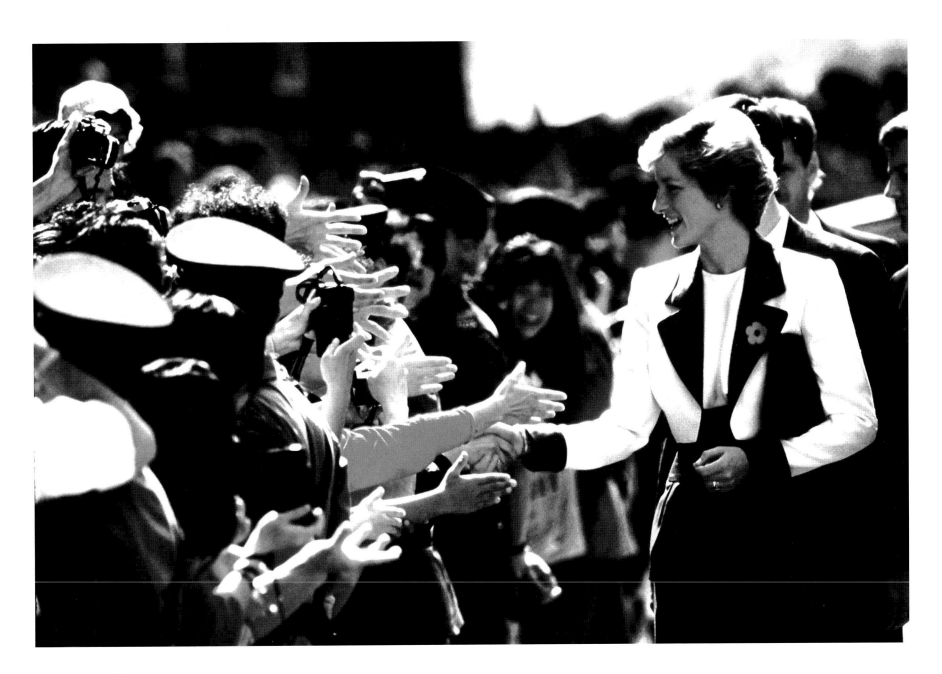

Italy
1985

The Italian press went crazy about Diana. I was on a three-week tour of Italy which would include all the main highlights the country had to offer. Having never previously experienced the country or its people I was looking forward to my arrival in Rome.

The Italian media were hyped up to excess. The newspapers and magazines had cleared the pages in preparation for the Princess Diana roadshow to hit town. Italy was waiting to explode with 'Di fever' and so were the Italian photographers . . . so much so that it nearly got me killed.

The press area was full to bursting when another bus delivered about twenty more Italian photographers. With their camera equipment over their shoulders they simply stood in front of the British photographers, completely blocking our view. The British press had been waiting for over an hour for Diana to arrive at the Forum and we weren't going to just stand there and have the view obscured.

I tapped on the shoulder of the photographer who had stood in front of me. He turned and smiled sarcastically and said 'No speak English'. I tapped him again and he turned around, then suddenly grabbed hold of my wrist and with his full strength rammed it down onto a sharp spike on an iron railing. The guy seemed to be suffering from a lot of stress as his eyes were staring wildly as he repeatedly smashed my arm down on the point. He was trying with all his might to impale me on it. Five or six times he tried before his colleagues pulled him off me. They had intervened before he had a chance to do any serious damage. He screamed at me in Italian as he was pinned to the ground by the police who had seen everything happen. Fearing reprisals, the other Italian photographers had managed to move across the road to find an alternative position. The Italian photographer had managed to break the skin in three places on the thin part of my wrist, but I'm sure he wanted to pierce my artery.

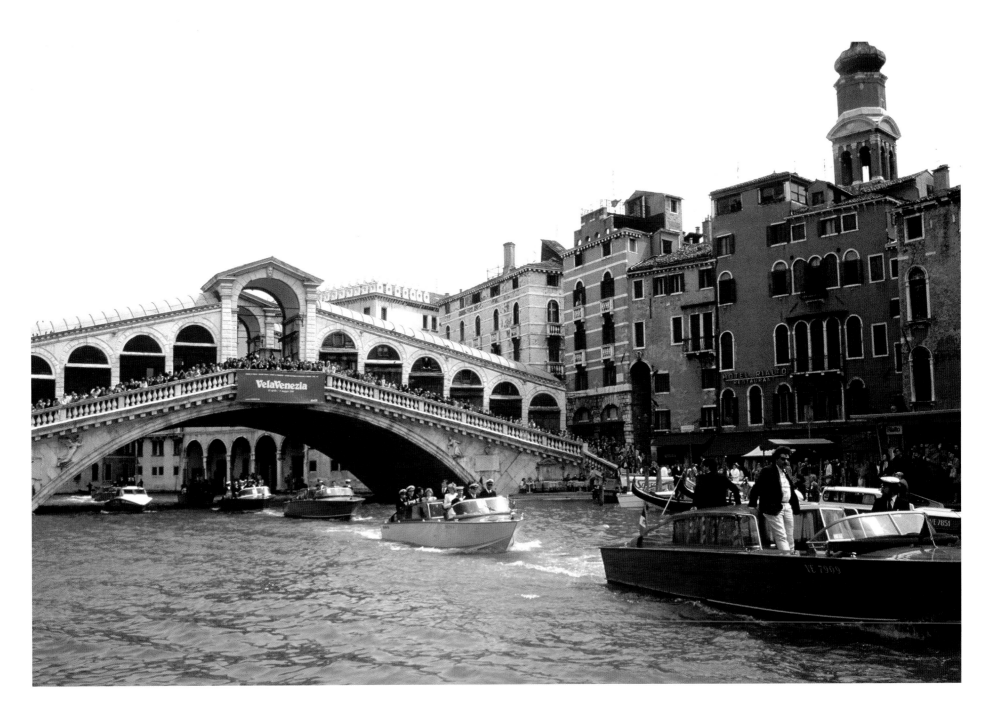

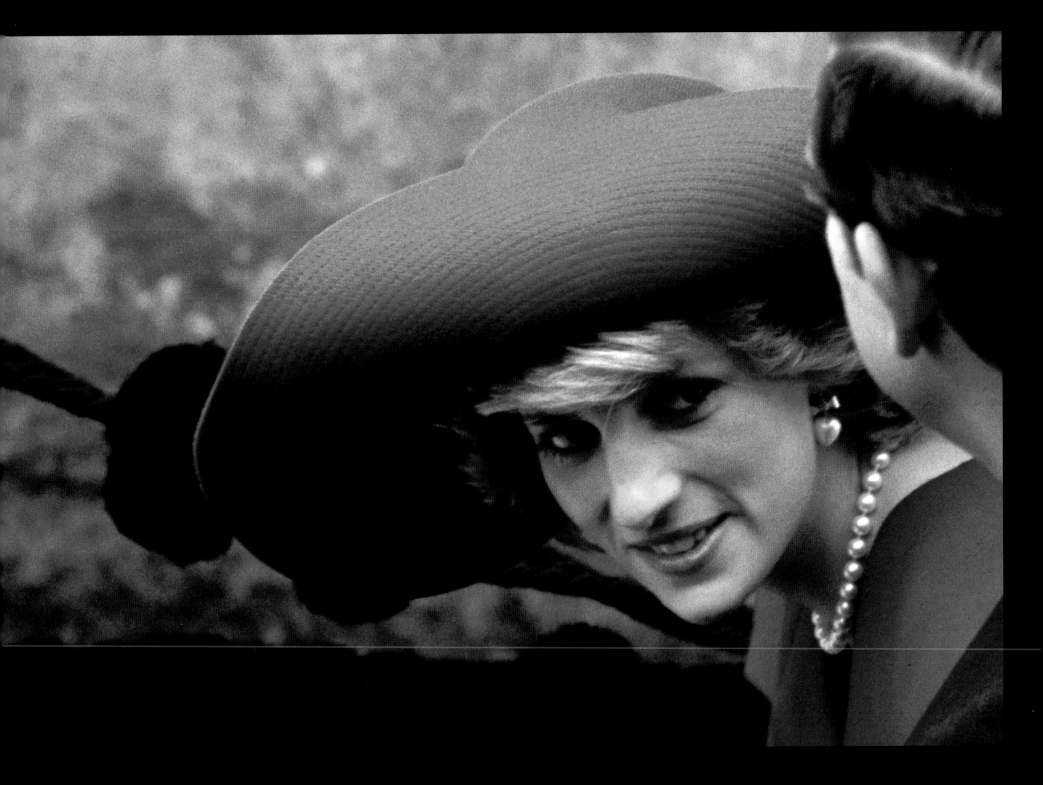

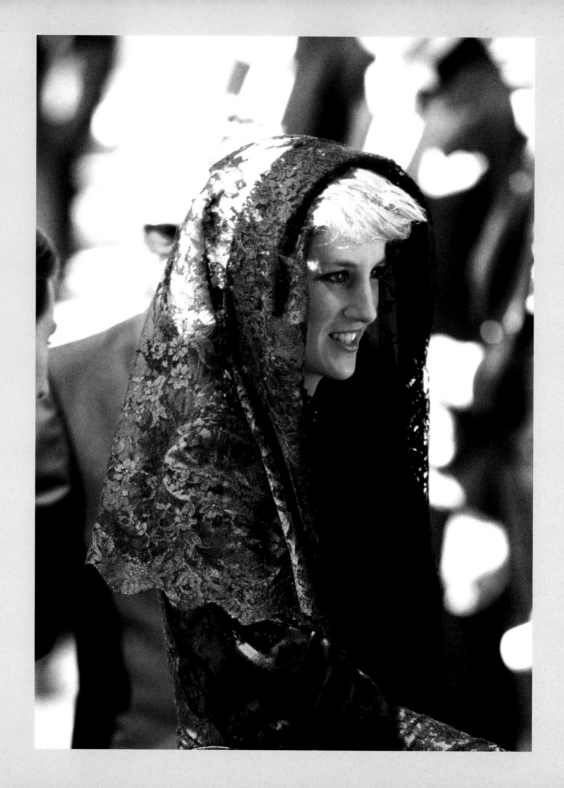

As the tour progressed over the next few days and the photographers had managed to take some good images, the pressure on them had reduced. The British and Italian press were socialising happily by now and even sharing each others' pictures. As for the crazy photographer and myself we became good friends and have remained so to this day.

Diana's royal tour included a visit with Pope John Paul II at the Vatican. Diana was 24 and this was one of her early tours. An audience with the Pope was a daunting prospect but she seemed to take it all in her stride. Diana was becoming accustomed to meeting high profile leaders in front of the world's gaze.

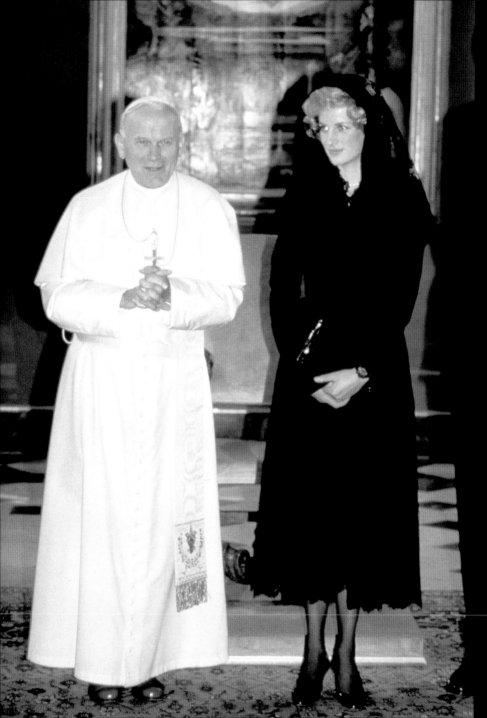

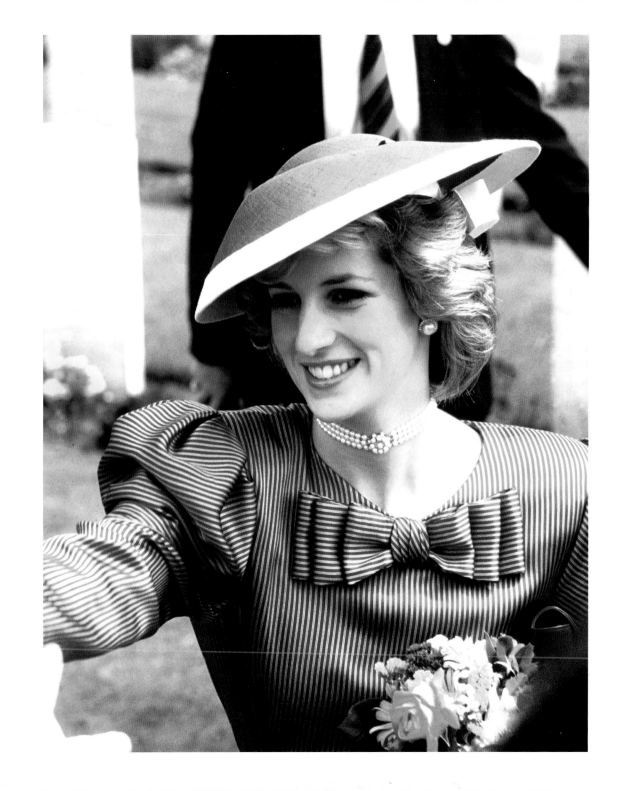

37 Italy

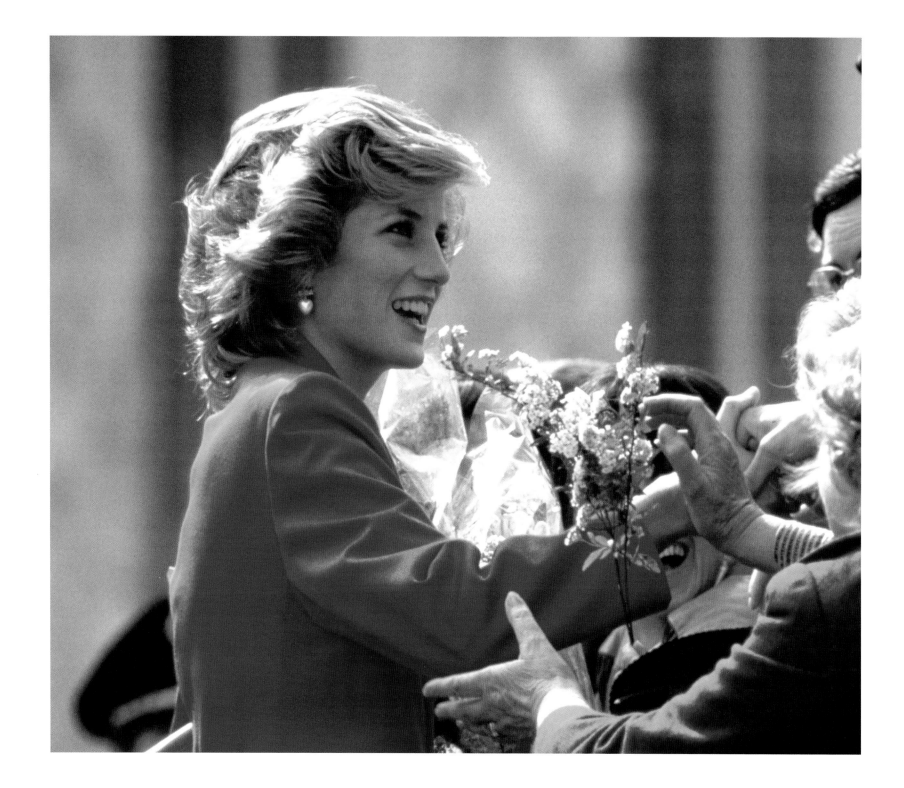

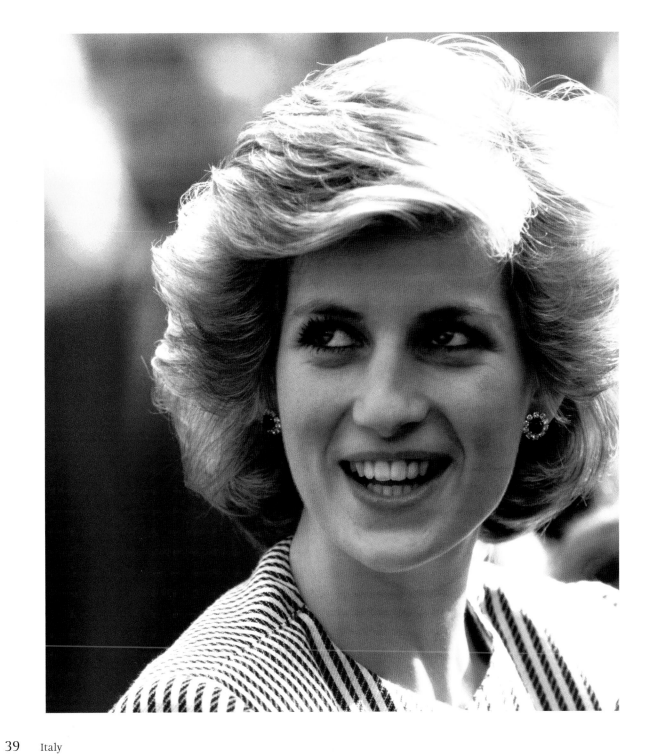

39 Italy

Australia
1985/88

You couldn't have squeezed another vessel into Sydney Harbour on this summer day in 1988. Anything that floated on the choppy sea would suffice as long as you could say to your friends that you were there. This was the Australian Bicentennial Day, celebrating 200 years of permanent white settlement after the arrival of Captain Arthur Phillip's First Fleet in 1788. Jet skis, dinghies, rafts, cruisers and ferries jostled for a front-row position for the arrival of the eleven tall ships and their re-enactment of the landings. The Aussies, Diana and the tall ships were gathered here for the biggest party ever to have been seen in the Australian continent's history.

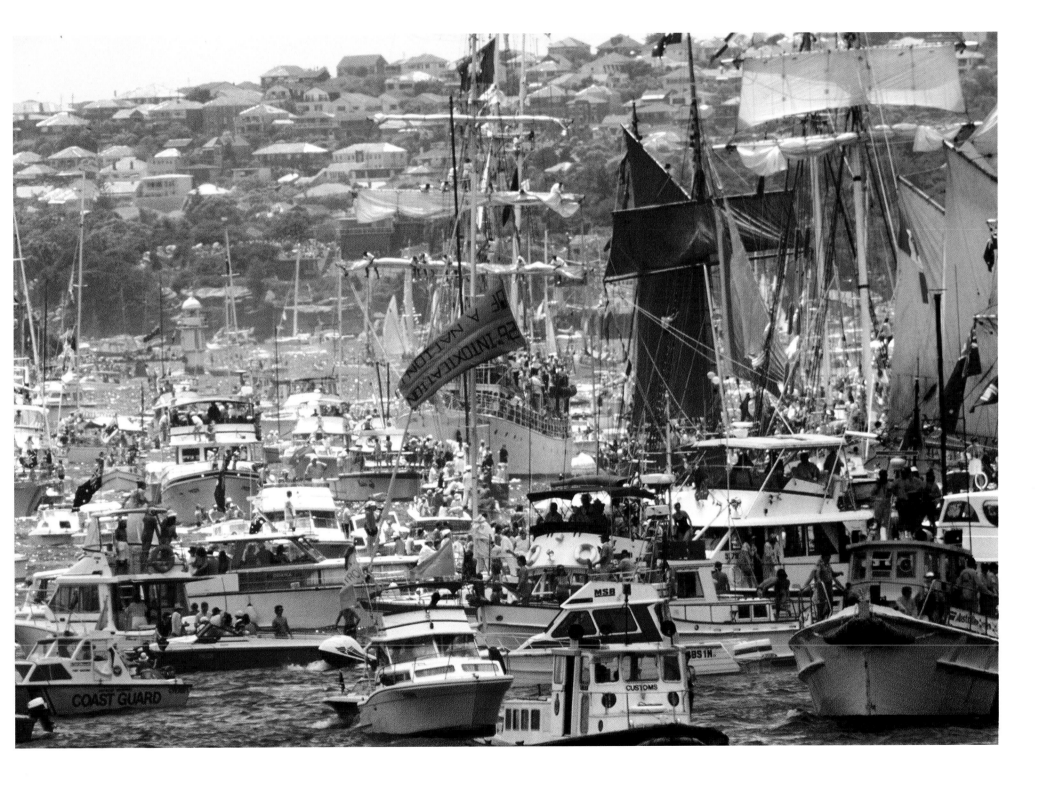

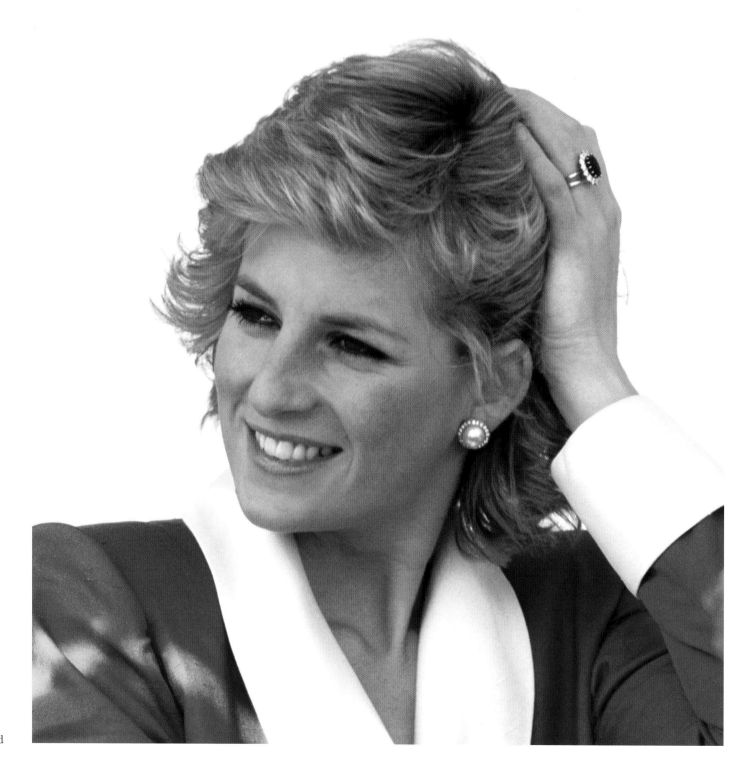

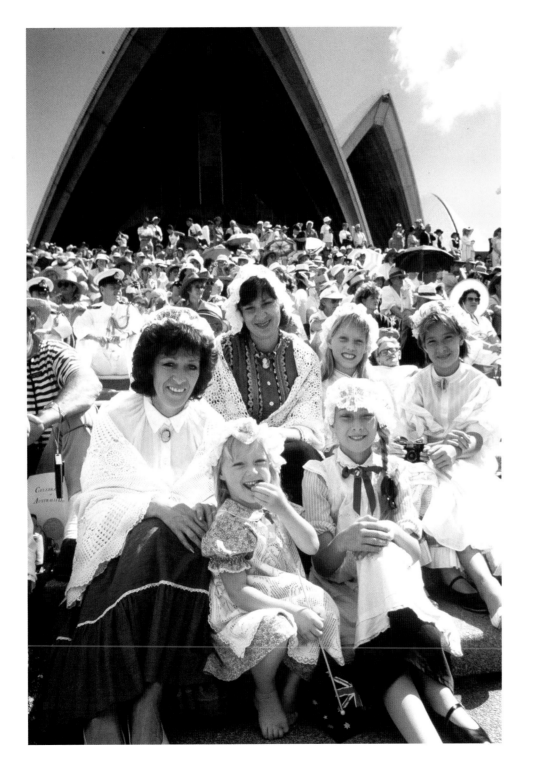

After the official ceremonies at the famous Opera House, the royal party and dignitaries boarded the ship, as did a small party of pressmen, myself included. Diana looked superb in her green-and-white suit. The Princess was in a buoyant mood as she took her place in a front-row seat within a makeshift royal box near the bow of our large vessel. Laughing and joking with the ship's crew and dignitaries, the joyful Princess waved at the cheering Australians aboard their overcrowded water crafts. The floating crowds were enjoying the bright sunshine, the crystal clear air and also the delights of the amber nectar.

The spectacular tall ships slowly arrived in the harbour, greeted by a chorus of ships' horns and applause, but after a couple of hours of bobbing up and down on the sea, Diana's ocean legs began to give way. The pale-looking Princess got up from her seat and went out from the public view to a secluded area near to the ship's bridge. Diana steadied herself as she clung onto a pole. She remained there motionless for another twenty minutes, hanging onto her pillar of stability. One of the ship's officers brought her a glass of water which she drank in one mouthful. Although dealing with her more personal problems, Diana still acknowledged the attention of a group of screaming teenagers who had spotted her. Their small yacht floated uncontrollably beside our ship.

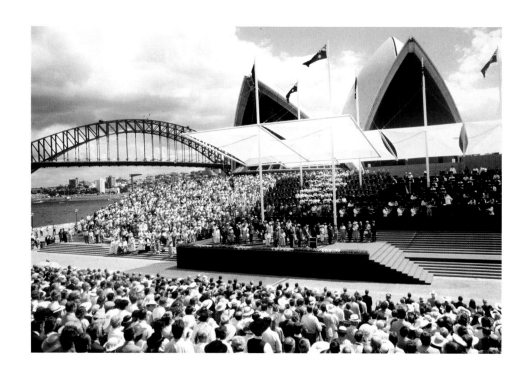

As our ship continued to roll about from side to side Diana eventually began to overcome her seasickness and bravely returned to her seat, back onto the world stage where the valiant Princess smiled and waved once more for the thousands of people in the harbour and the millions watching at home on television. Still enjoying the great Australian event, they were blissfully unaware of Diana''s poor condition; although from her outer appearance nobody would have guessed any different.

The successful royal tour continued to Melbourne, Shepparton and Canberra, where the royal party were warmly welcomed by the local people with a great passion. Any mention of an Australian republic had been squashed by the unstoppable, enthusiastic momentum of this royal tour down under.

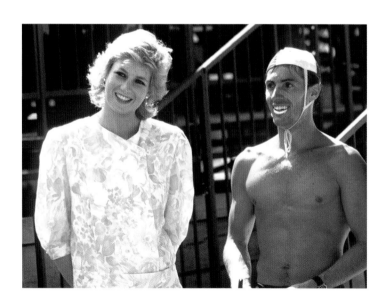

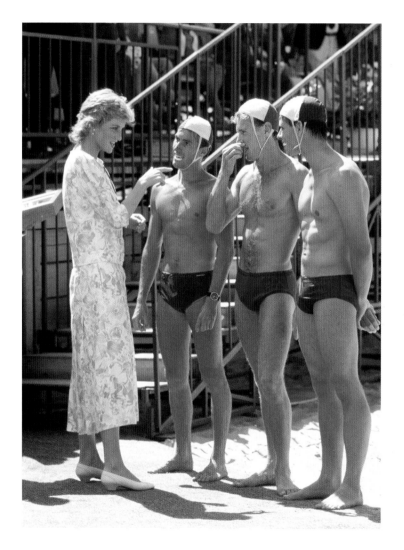

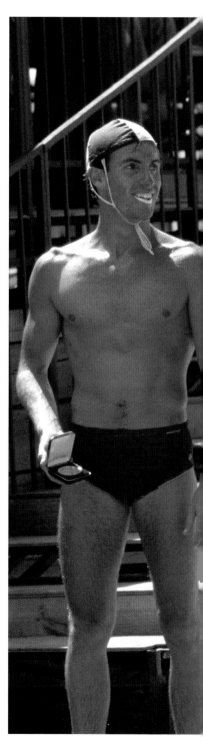

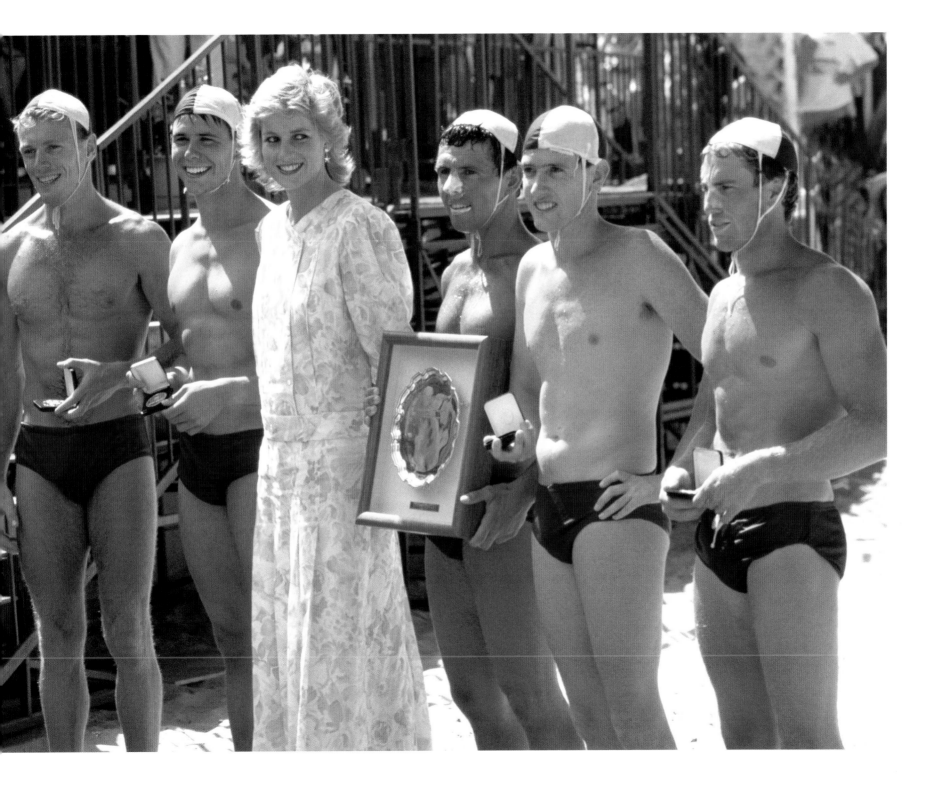

Japan
1986

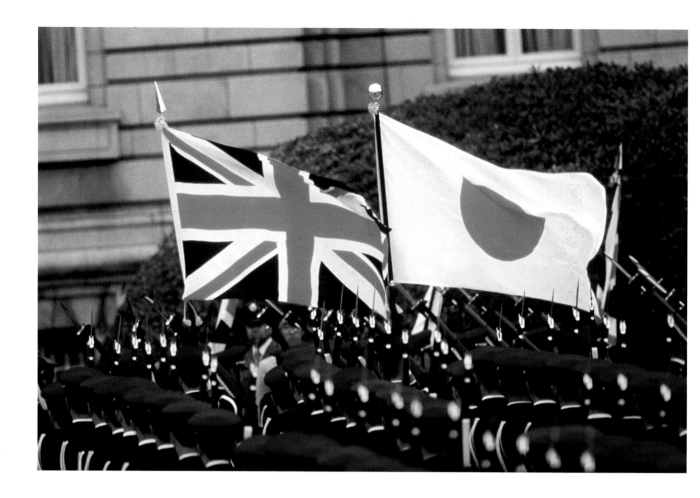

As I was watching Diana take her seat next to Emperor Hirohito of Japan at a banquet hosted by him, I was wondering to myself what the pair could possibly talk about all evening. They were to dine in the lavish setting of the Imperial Palace in Tokyo. They surely couldn't have had that much in common to stay amused for the next three to four hours.

He was 85 and Diana only 25. The Princess looked the most uncomfortable as the Emperor sat in silence next to her. Diana wore a necklace around her forehead which I'm sure could have given them some-where for the conversation to start off. The uncomfortable scene most probably would have changed a little later on, having seen the Princess break the ice on previous occasions with her inimitable whit and charm. Diana seemed to have a knowing look on her face as she watched myself and the other members of the media briskly ushered out, as the smartly dressed Japanese waiters brought in the appetizers on silver platters.

At a traditional tea ceremony at Kyoto Castle Diana wears a dress in keeping with the royal visit to Japan.

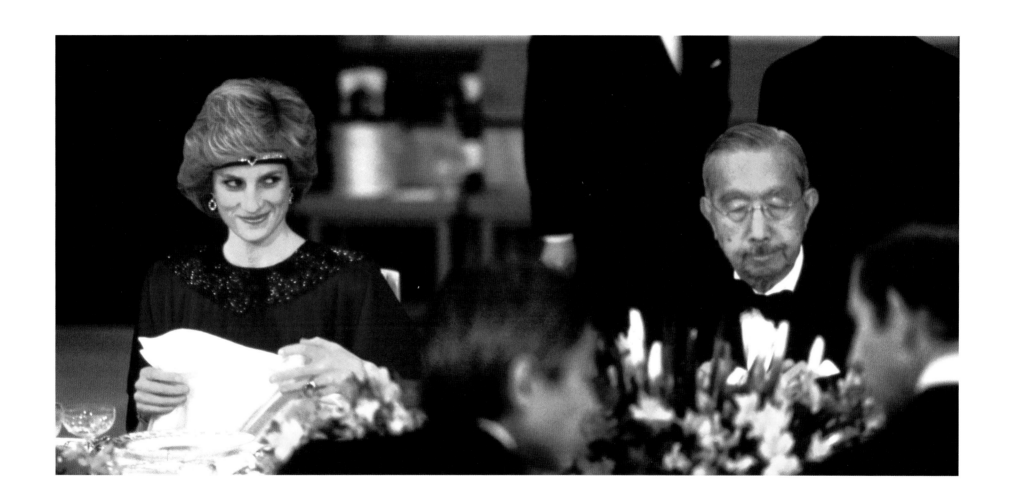

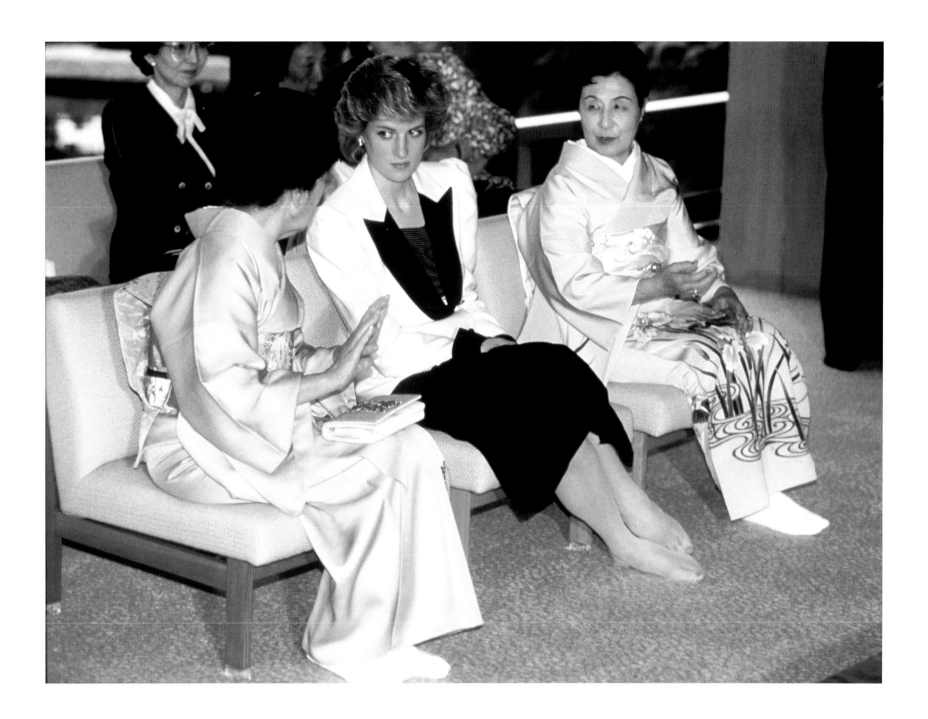

Egypt 1992

Being a photographer covering royal tours can be a very rewarding profession. As well as being paid (sometimes!) we get to see, although briefly, many of the beautiful and ancient sights that are proudly shown off by their hosts to their royal visitors. I was particularly looking forward Diana's visit to the magnificent and historic country of Egypt and the many treasures it had to offer. But on the first morning of the tour I was not taking pictures as I had planned but standing embarrassingly on a hotel balcony with nothing but a small towel wrapped around my waist. After a shower I had gone outside to check that the press bus was still there in the car park. The door slammed behind me leaving me no way back into the room. I was ten floors up and the press bus was now pulling out of the car park below me, packed full with photographers.

Working as a freelance on an overseas royal tour is a risky business. Your profits are entirely dependent on the photographs you produce and at this time I wasn't producing any. No amount of planning and preparation had prepared me for this. I spent the next couple of hours shouting down to the street trying to gain the attention of the locals below, whilst at the same time Diana was posing for the cameras in front of Egypt's finest monuments without me.

Finally the hotel maid came to make the room up. A now crazed Englishman was pacing up and down the balcony waving his arms in the air yelling. Unsure, she let me back in the door. I was dressed and out of the room with my cameras ready as quick as a Egyptian cobra's bite.

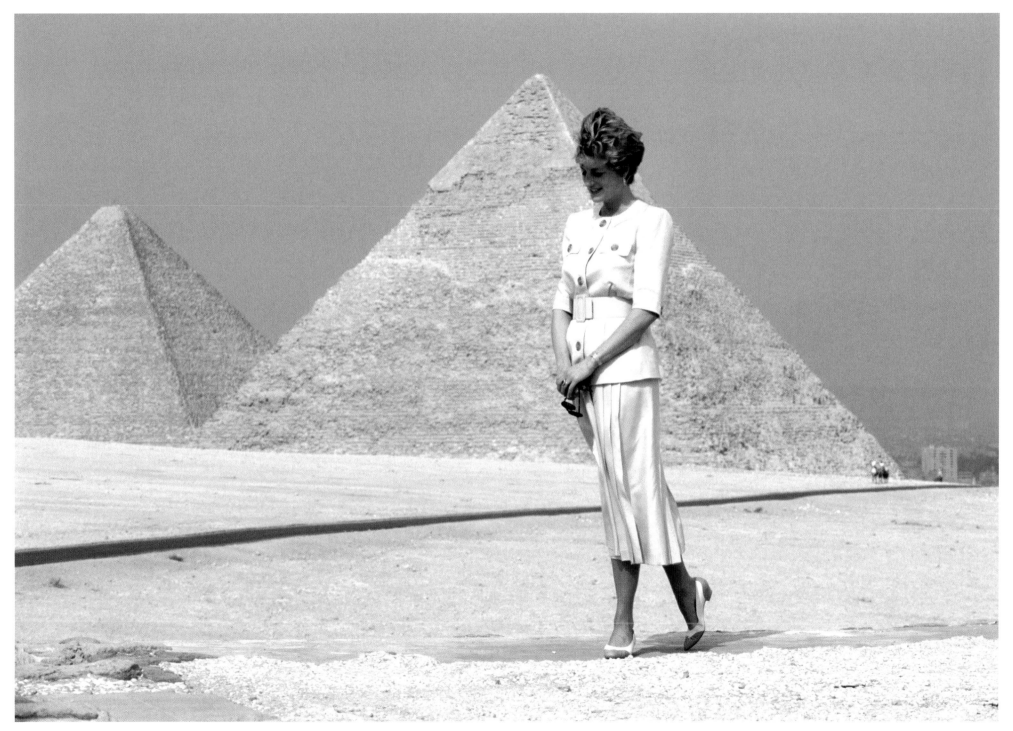

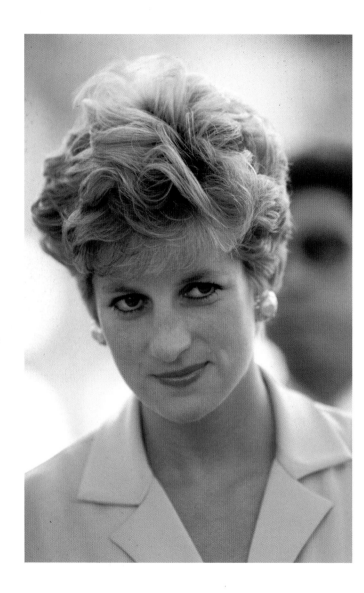

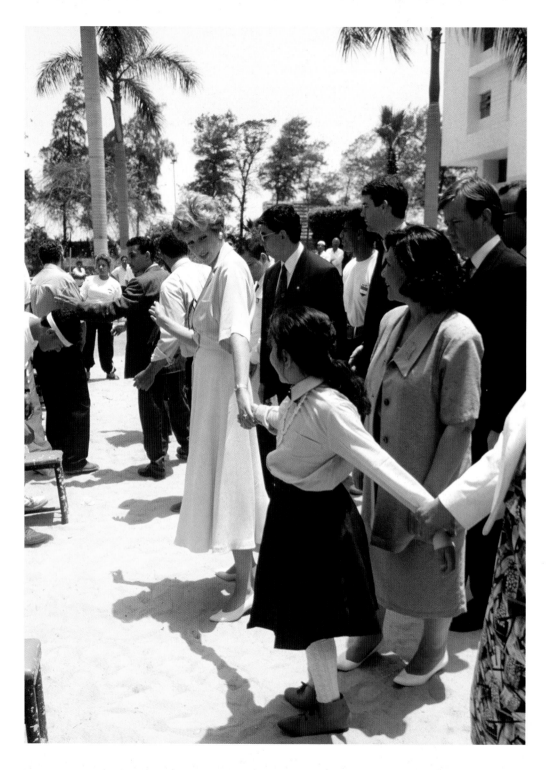

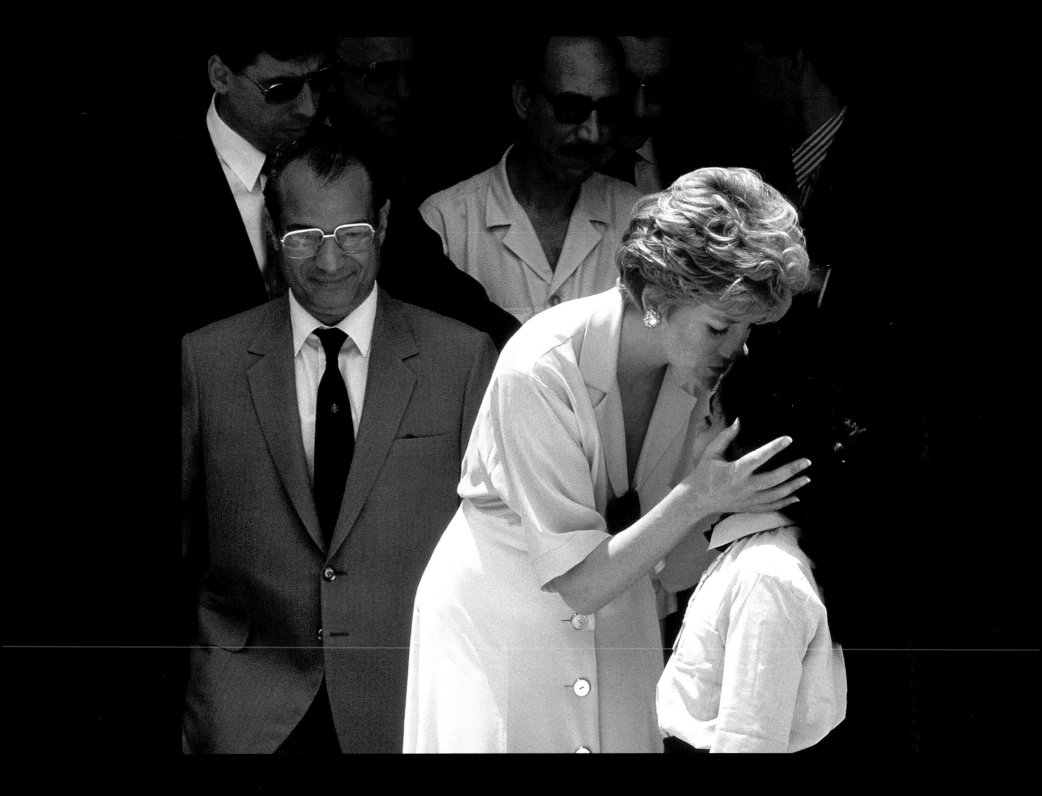

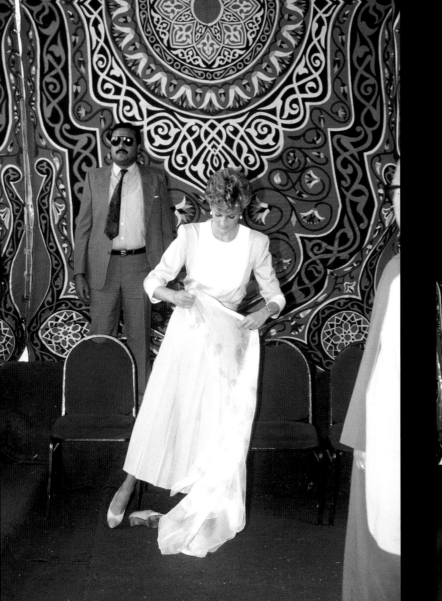
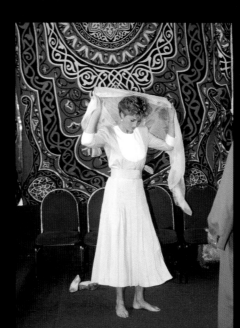
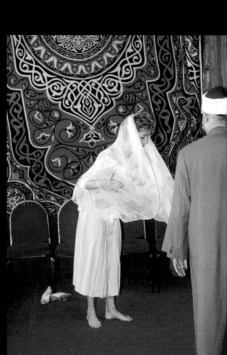

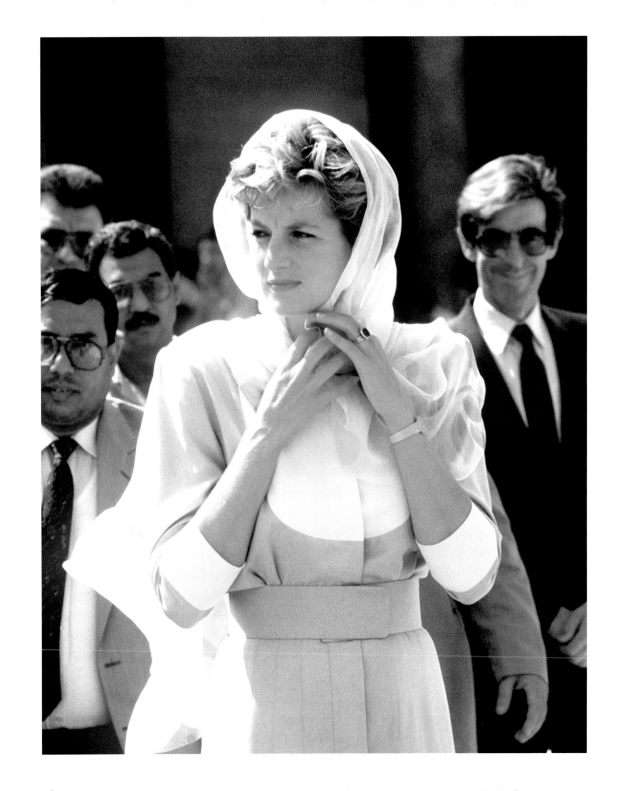

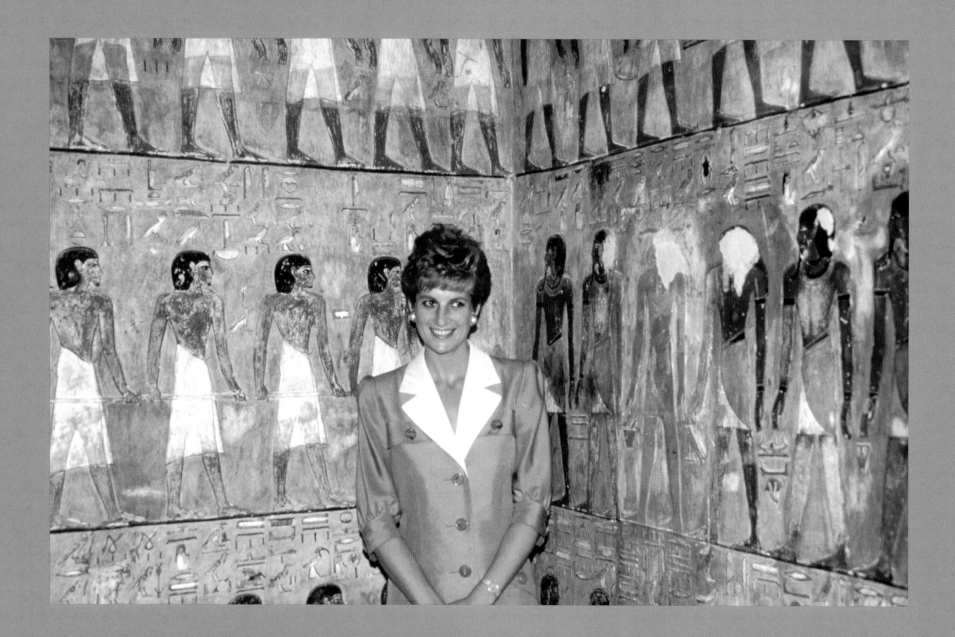

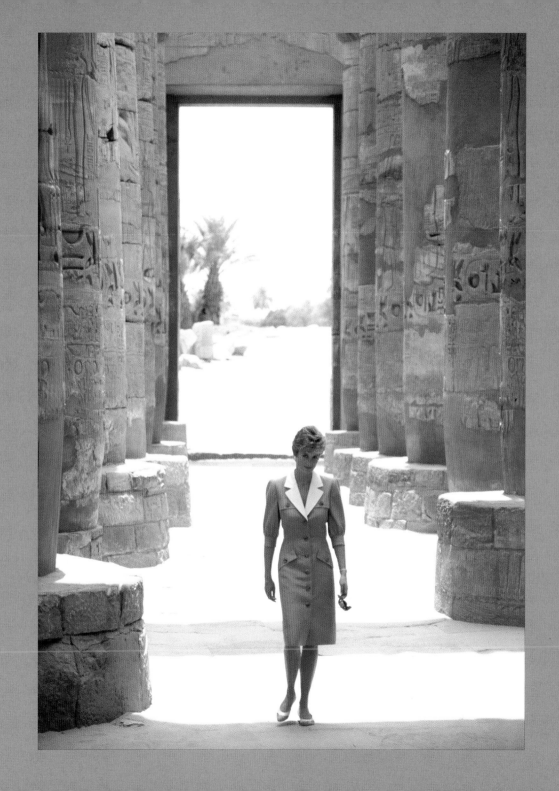

Germany
1985

Diana admired the armed forces and always took great interest in the work they had to do and, in truth, she was always upbeat when close to gentlemen wearing uniforms. So when she was invited to inspect the troops of the Royal Hampshire Regiment, she didn't need asking twice to make the long journey to Germany.

Upon arrival at the barracks in Berlin, she positively glowed with delight as she was handed a single red rose by one of the nominated soldiers. The troops were as fond of the Princess as she was of them. Diana flirted with the dapper soldiers on the parade ground. There would be no unclean shoes or untucked shirts when their Colonel in Chief visited the barracks. The Princess came to see the cream of the British Army looking their best and their best is what they delivered.

The Princess, still clutching her rose tightly, walked along the straight line of men standing proudly upright at attention. Row upon row of handsome young men stood shoulder to shoulder, waiting for their first close-up glimpse of the Princess as she slowly passed them by. Then in the next moment Diana came face-to-face with a combat soldier smeared in full camouflage face paint. Diana jumped backwards with surprise, she hadn't expected to see a filthy mud-covered man amongst this sea of perfection. Diana frantically waved her hand across her blushing face as she tried to compose herself. The Princess, still flushed, grimaced when she took a closer inspection. The soldiers face was covered in various shades of sticky dull green and brown paint which cracked as he laughed out loud. 'Do you want to try some on?' he questioned her cheekily. Her eyes fluttered then she lowered her head in her famous 'Shy Di' expression and whispered back to him, 'Maybe later, dearest.'

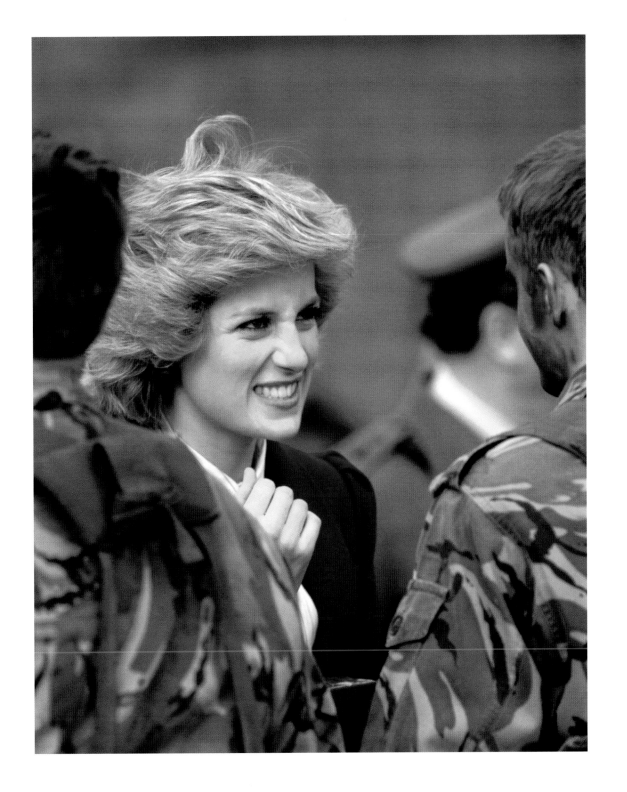

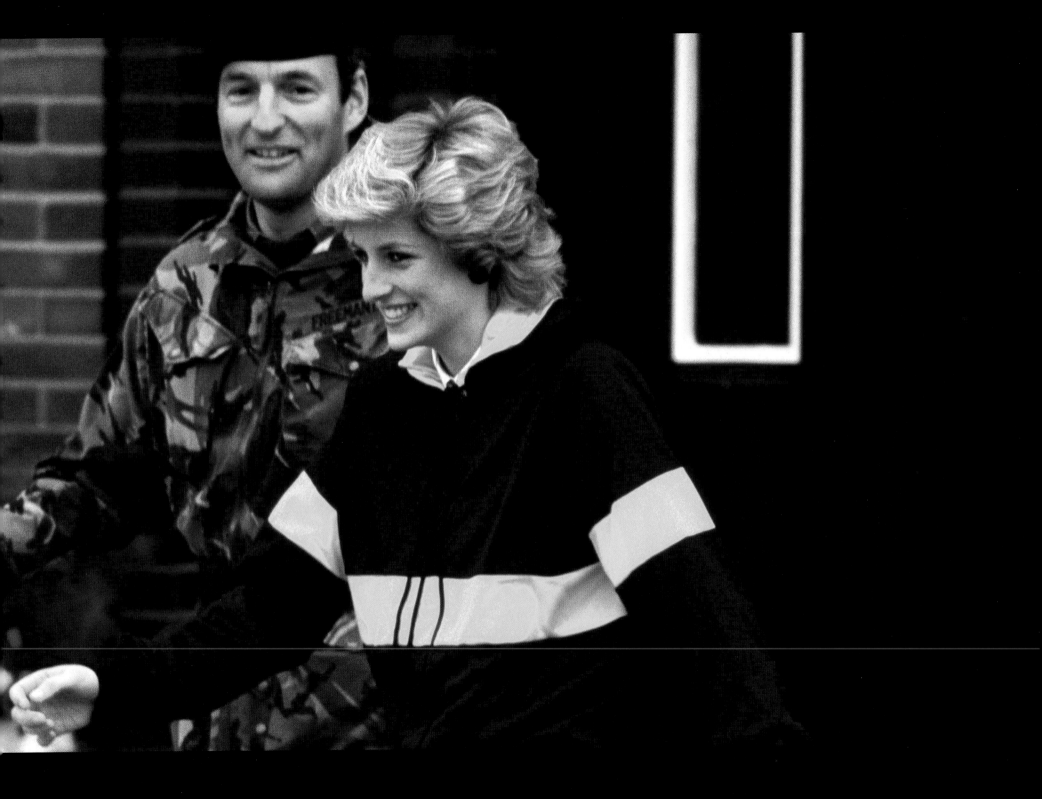

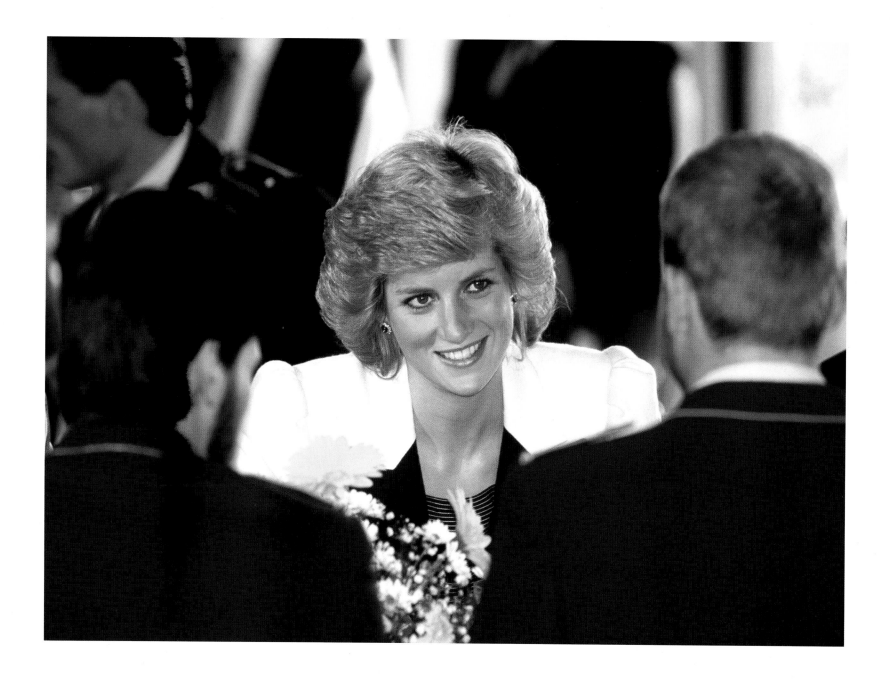

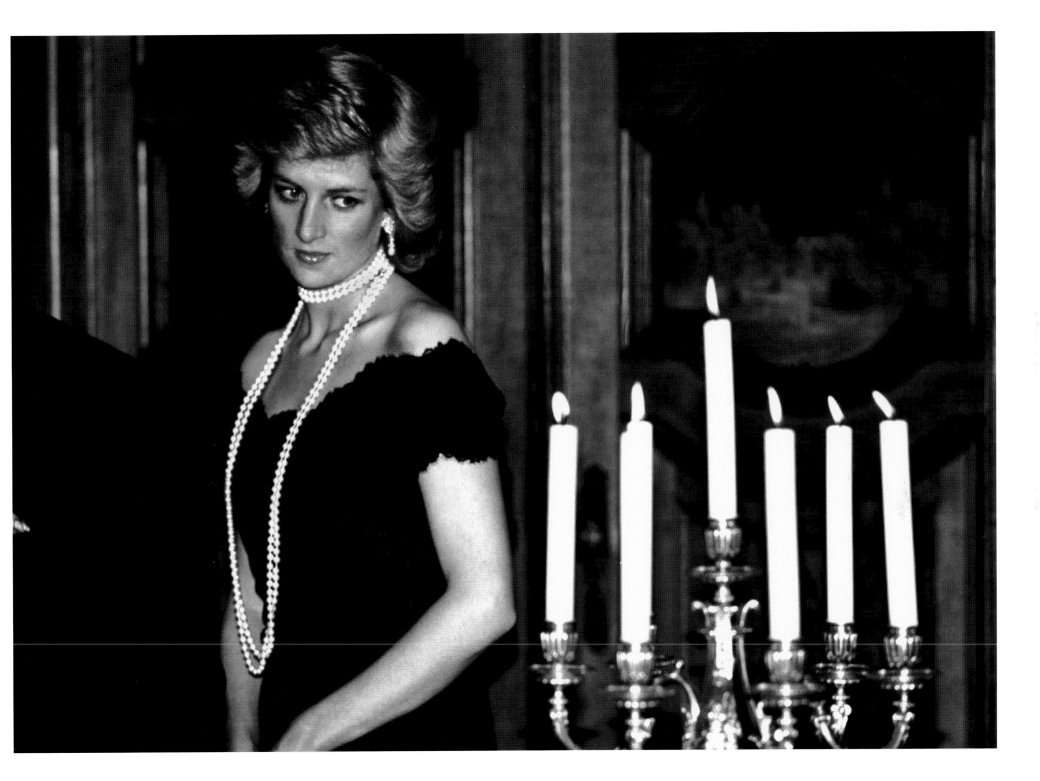

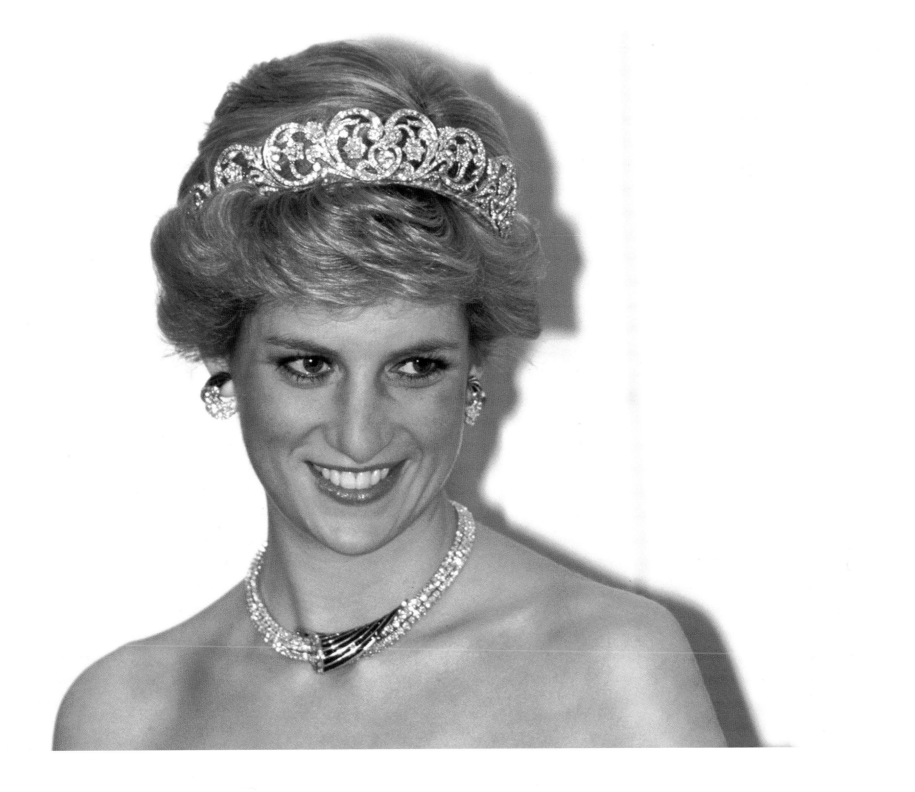

Nigeria

1990

A small boy, who couldn't have been more than seven, lifted my suitcase from the conveyer belt in the arrivals hall at Lagos airport. The piece of luggage was about the same size as the lad as he stood there smiling broadly at me. It emerged that he was to be my (unofficial) guide during my stay. I had not even passed immigration control yet; the boy was allowed to wander through the hall. He then snatched my passport from my hands. 'I have your taxi waiting for you, sir. Please come this way,' he announced pleasantly, then tugged at my case, pulling it across the concourse towards the passport check.

The boy handed over my passport with some authority to the immigration control officer; he was well known to him as he nodded, smiled then waved us both through. 'This way please.' He was a hustler of the most professional kind as he never waited for an answer to his remarks. I didn't even want a taxi as I had transport already waiting for me outside. To follow my bag was my only option as by now he was racing ahead of me nearly through the main airport exit. 'But ...?' I shouted behind. My objections were falling on deaf ears so I submitted to my fate.

There was a ramshackle car waiting outside on the roadside, with no hint of taxi written anywhere on it. The driver was a woman dressed in a colourful patterned dress and headscarf. She also had a large smile when she saw the tiny boy, probably her son, heading her way. By now there were four young boys, including my 'guide', pulling hard at my case and arguing to see who was going to lift it in the boot. The other photographers, who had arrived on the same flight, were also having similar experiences with their luggage outside the terminal building. All were at various stages of negotiation to retrieve their bags from the unrequired 'taxis' and to put them on the press bus waiting nearby.

Out of the 16 media who arrived on the flight, only one made it unscathed to the press bus with their luggage untouched. The other 14 and myself resigned ourselves to hiring the unmarked and probably unregistered (there was no meter) taxis to the hotel whether we wanted to travel this way or not. The 'airport boys' were very persuasive but also extremely charming with it. Who could have refused their guile and enterprise that day and, after all, we were helping out the local economy in the end.

The press bus arrived at the city hotel later, empty but for a single passenger.

The Princess arrived in Nigeria soon afterwards to promote British and Nigerian business and cultural links. Formerly a British protectorate state, Nigeria had gained its independence in October 1960, but many years of political instability had followed.

But for now Nigeria was ready to welcome its royal visitors with some style. The Princess was entertained in Enugu by dancers and musicians traditionally dressed in colourful outfits, much to Diana's delight and the media's. The photographs showing traditional African people represented exactly the material required by the world's press. Diana stood and chatted with the entertainers afterwards and thanked them for their highly entertaining show, then gladly posed with them for the cameras.

The local people, who had also watched the entertainment, did so with ecstatic enthusiasm. Taking time off work from a nearby hospital, young nurses didn't miss the opportunity to snatch a glimpse of the Princess. The young ladies waved Union Jack flags vigorously above their heads and also the green and white national flag of Nigeria as the royal car passed by, on its journey back to Lagos. As Diana's face became visible in the car window, the group jumped up and down screaming and cheering. The Princess waved and beamed a delighted smile at them.

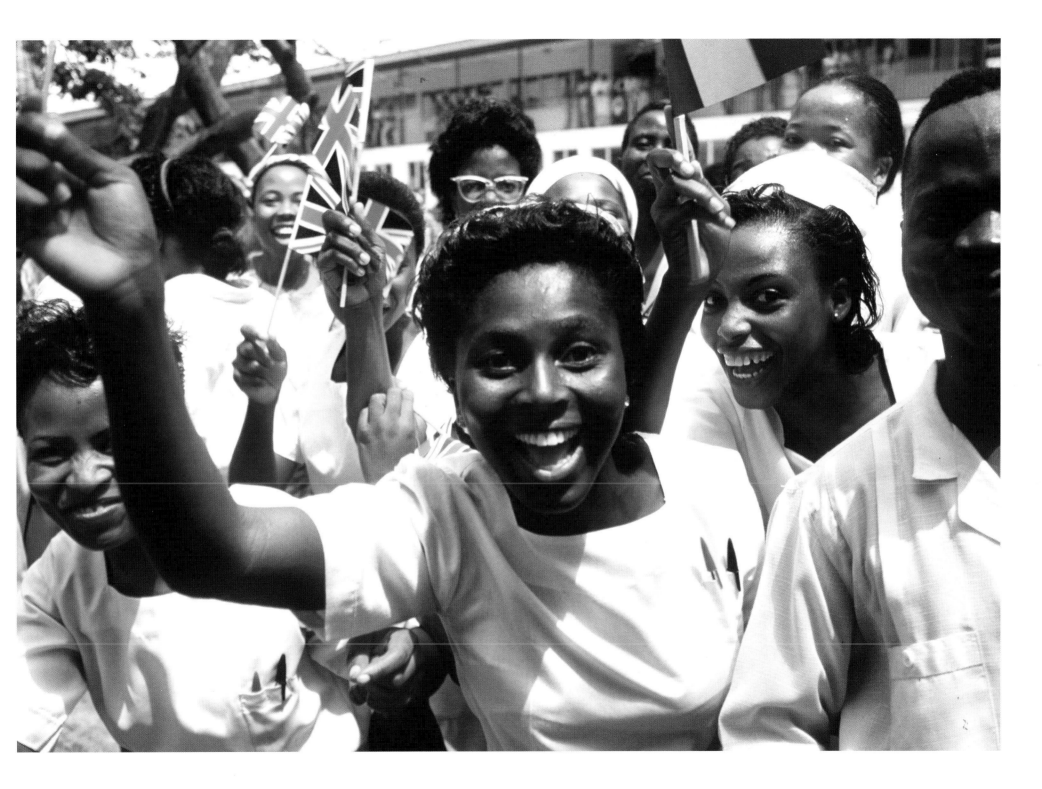

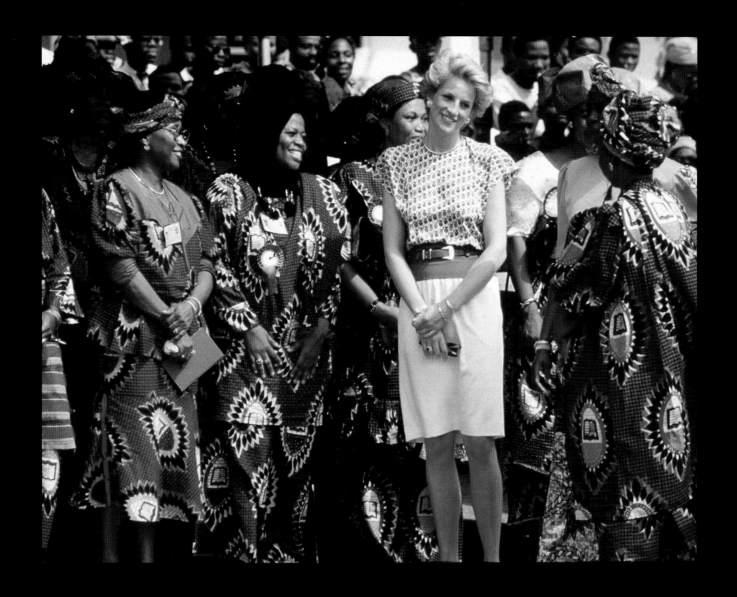

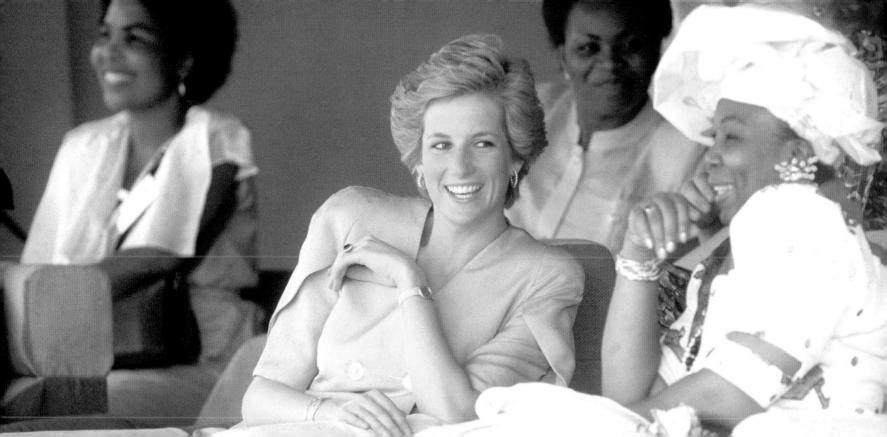

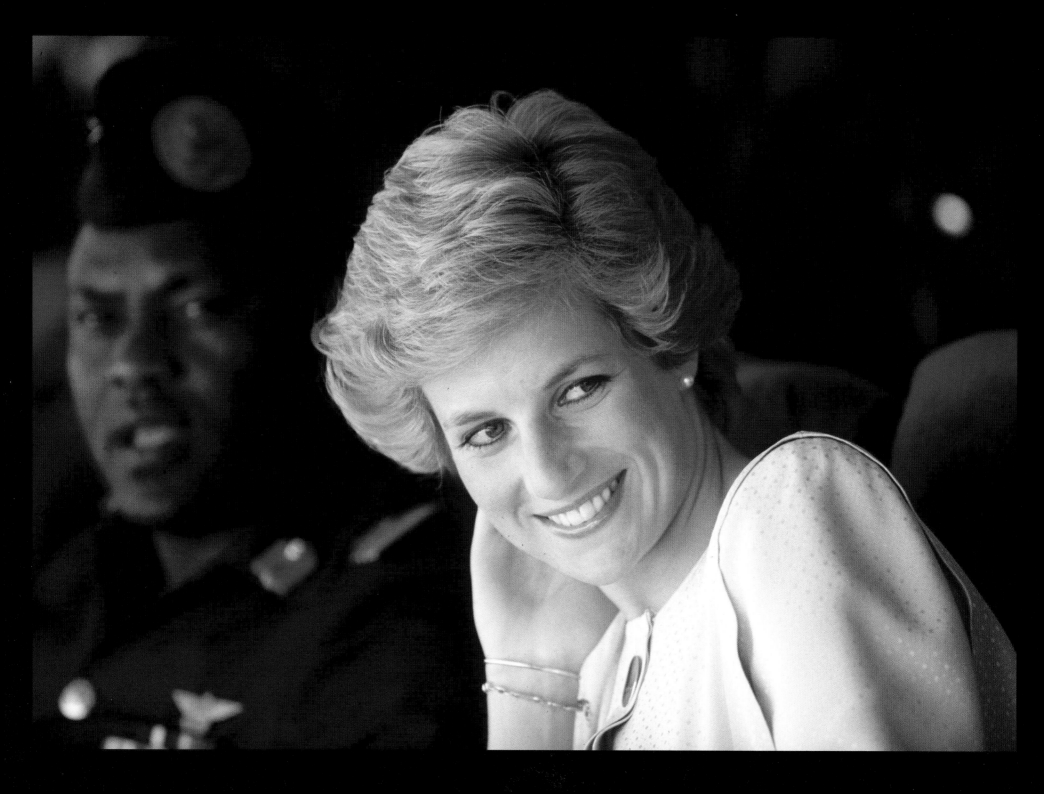

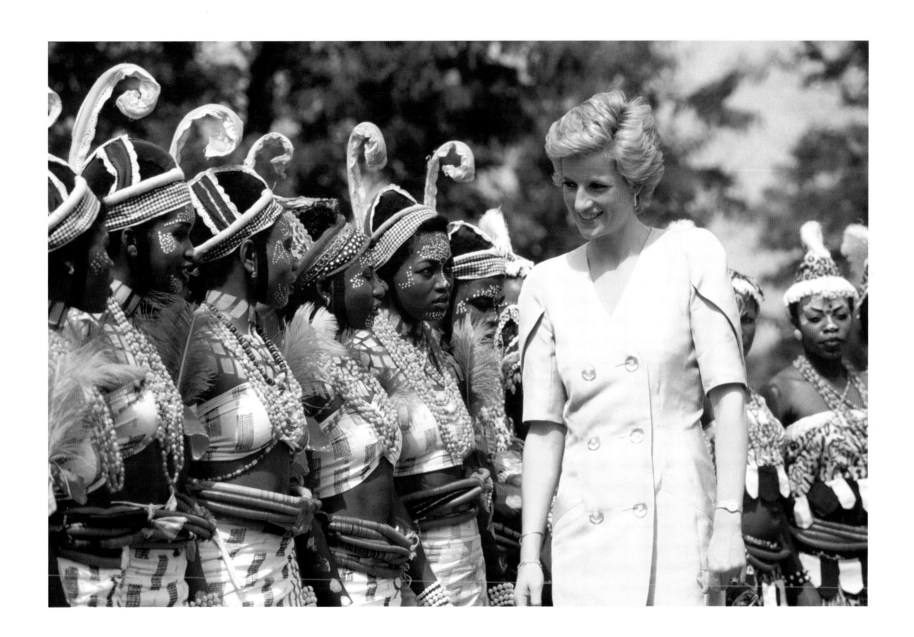

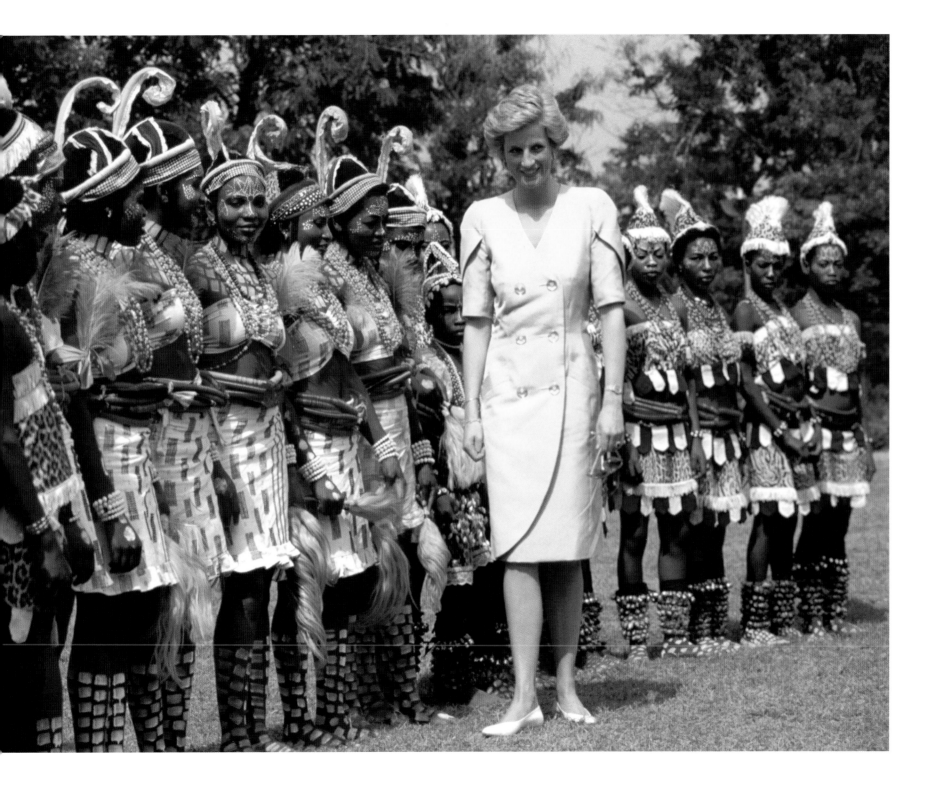

India

1992

This tour was never going to be easy for Diana or myself. For Diana it would be the realisation of the breakdown of her marriage to Prince Charles. I would witness for the first time the horrors of extreme poverty, scenes I will never forget.

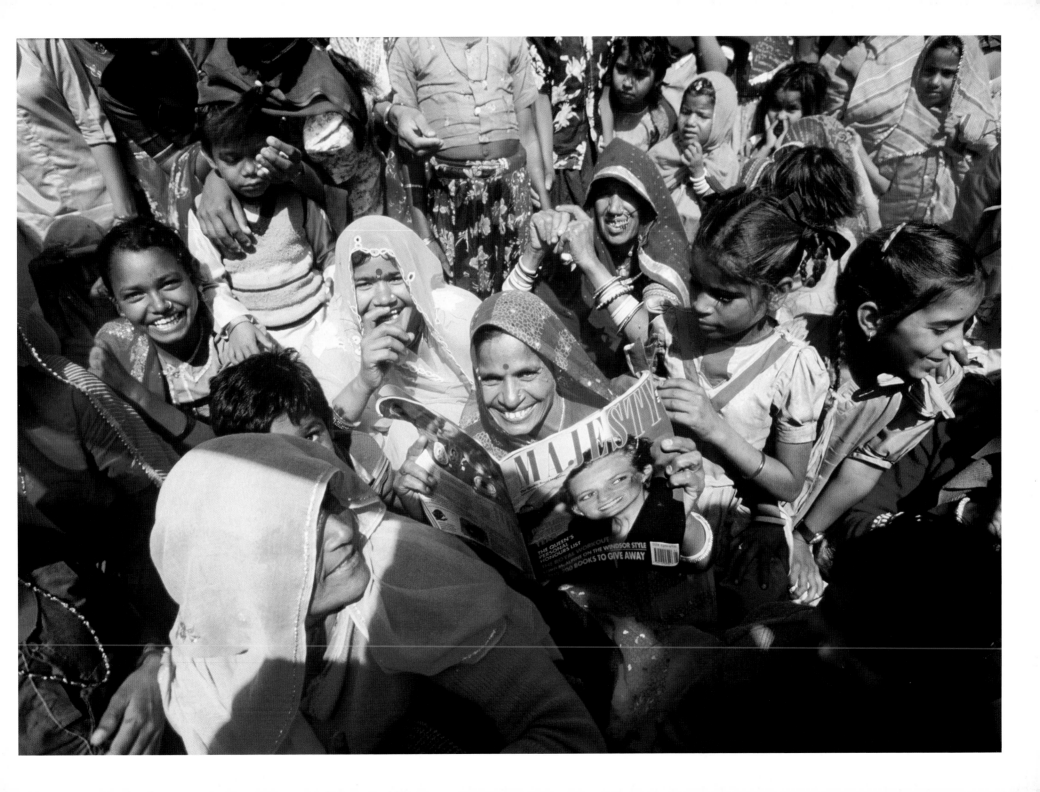

The Taj Mahal, a mausoleum at Agra, was completed in 1649 by the Mogul Emperor Shah Jahan in memory of his favourite wife. When the Princess arrived at the Taj Mahal alone to reflect and celebrate such a symbol of love, the world knew that Diana's marriage would be over soon. The Princess toured the grounds in silence, taking time to compose herself for the obligatory photo opportunity in front of the building. One of the best photos of the tour came from this photo shoot. Ironically, the image would have been spoilt if anyone else had been in it.

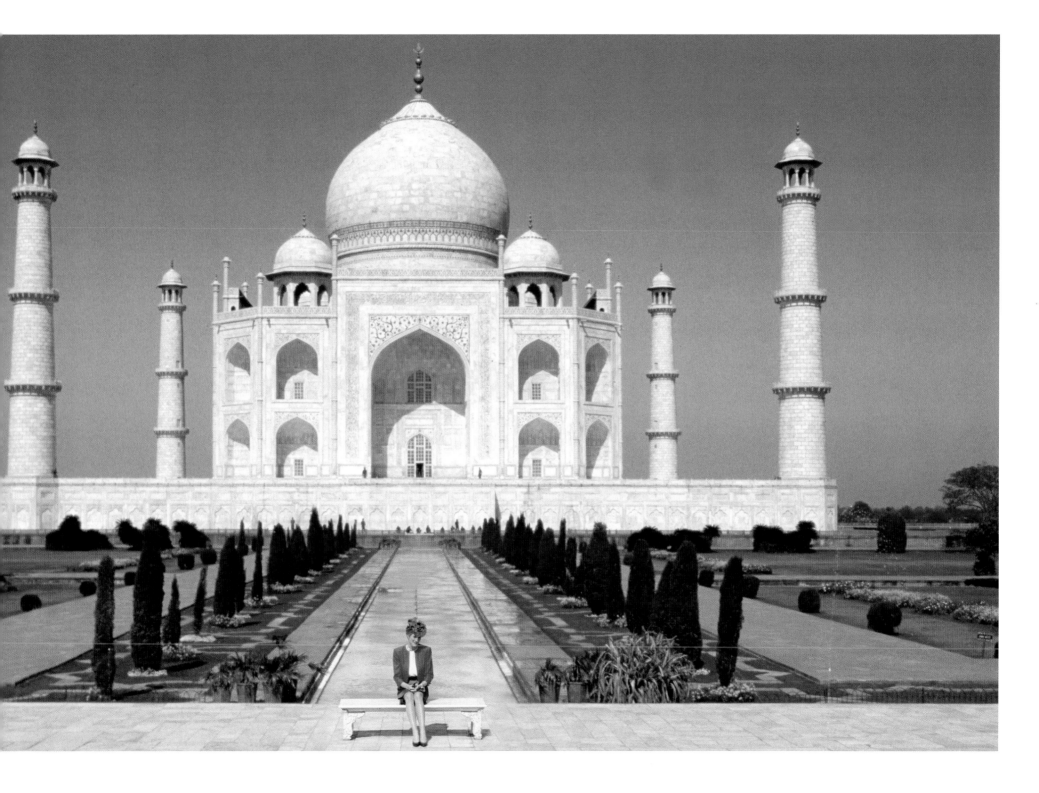

The misery and hardship of the needy and poor people of Calcutta had been harshly revealed to me, and Diana, when we toured around the hostels of Mother Teresa's Order of Missionaries of Charity.

In the hostels the poor and the sick were lined up on the floor in dark, humid halls, waiting for someone to help them. Row after row, in various stages of discomfort and ill health. Diana stood amongst them, giving comfort and food in the best way she could. I doubt if the patients even knew who she was or cared. She clasped hands tightly as she was told by the courageous nuns of the patient's story. These were people at their lowest ebb with nowhere else to go.

As the afternoon slowly passed I realised that no matter how low to the ground I had got with my camera, the Princess's face would be permanently looking towards the ground. She was hiding her tears. She had to face this reality in the full glare of the cameras, my cameras.

As evening arrived the day's events finally caught up with me. The small press bus I was sitting on was jammed in the Calcutta traffic once again. The noise, smell and pollution poured through the broken window by my seat. There were only three other people on this small dust bucket and I was at the rear. The place seemed to me like hell on earth. Overcome with sad emotion, I let some tears go before anyone saw me. This was the final journey of the day, a day I will never forget, or want to.

Our visit was only a brief one but it was a memorable one for both Diana and myself. On the press plane we had a collection and despite the reputation of Fleet Street's finest, we raised quite a sum. I think the trip had touched us all.

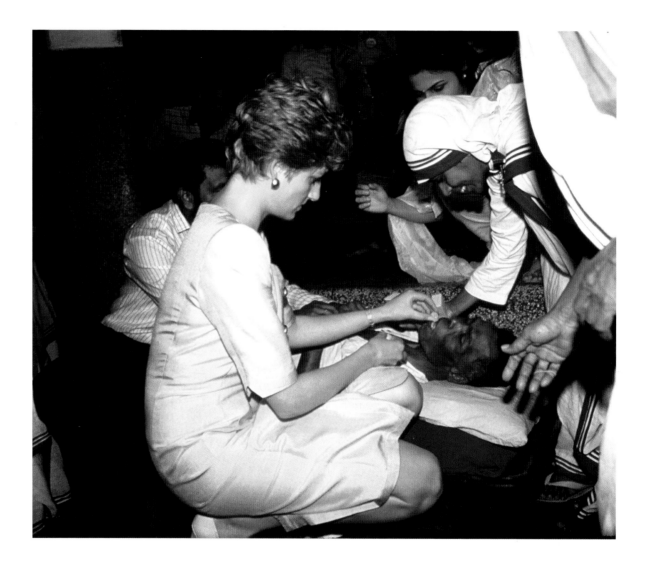

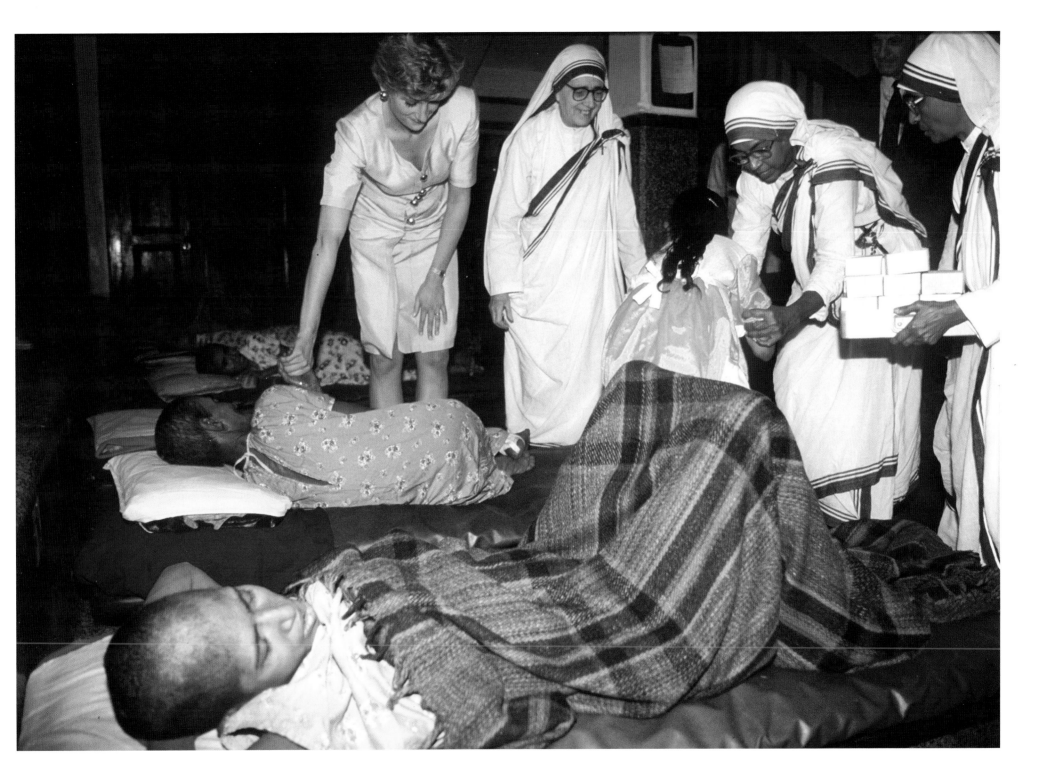

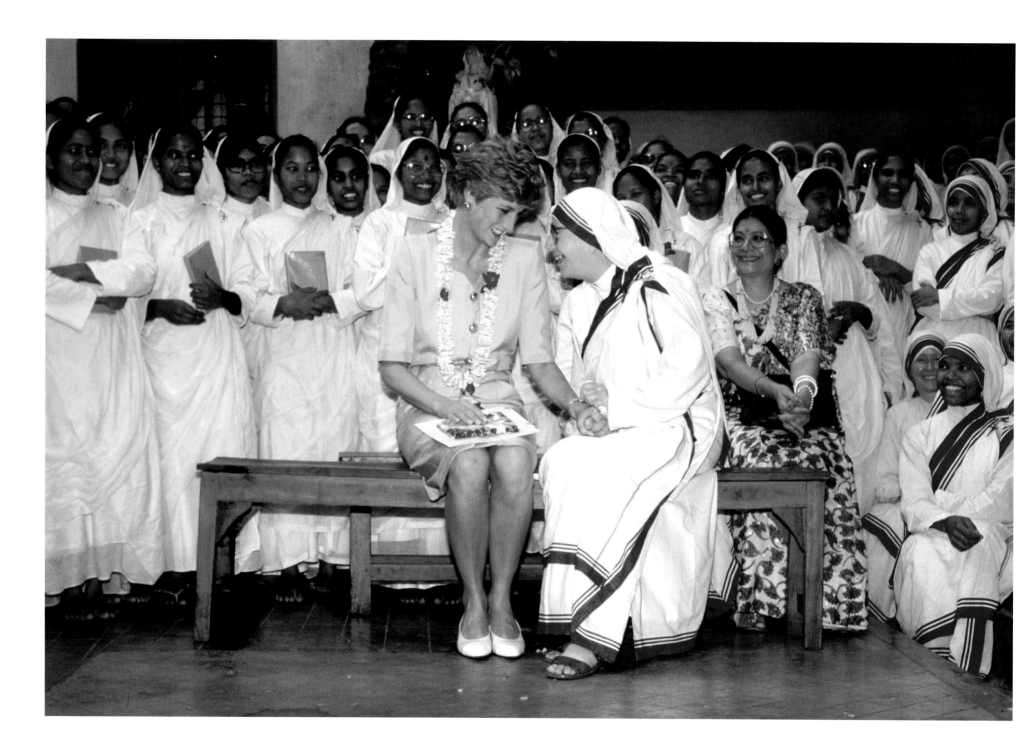

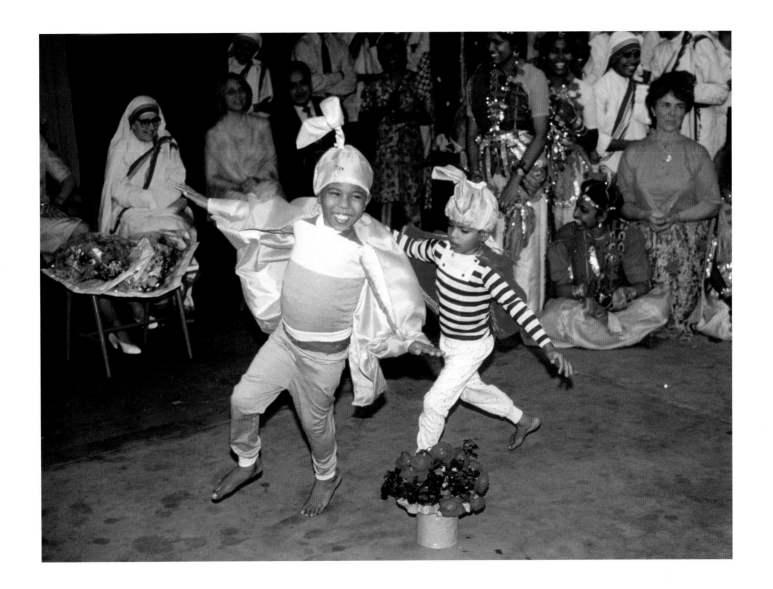

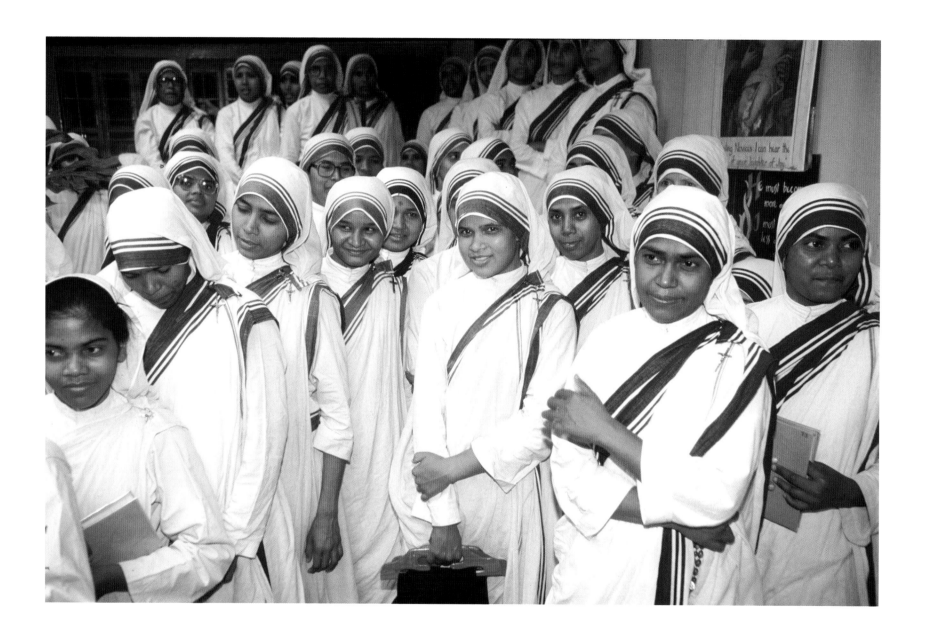

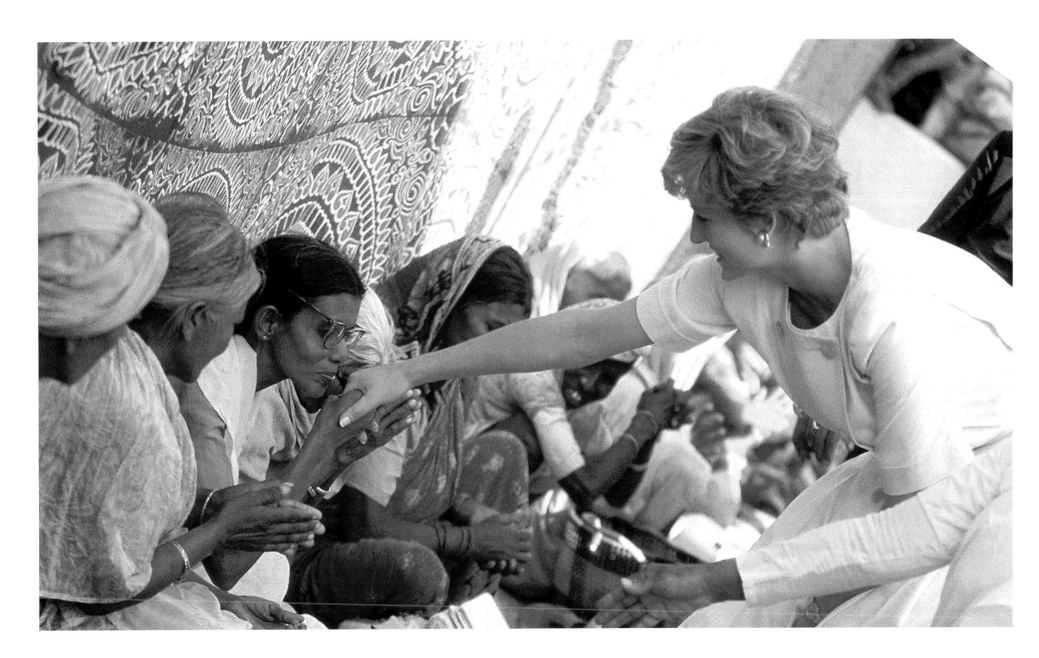

The brilliant and delightful children of India
display their charms to Diana.

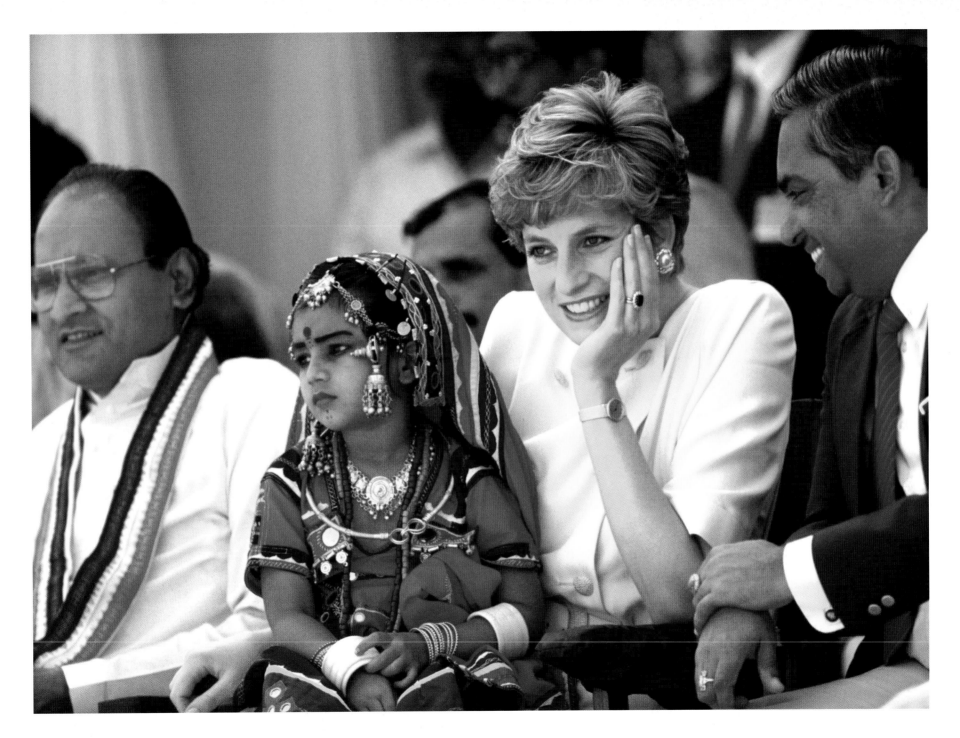

91 India

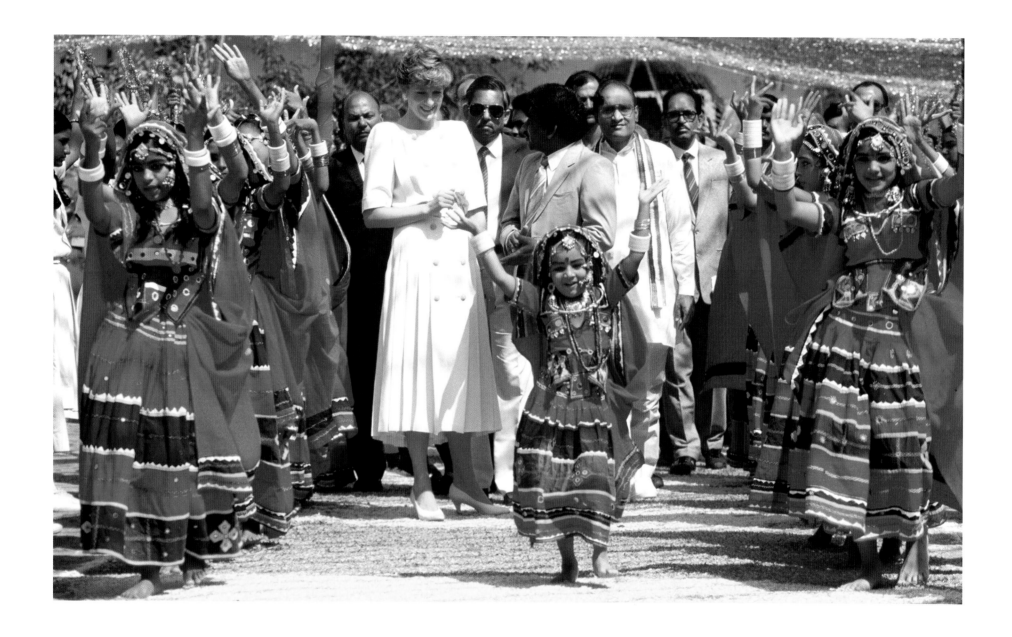

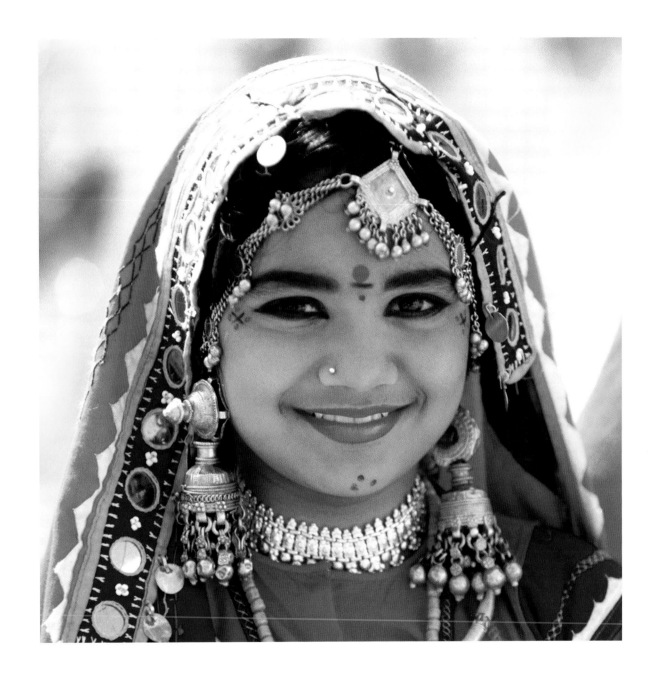

Canada

1991

The Diana fever across the world was spreading fast. I don't think she even knew how globally famous she really was becoming. The royal tours stacked up as countries across the world presented their invitations to the Princess for her to visit . . . and Diana wasn't going to let anyone down, not least the Canadians.

The Canadians were eager to show off their spectacular country to the royal party, one of the best highlights being the magnificent Niagara Falls. Diana was accompanied on the tour intermittently by Prince William and Prince Harry, who were staying aboard Her Majesty's royal yacht Britannia. They had their own trips planned for the week but after much persuading their mother gave in and they were able to join her on this once-in-a-lifetime trip, aboard the world famous Maid of the Mist ship.

With the thunderous waterfalls cascading down onto the rocks from 47 metres above them, the roy-als had a moment to forever behold ahead of them. William, however, was all of a sudden not keen to go when he saw the very uncool-looking raincoat he was expected to wear. 'Put it on or you're not going,' Diana was heard saying. 'You'll get soaked out there'. Prince Harry laughed as the pair were at loggerheads. Harry had his coat on, uncaring how he looked, he was just ready for a good time. The ship, specially chartered for the morning, waited for the small royal passenger to comply with his mother's instructions. He stubbornly stood his ground – there was no way his friends back at home or anybody else for that matter were going to see him in that bright blue, shiny plastic mac.

The press had no choice but to wait. The royal party were due to stand at the bow on the top deck so as they left the dock we would be able to take our photos and show the world, via our cameras, what a great time they all were having. The atmosphere became tense as the captain ordered the ship out onto the water.

The Princess made her way to the stairwell to head to the top deck, and Harry followed excitedly. 'You wait until your father hears about this,' Diana said sternly, looking back with a final glance. In a flash, William put his arms in the un-trendy coat and dashed up the stairs, passing by the other two royals.

Diana and Harry were guided by a crew member to the location where they would have their photographs taken. Sulky Prince William stood hiding at the rear, hoping no one would notice he was missing, until his mother gently pulled him forwards between Harry and herself. 'Smile!' the photographers yelled from the shore. 'Smile, William!' He'd given in to his mother's wishes and put the coat on but there was no way now that he was going to appear to be happy wearing it.

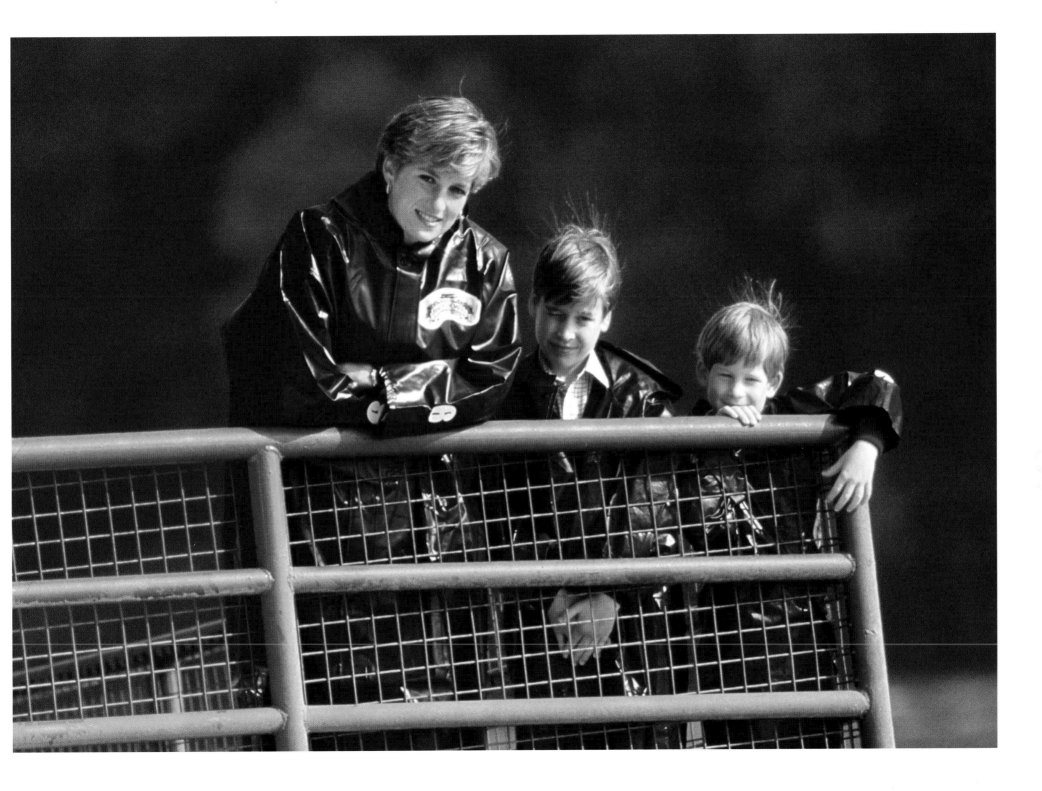

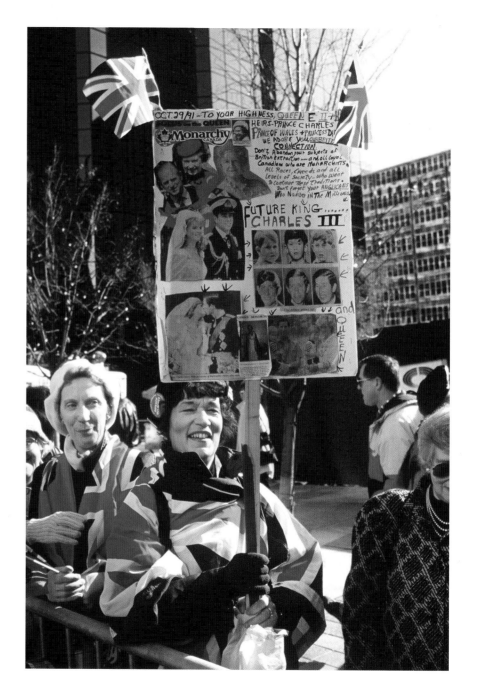

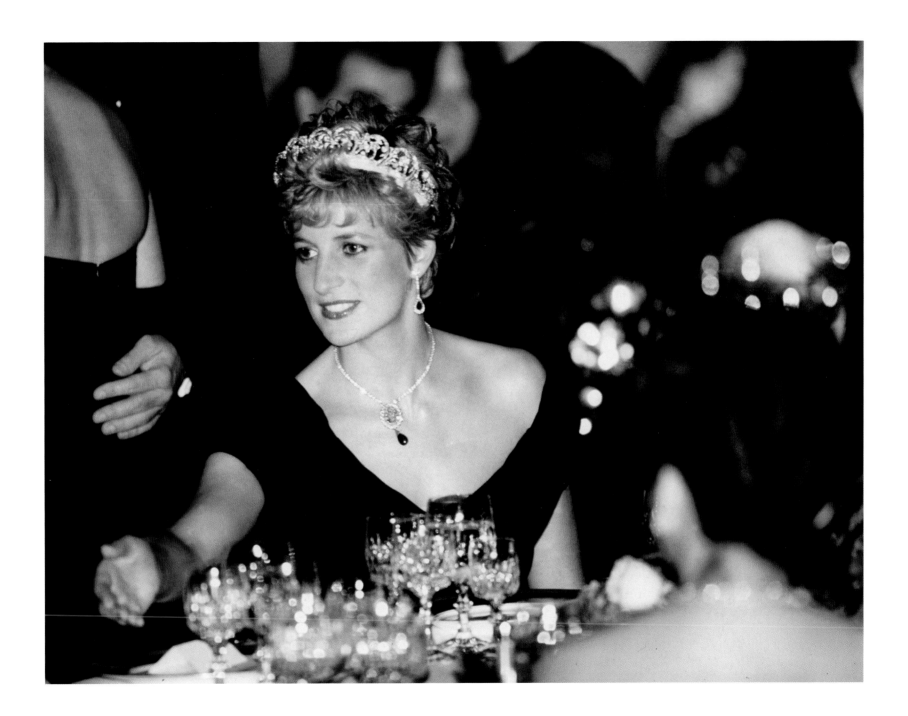

England

1992

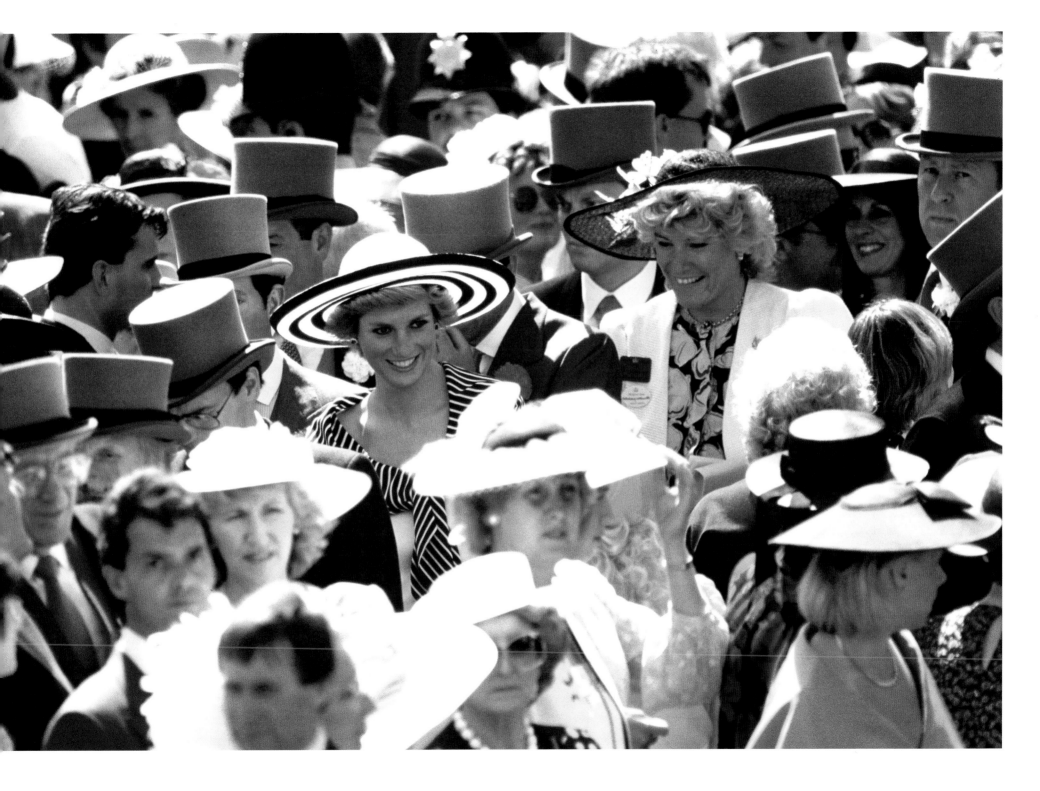

By a beach in Devon, the Princess of Wales stood before a gathered crowd of 100 people and pondered to herself for a moment.

It was pouring with rain and the beach in front of Diana, where she was to due to open a lifeguard station, wasn't at its best. It was wet, sandy and very muddy, up to the knees in parts, if you were unlucky. This clingy concoction was sticky and stayed glued to your lower leg for the rest of the week. It stuck to your shoes, and especially £300 designer shoes bought that same week in Knightsbridge, London. The lifeguards from Saunton shivered on the beach, wearing only their trunks and light yellow T-shirts, fit for a summer's day. They remained steadfast in their specified position.

Totally unprepared for the situation, Diana pondered about ruining her new shoes momentarily. She tentatively took her first steps onto the beach and into the sludge, accompanied by cheers and clapping from the Devon crowd. Throwing caution to the wind, the Princess bravely ploughed her way, as if she were on the lunar surface, to the gathered lifeguards who were now laughing along with her.

As usual Diana saw the funny side of the situation. Saying goodbye to her expensive new shoes entertained all around. Diana showed that despite living in a palace, driving in lavish cars and having a HRH title, she was just like anyone else. Windswept, she made light of her predicament and gained more respect and admiration.

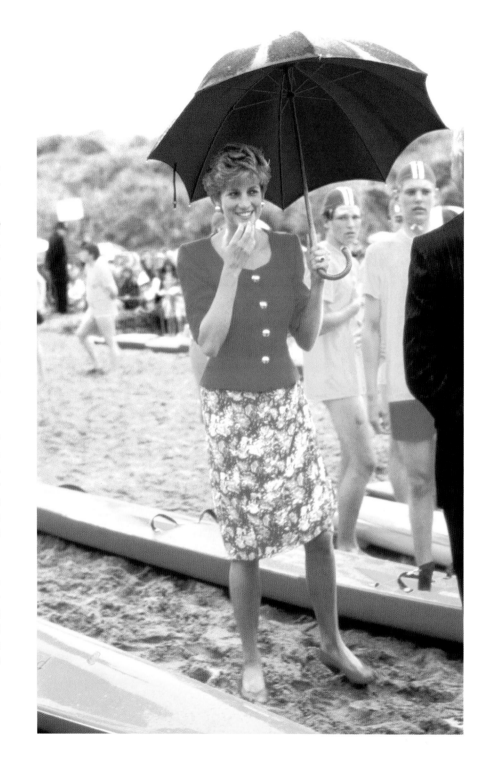

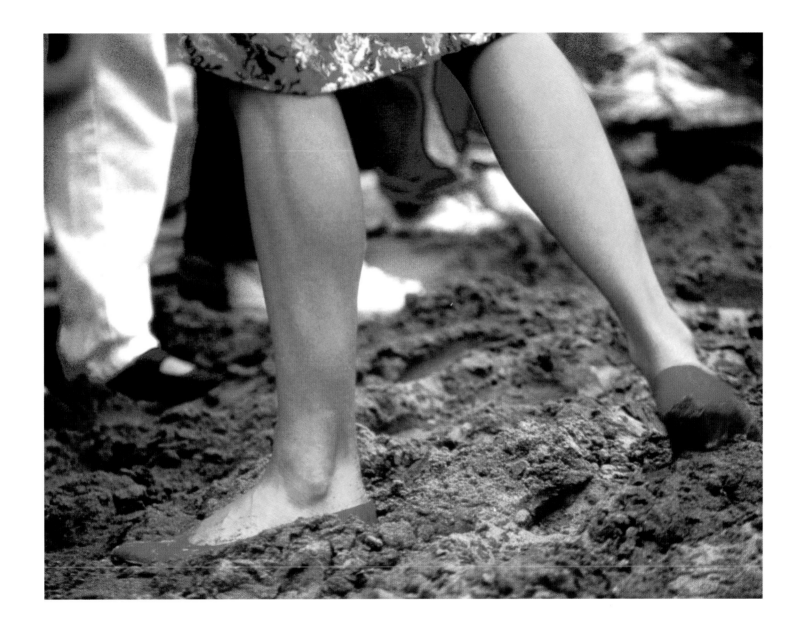

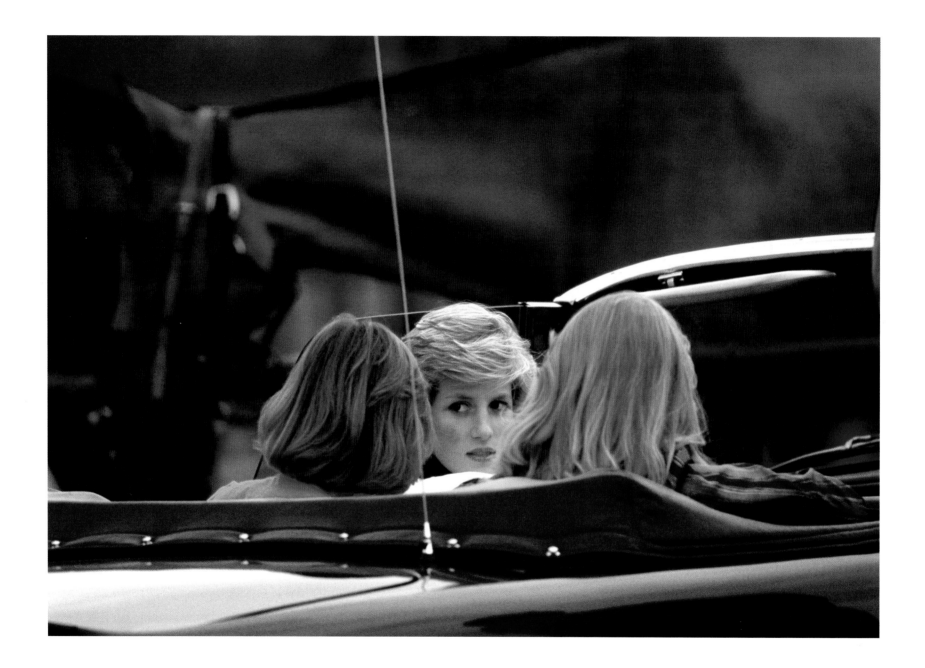

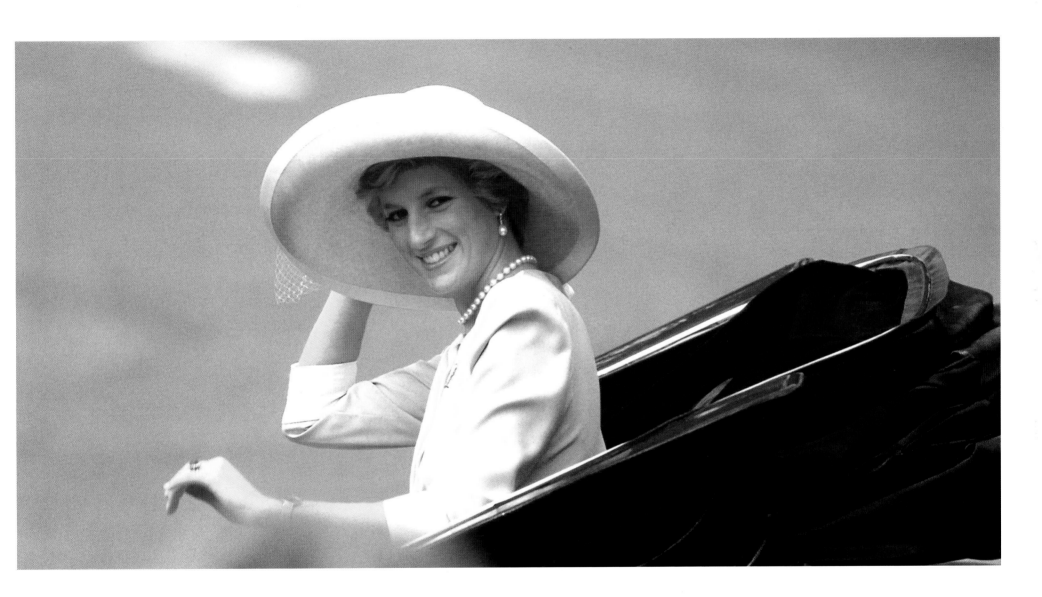

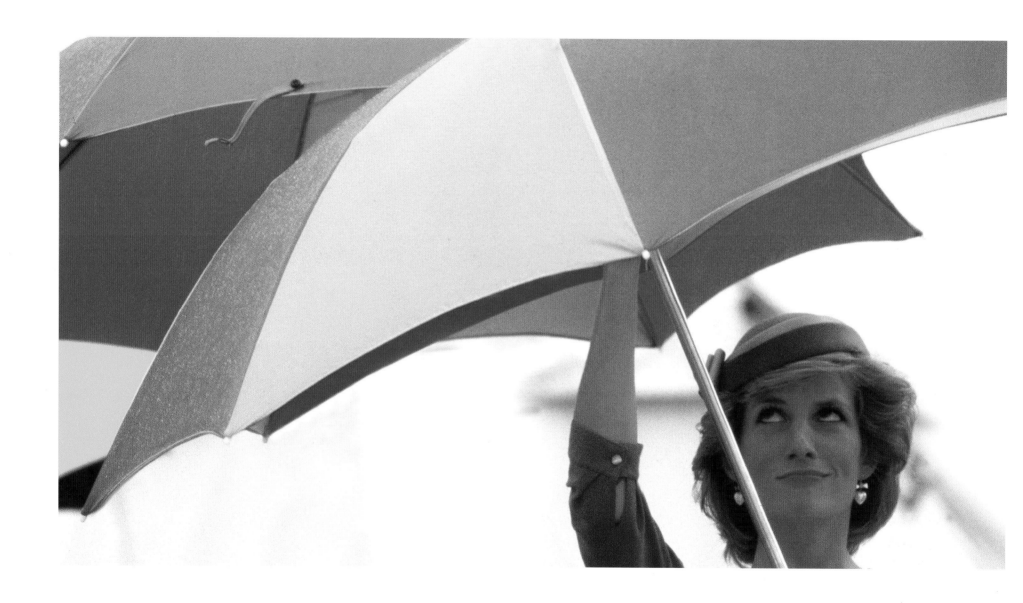

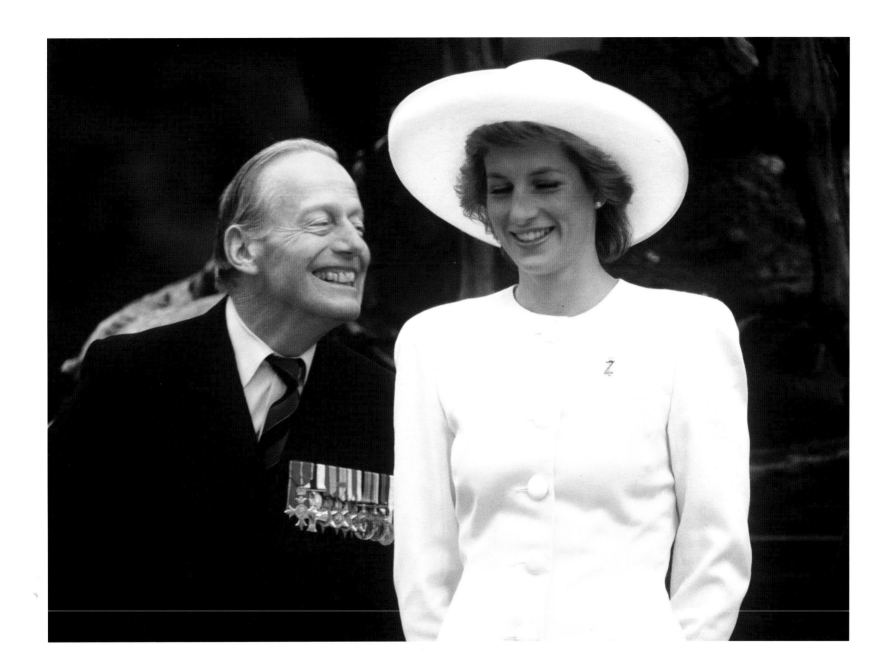

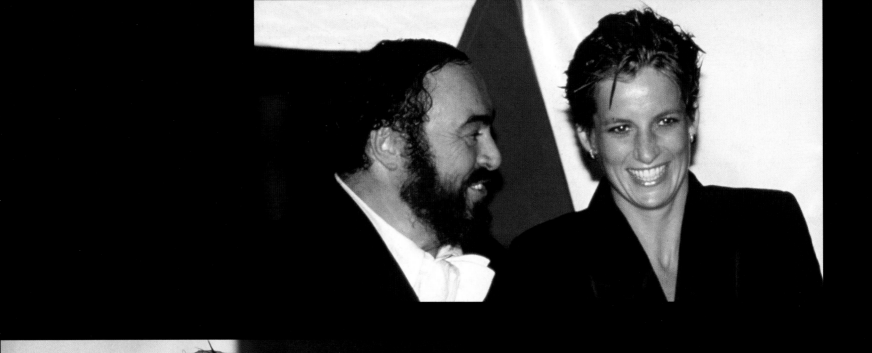

this way' noises would originate from, always capturing your subject's best attention.)

With most of the freelancers investing large amounts of money to come to Liechtenstein for this one chance to get photos, it was imperative to reach the top in time. The snow and ice had already taken its first victims. A small Fiat car crammed full of Italian paparazzi had fallen off the road and was lying at a 45-degree angle in the ditch. The two 'paps' had got out and were now running with their cameras swinging at their sides up the mountainside. One tried the rear-door handle of my car to get inside; the stress on his face was clearly evident as he desperately pulled hard on it. Myself and two the other photographer's inside quickly locked all the doors (competition was fierce). Our large load of equipment covered the only other spare seat and we didn't need him sitting on it and breaking it into small pieces. Anglo-Italian relations had hit a new low as we edged past him grinning and waving like our Queen.

We came across a British press car standing motionless; its wheels were spinning on the snow making black ice. The car was inches from the cliff edge – one slip and they would have landed back down in Vaduz. The occupants, tabloid photographers, were opening the doors and clambering out to push it. At least four other press cars, including us, passed it by, driving at a snail's pace without even a glance of acknowledgment from any of us overtaking. One catch of their eyes and we would have been almost

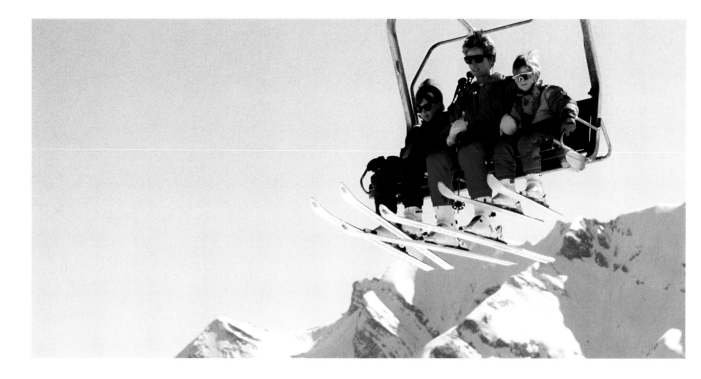

certainly compelled to help out our fellow Brits. But not this time, it was every man for himself as we only had minutes remaining on this impossible journey. Our wheels span also but I managed to control them with the aid of the two other photographers bouncing up and down on their seat behind me, trying to give the wheels more grip. We finally reached the top with our lives intact, not knowing or caring about the welfare of our competition behind us.

Out of the 40 cars that started the treacherous journey at least half didn't make it to the summit. Once we got there, we were informed the photocall had been delayed by a further hour because of the late arrival of the royal party.

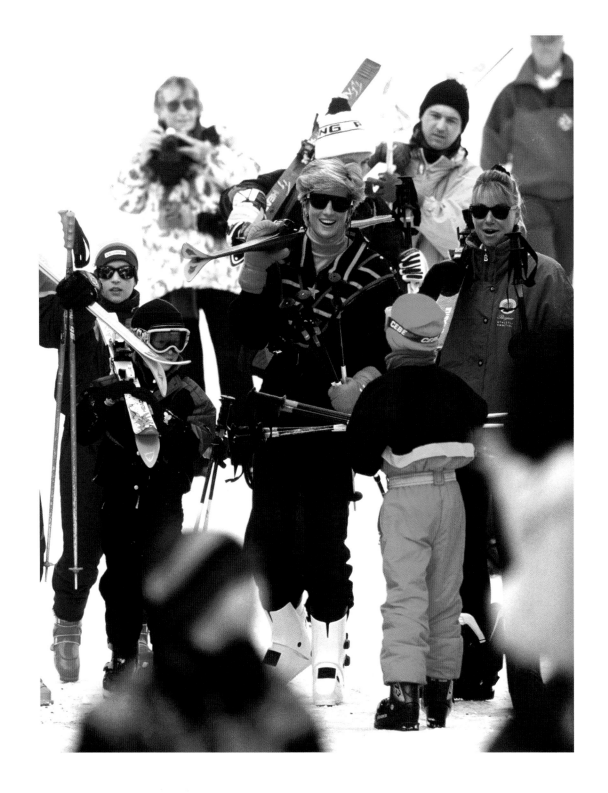

Skiing

One of the first of the Princess's skiing holidays was in 1985 in Liechtenstein, a small, independent principality in the heart of the Alps between Switzerland and Austria.

In one of their finest moments of madness, the Buckingham Palace officials escorting the royal party organised a photocall, but were strangely reluctant to let us, the press, know about it until the last moment.

Crammed into a small hotel conference room, the world's media had no idea when or where or if there would be a photo opportunity. The palace press officers were tight-lipped and slightly arrogant as they laid out their plans for us.

The Palace Press Officer made the rules clear. At the photocall, if they were to organise one, the press would be allowed to take photos of Diana and the royal party and then afterwards we would be expected to be on the first flight home, leaving the royal

party to enjoy their skiing in peace and have a private holiday, uninterrupted by the international press for the remainder of that week. If this were to happen anyone found not obeying these regulations would be excluded from any future cooperation from Buckingham Palace and the royal family.

The briefing lasted over an hour, then suddenly without warning it was announced that there would be a photocall and it was to be in half an hour in a village called Malbun. Some photographers didn't even have their gear with them as they had left it in their hotel rooms. The race was on: we had only 30 minutes to gather our cameras and get to the top of the Alps.

Like the *Wacky Races*, the small, single-track mountain road became a racetrack. A blizzard closed in as the press cars slid from side to side on the ice-covered mountain pass. The last photographers to reach the top would only be left the position at the back or at the side of the press area. (It was always best to be in the centre as this was where most of the loudest 'look

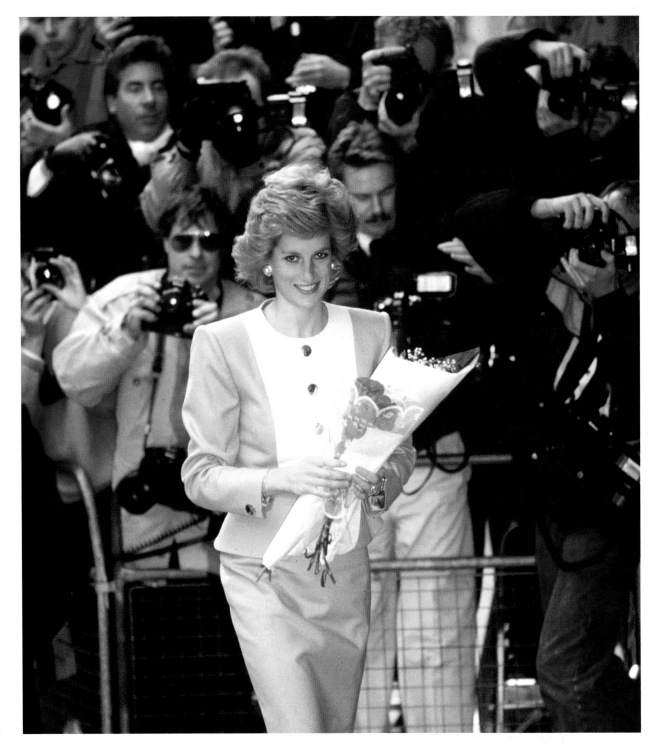

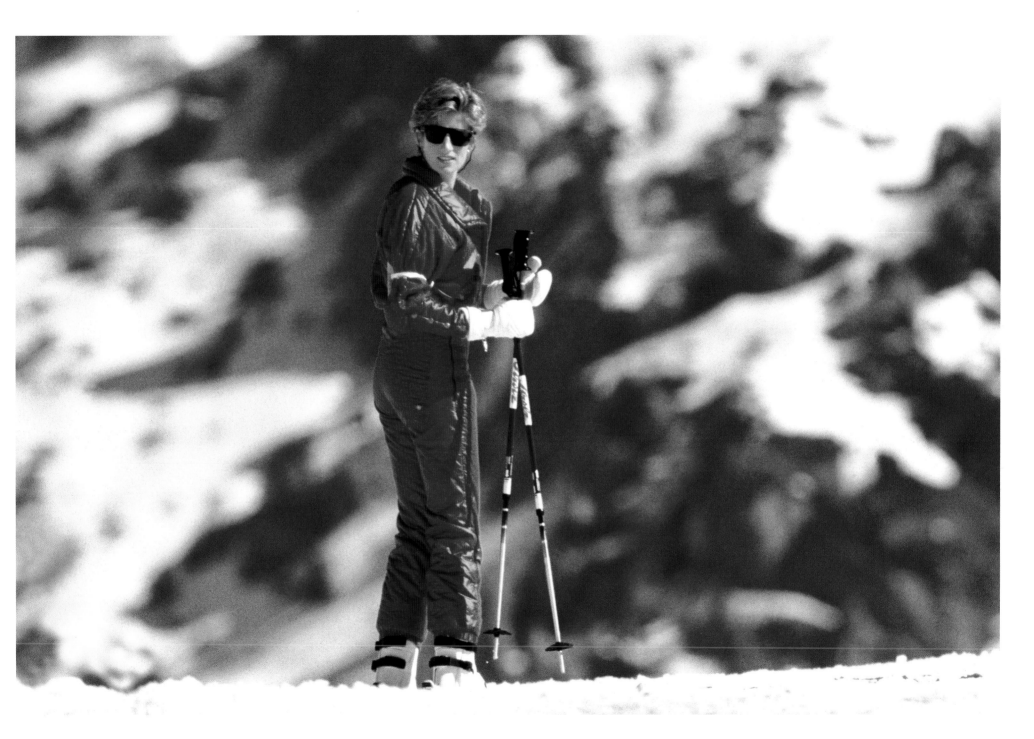

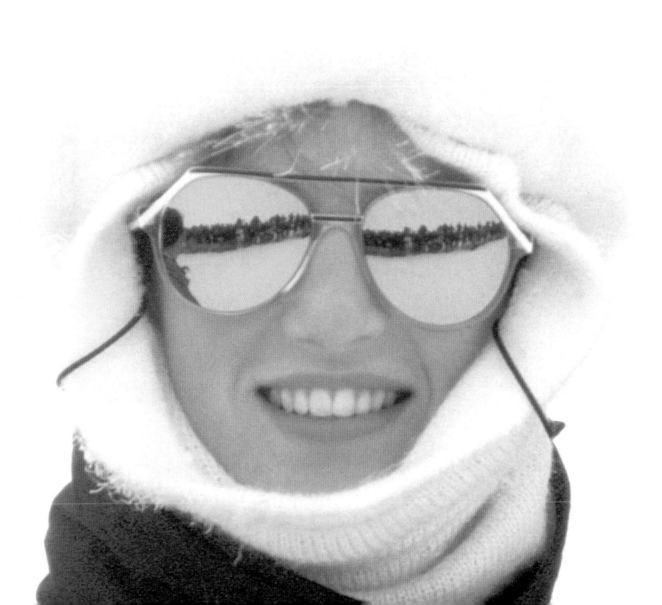

USA
1990

Diana was a phenomenon in the USA. If she'd have moved across the Atlantic to live, which previously had been rumoured, she could have been Queen of the USA. The American people couldn't get enough of her. This was Di-mania – Beatlemania had previously triumphed two decades before . . . however this was not the 'fab four', but the 'fab one'.

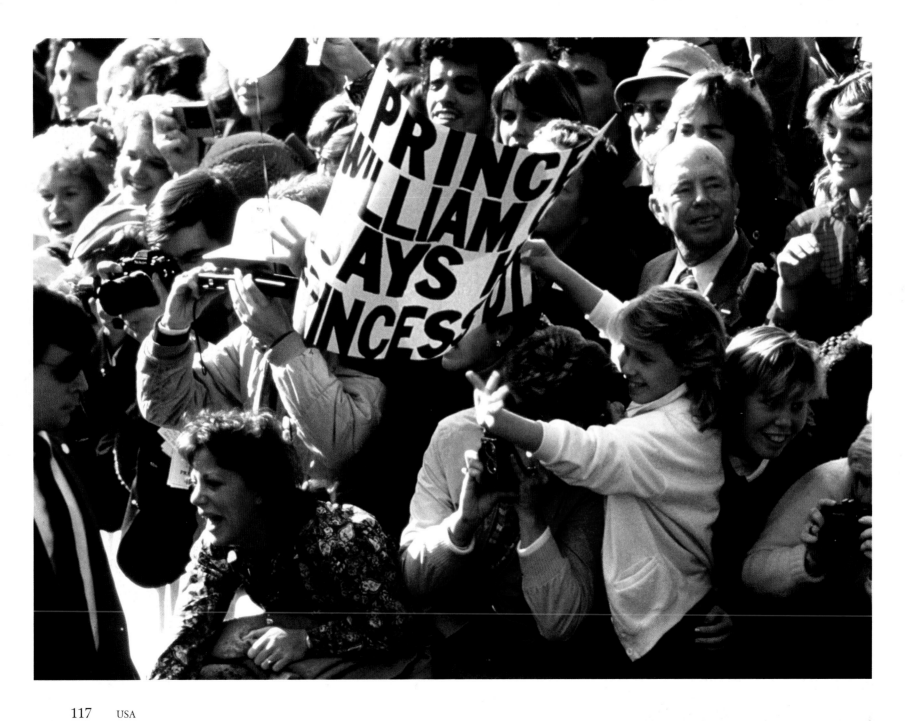

Presidents, Hollywood actors and the wealthy all waited their turn to greet and to be photographed standing next to the most famous woman in the world. But despite the adoration from this quarter of society, Diana still concentrated most of her attention while in the States to the unfortunate, needy and ordinary US citizens.

What I found interesting in the USA was that wherever you went, as an accredited photographer you remained in a cocoon of sterility. In the monotonous words of the Secret Service man, 'You're in a sterile area, sir. You can't leave.'

Arriving at the White House for a function, the international press would be searched thoroughly and then closely escorted down through a maze of underground tunnels. Escorted below the ground by the Secret Service, you would suddenly find yourself, after climbing a flight of stairs, at the centre of the White House banquet hall. With exact precision the press party would arrive seconds before the after-dinner speeches were due to happen and then be whisked away back down a stairwell, returning to the front gate travelling through your specified tunnel. This, I had discovered, was no ordinary house.

If you were part of the foreign media that were assigned to the 'White House Pool' then you would really be treated as if you were royalty as well. There would be no tunnels for the White House Pool. You wouldn't be expected to use the lower parts of the house; you would be privileged to have access to the ground-floor corridors.

Wherever the royal party and the presidential party visited, we were there ten metres ahead taking our pictures. The organisation for the press was the best I'd encountered anywhere in the world. This efficiency included transport to other cities and states. Jolly Green Giant helicopters waited on the Pentagon helipads with rotors spinning, ready and waiting for the White House Pool to quickly jump onboard. This would be closely followed by the President's helicopter. Ground transport waited at your destination to dutifully whisk you around to each royal and presidential appointment.

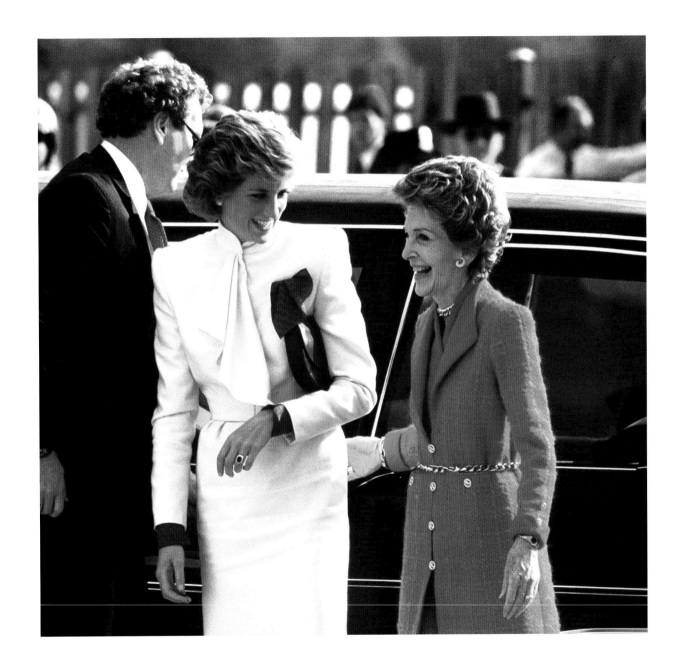

During my stay it had occurred to me that the Princess hadn't managed a single 'walkabout'. She had not shaken the hands of ordinary American people on the street. Diana was in even more of a cocoon than the press. This wasn't the norm for Diana or the following media pack. All of the Princess's visits across the world had involved meeting the public in the street. But after the assassinations of four US presidents and five significant attempts on other former presidents, the Secret Service, as ever, were taking no chances.

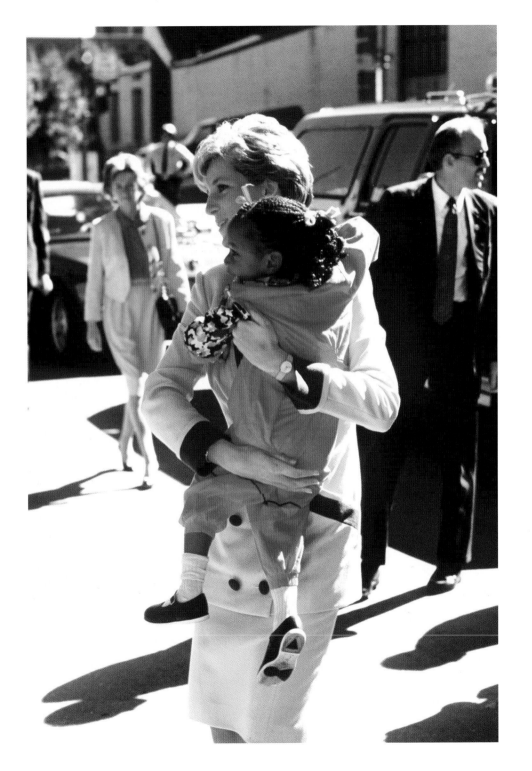

Diana was not to be deterred from meeting the US people, despite the risks. On arrival at a drug rehabilitation centre in Washington, escorted by the American First Lady, Nancy Reagan, Diana caught sight of a small girl in a wheelchair holding a flower in her outstretched hand. Without a second thought, the Princess escaped from the confines of the VIP area and went across to meet the young girl. The large crowd erupted with applause and cheered loudly. This action by the Princess was something they had never seen a VIP attempt before. Up close and standing alongside them on the street, Diana took the flowers and casually chatted with the people. The Secret Service leapt into action. Officers urgently gave orders through their finger microphones to form a tight circle around the Princess, blocking the view of the crowd across the other side of the street. Loud boos and jeering ensued, then Diana, on seeing the problem, spoke briefly with an advisor who gave the order for the guards to pull backwards. They did, reluctantly, accompanied by even louder cheers. Diana was determined to meet 'ordinary' Americans on her visit and not just the usual VIPs assigned to meet with her.

Despite the high risks to her personal safety Diana, with this one gesture, successfully began to win over the hearts of the American people and again she had reached out to ordinary people who responded accordingly.

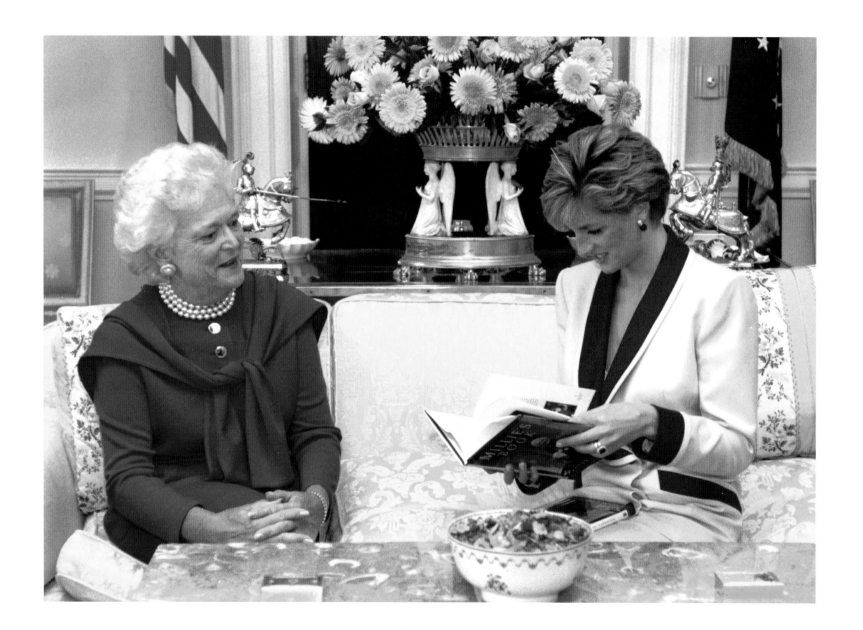

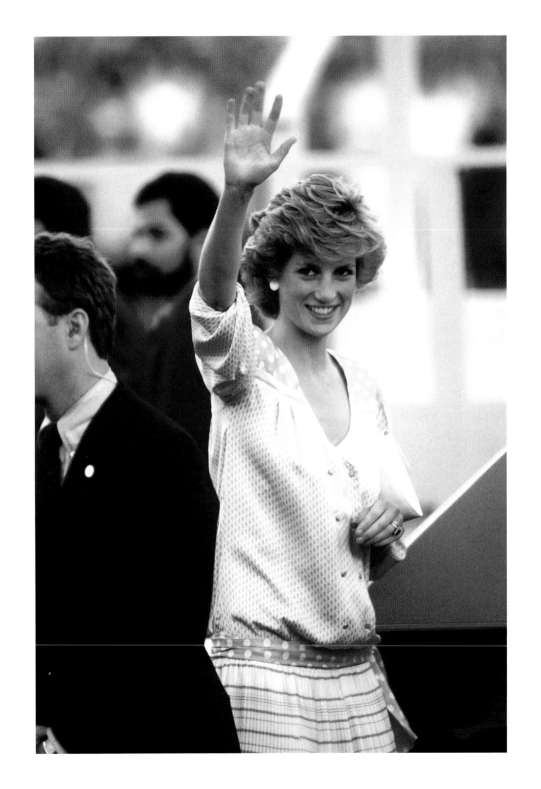

Hungary
1990

It wasn't long after the fall of the Iron Curtain in 1989 that the Princess was invited to visit the now former Eastern Bloc country of Hungary.

In the main square in Budapest the crowd stood crammed ten people deep behind barriers. They had waited from early morning just to catch a glimpse of the international iconic figure. Having, over many years, been fed by the Communists in the Soviet Union the dangers and excesses of the western side of the Iron Curtain, the Hungarians were keen to find out for themselves how frightening we really were.

Diana arrived in the centre of the square and was greeted with polite, but tentative applause. However,

by the time she had finished her work, the Princess would transform the large crowds into her loyal and most devoted fans.

One particularly large and very hairy man couldn't resist holding her hand in his and like a perfect gentleman greeted her by planting a long, lingering kiss on the royal flesh. The Princess blushed uncontrollably and whispered to the gentleman, 'How charming you are, sir.' He continued to hold the Princess's outstretched hand and then began to sing her a serenade. The Budapestians erupted into an immediate and ecstatic applause with most of them joining in with the well-known Hungarian love song. With one simple kiss and song, a large bridge had been built between East and West. We were as one once more. The Hungarians were again free to express themselves in a manner that had been previously frowned upon by their Communist guardians. Diana, by now, had picked up the last words, in Hungarian, of the short chorus and had joined in to sing along the last few words, bringing it to its conclusion along with the people. This made the crowd even more animated than they were before.

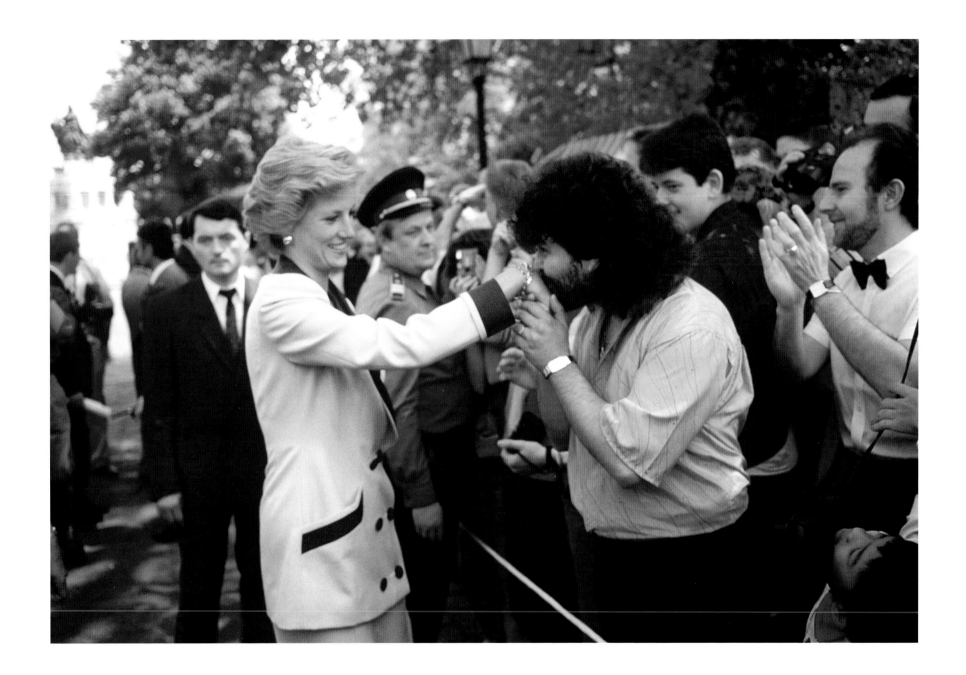

For Diana, this was one of the most important royal tours of her life: a visit to try and establish better links with Britain in the West and Hungary in the East. To earn trust and respect for each other and to help build a lasting friendship . . . who better for the job could we have sent as our ambassador abroad?

As the twenty-first century begins amidst international mistrust, hatred and bitter wars, it is interesting to reflect on a world which seems bereft of people who can generate understanding and friendships between nations. Princess Diana became a natural ambassador for this country and hasn't been replaced.

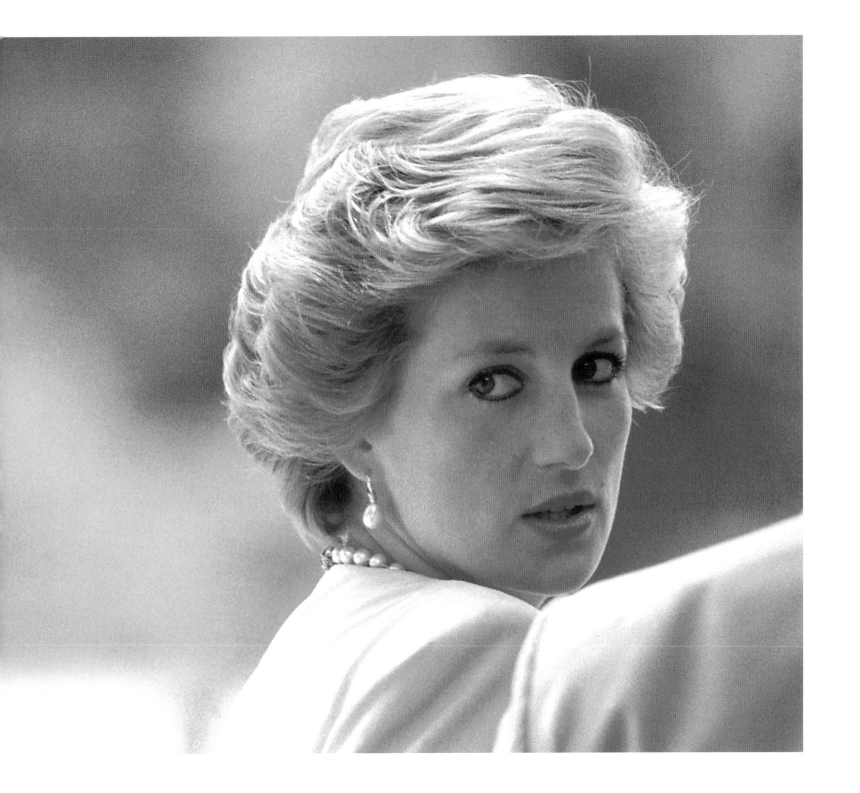

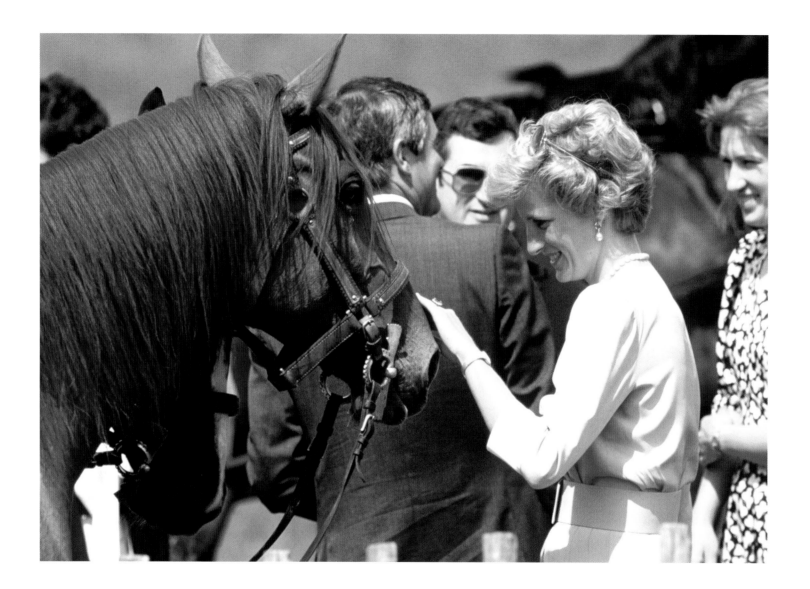

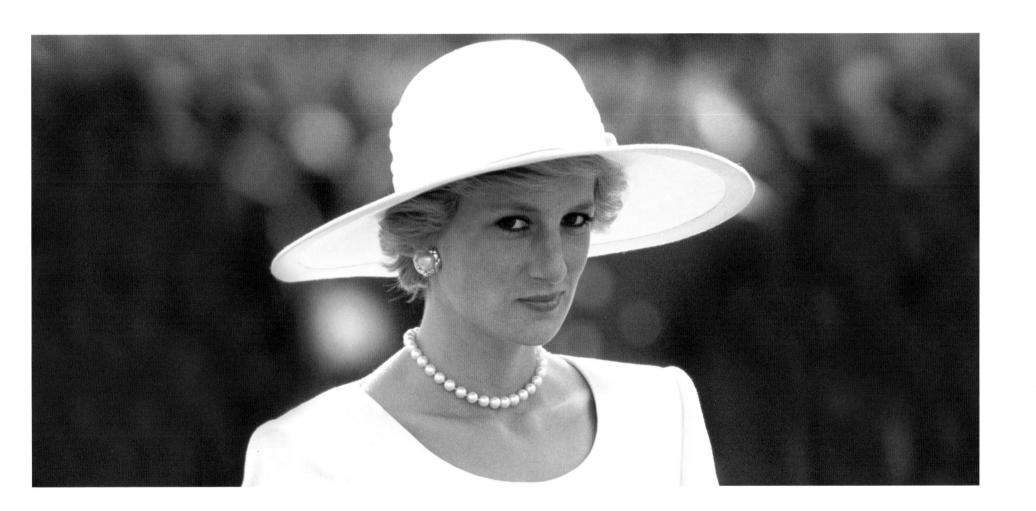

131 Hungary

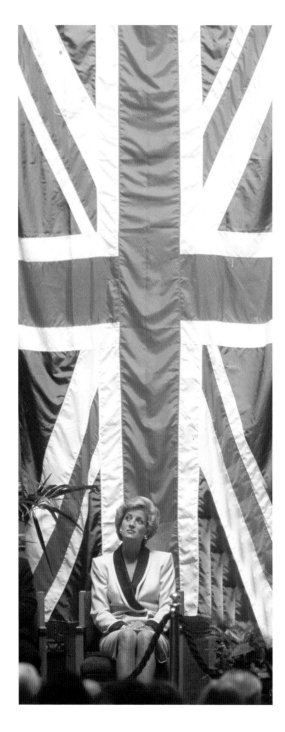

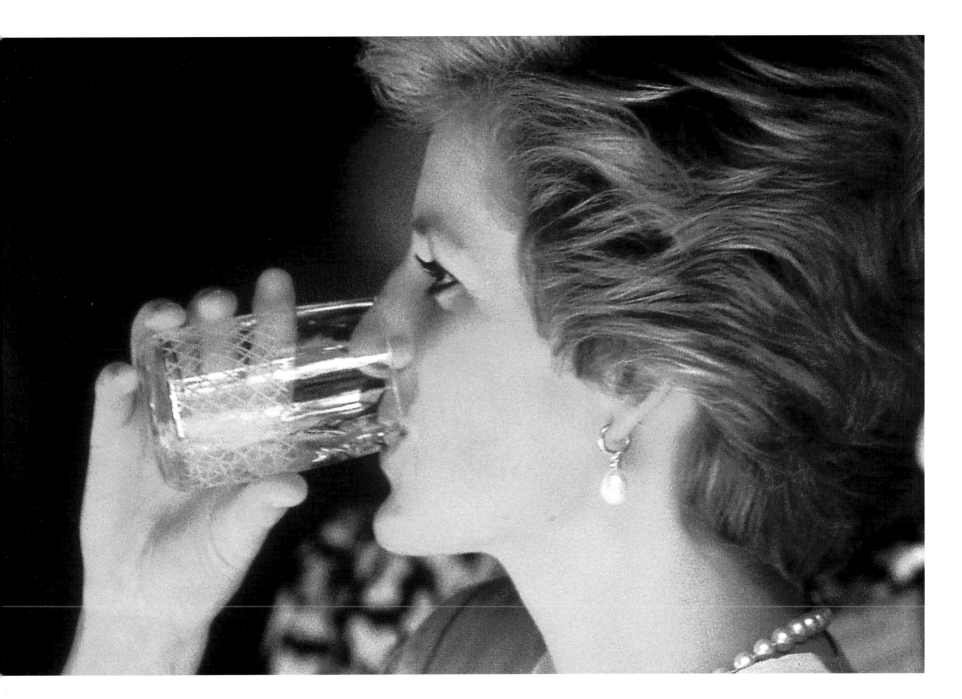

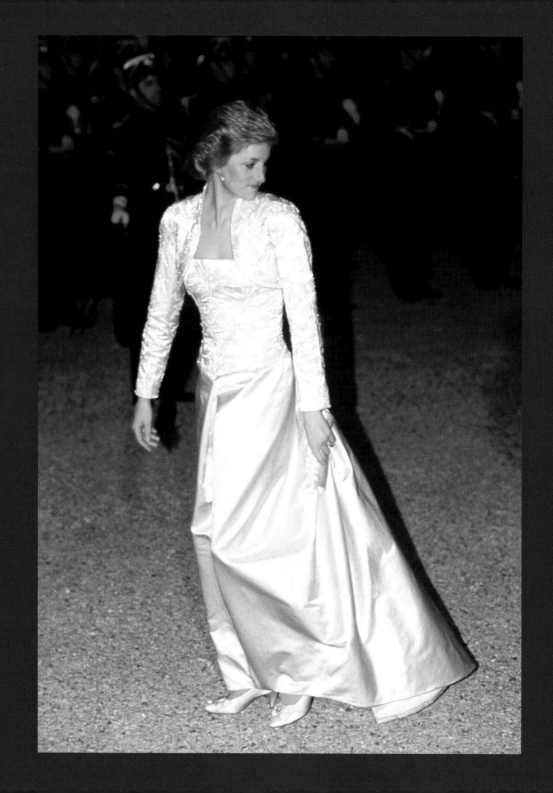

France

1988

There is only one form of transport for the French media: the motorcycle. It is how they have evolved over the years of tight magazine and television deadlines and, of course, the Parisian traffic. It was with this in mind that I arrived at Charles de Gaulle airport for Princess Diana's royal tour of France. I was to be met by my personal chauffeur, Jacques. He had been assigned by my French photo agency, whom I was working with at the time, to drive me on his 1,000cc Honda wherever I wished for the whole of the following week. Most of the other British photographers had similar transport waiting for them as we climbed aboard the saddle and headed to the other side of the airport to the VIP arrivals gate.

The royal party flew in shortly afterwards on the Queen's flight. Dressed in a red suit, Diana eagerly awaited her French visit and I'm sure couldn't wait to experience the French cuisine once again. The Princess met with the line of dignitaries on the tarmac and then departed in her limousine for the centre of Paris to start the tour.

On the main A1 motorway into the city the media motorbikes out-numbered the convoy ten to one. Restricting the flow of traffic, the police motorcycle outriders escorted the convoy of royal cars, straddling all three lanes of the motorway. The police were followed from behind by us, the press. In all there were over fifty motorbikes following including; national television cameramen, presenters, soundmen, newspaper journalists, and magazine and tabloid photographers. The world's media were on the road to Paris on the back of, for most of us, a new form of transportation.

The procession moved slowly and steadily as the traffic ahead was cleared out of the way for the Princess. The police motorcycle outriders knew the press riders well by name and chatted to each other as they cruised along side by side. Over the years they had built up a special relationship. Everybody on the media bikes knew the boundaries of what is and isn't allowed when following a VIP convoy and they vehemently stuck to them. It seemed that the whole of Paris had come to a halt to let the convoy pass through, much to the annoyance of some of the Parisian commuters.

We arrived in the centre of Paris at the welcome ceremony, where I met my French counterpart and his driver. George was a photographer with Stills Photo Agency, to which we were both assigned. Based in Paris, Stills was responsible for the sales of our photos to the French media, mainly *Paris Match* and *Jours de France*, and also the worldwide media. George and I, onboard our transport, leapfrogged Diana's engagements during the rest of the day – one photographing Diana's arrival at a venue and then the other photographing Diana's departure. This is how the French press worked with their counterparts.

The tour finished in the same steady manner in which it had begun. The French and international media captured a great set of pictures of the tour which were seen worldwide in all major publications and on television. The police limousine drivers, assigned by the French government, were very accomplished, as were their motorcycle outriders. They wholly accepted the media trailing the convoy as long as they obeyed their rules. The police protection officers knew as a basic first rule that their priority was the safety of the royal family in the event of any attack from gunmen or bombers, and at the bottom of the list of priorities was the international media trying to film or take photos of their charges. They did not at any time during the tour divert their attention away from the main reason they were assigned.

In the future Diana was to relinquish her official police protection officers and would travel under the protection of less-equipped and experienced outfits.

On this tour Diana was to meet her counterpart in France, Princess Caroline, for the first time. The two beautiful and charismatic princesses had been leading parallel lives but they had never met. They made

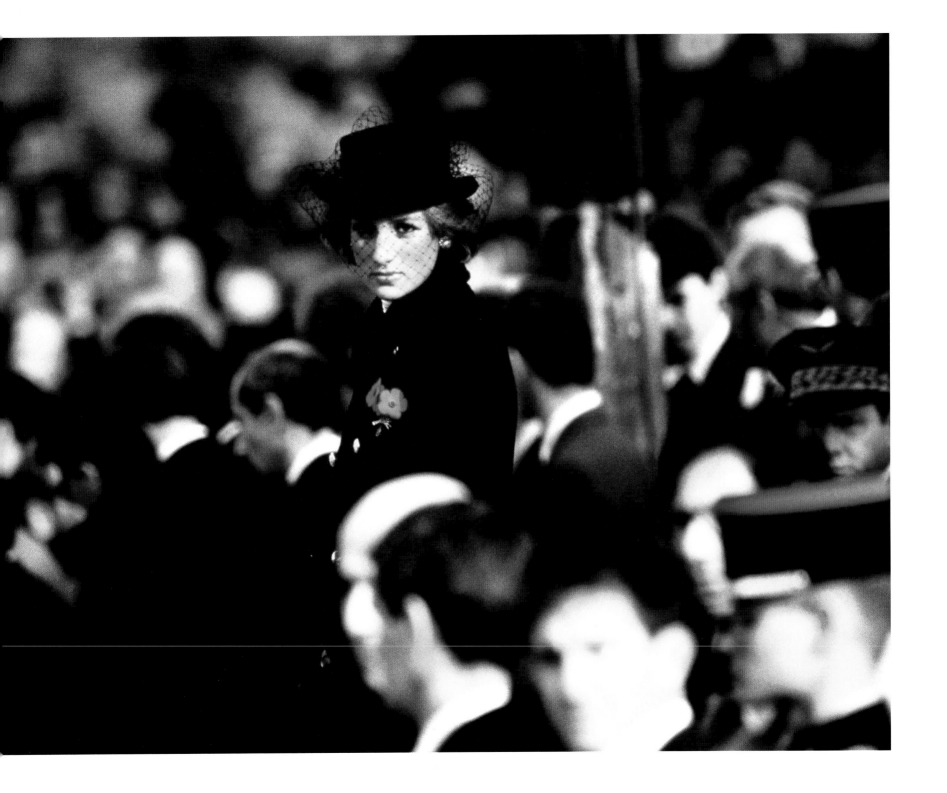

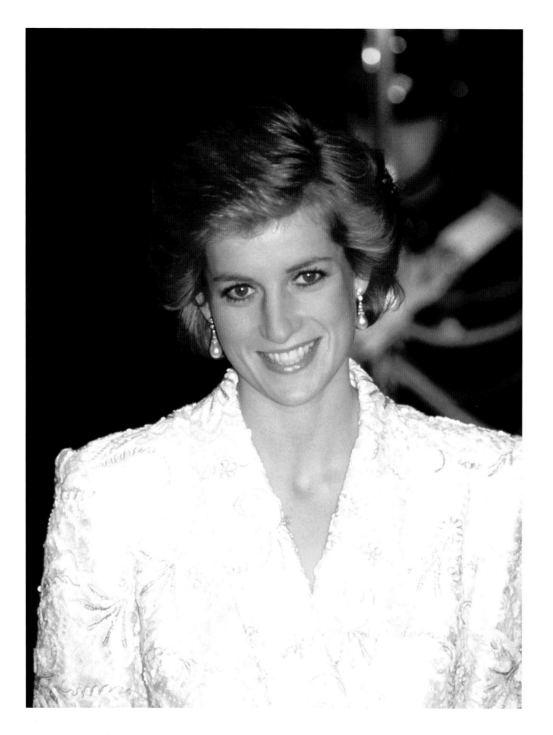

quite a formidable pair as they entered the banquet hall together to dine.

Being in France was always an especially difficult and very unhealthy time for me. It seemed that all the menus wherever I went were meat based. Being a vegetarian, I would always have to settle for a cheese sandwich – as all vegetarians know when visiting France, this is the only choice available to you. After a week of eating cheese your health begins to suffer a little.

No such problem for the royal party, of course. It was always easier for my diet when we visited countries like Thailand, India and Holland where vegetarian food is more widely available and their chefs have got a lot more imagination with their cooking.

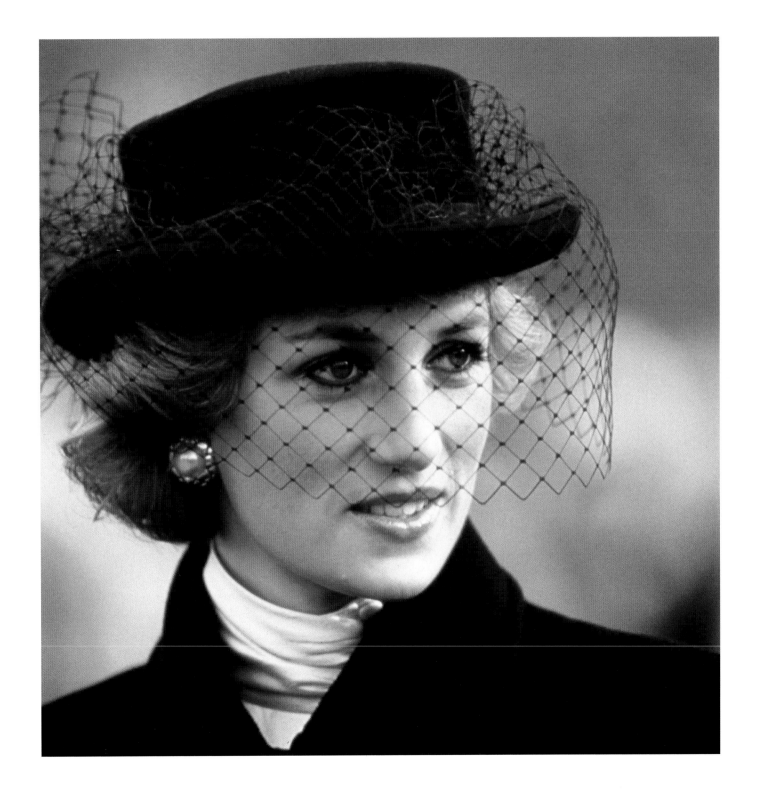

Spain
1987

Paris Match was and is considered by photographers as the ultimate international magazine for your pictures to appear in. If your name was printed in the photo credit list located inside a small box at the intro page, you were considered by the Royal Ratpack as one of them. Until such time, you remained a beginner on the royal overseas tours.

Each Diana tour would, without fail, be followed a week later by at least ten full-colour pages in the magazines. The colour sections would be completely devoted to the tour you had just returned home from. Sometimes, on particularly long trips, the magazine would appear on the streets whilst the tour was still ongoing. This would always result in the pack of freelance photographers gathering around a copy purchased moments before. We would all be desperate to see who, in *Paris Match's* opinion, had taken the best photographs the previous week. It

was a few moments that could make or break you as a valued member of the elite group of 'royal photographers' specialising in the field of the British royal family.

But despite this unofficial competition it didn't matter how many photographs you had published inside this magazine of notoriety, it was the cover that held the most prestige for the pack. In fact, if your photo made the cover not only were you considered one of the pack, you were also made an honorary member with a lifetime membership guaranteed. Your name in the credit box would be promoted, not to another box, but printed, albeit very small, on the cover itself. A proud moment for anyone to be crowned King or Queen of the Royal Ratpack. The cover photo was seen by not only the people that bought the magazine but by most of the people who went inside a newsagent's across the world and even better still seen on poster-sized advertising billboards spread across France and most of Europe. Just as importantly, it was seen as a showpiece to all of your peers who worked in the newspapers and magazines in Fleet Street and abroad. It was a very good advert for your photography and the photo agency that had sold it on your behalf.

The photographic agencies held the responsibility of selling the freelance photographers' pictures for the highest price and to as many magazines as possible. In partnership with their designated photographer, they had the key to your success as a freelance. You could have far better photographs than the photographer standing next to you but if your agency didn't work as hard as your opponent's, you would begin to have some serious cash-flow problems.

For the agencies, especially those in Paris including Sipa, Gamma, Sygma, Angeli, AFP and the newly formed Stills Press Agency (mine), a similar ad-hoc competition had begun with regard to the cover, as they also shared the printed photo credit with you. Stills Press Agency were the new 'Bosses' on the block. They had to prove that they could perform just as well as the other, more well-respected and established French photo agencies. More exposure for them via photo credits meant that more freelancers would be impressed with the results they were having, and maybe Stills could do the same for themselves if they joined this new team.

After completing a few royal tours I achieved a small collection of *Paris Match* front covers. I was made a lifetime member of the pack, much to the irritation of some other photographers who worked with the French agencies. The cover became my domain for a

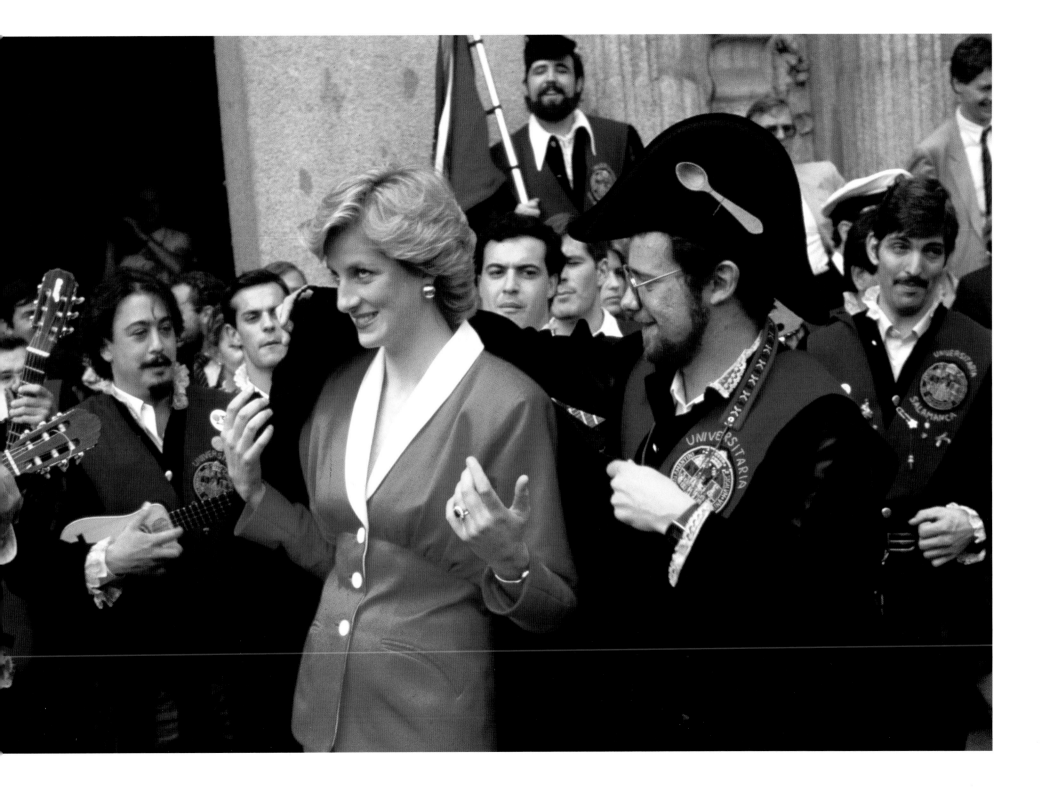

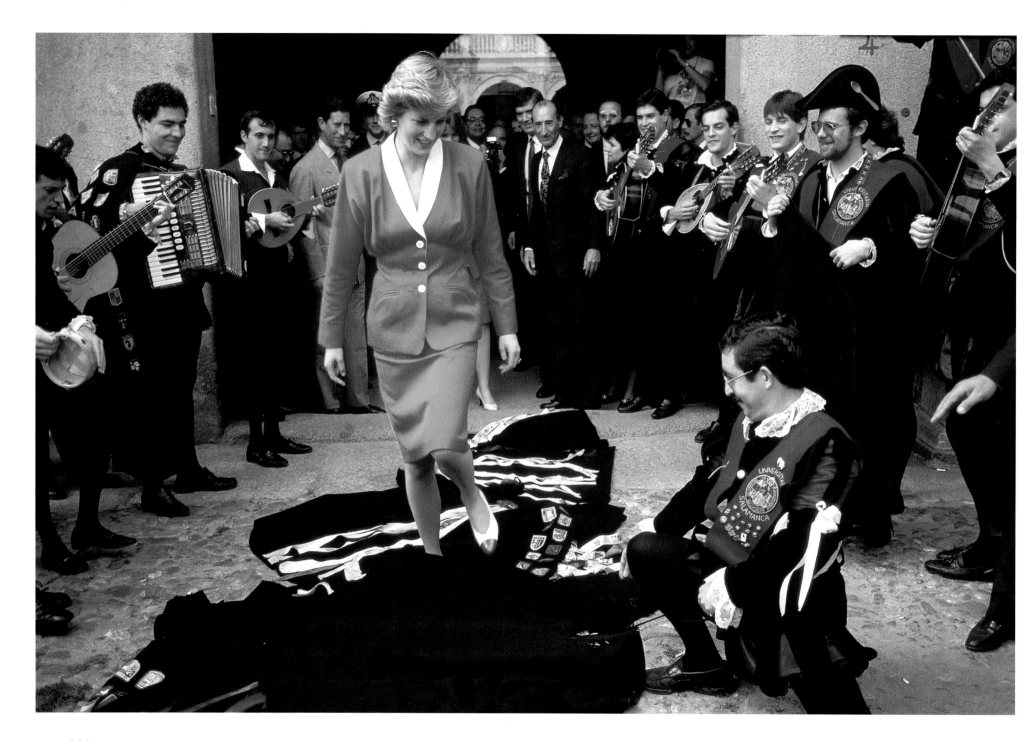

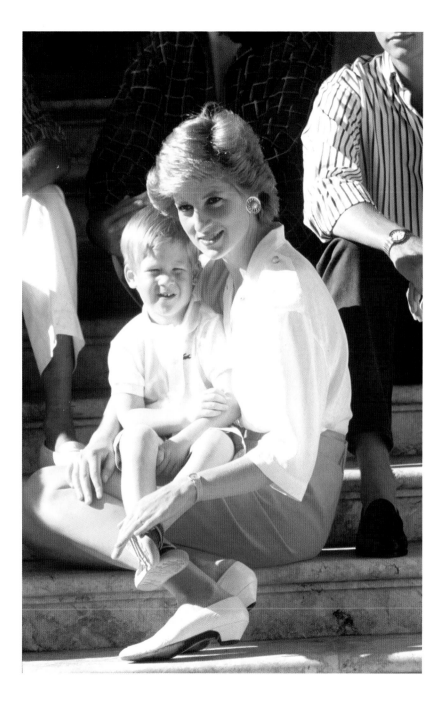

while which led me to some suspicion as to why. Surely my photos and/or my agency weren't that good? There were some highly competent photographers in this field, many of whom had far better more established agencies.

I found out that although my pictures were worthy, in my humble opinion, of *Paris Match's* cover, it probably had been Stills who were offering the pictures at a low introductory offer to get themselves known amongst the French and international publications. This introductory offer was to last for a few tours until they were up and running at full steam and standing as equals with the other French agencies. I have never proved that this was the case; perhaps all the agencies were selling at the same price. As in all free markets if there is competition you have to lower the price of your item. No matter the price, I was forever elated and if it had been up to me I'd have given them away free just to have the cover of *Paris Match*, as would have most of the other photographers in the Royal Ratpack.

What has all this to do with one of my favourite countries, Spain? This country, for me, has been the most successful with regards to Diana *Paris Match* covers, having had three spanning the ten years of photographing royal tours thanks to Stills Press Agency, which went into receivership a few years later.

Czechoslovakia

1991

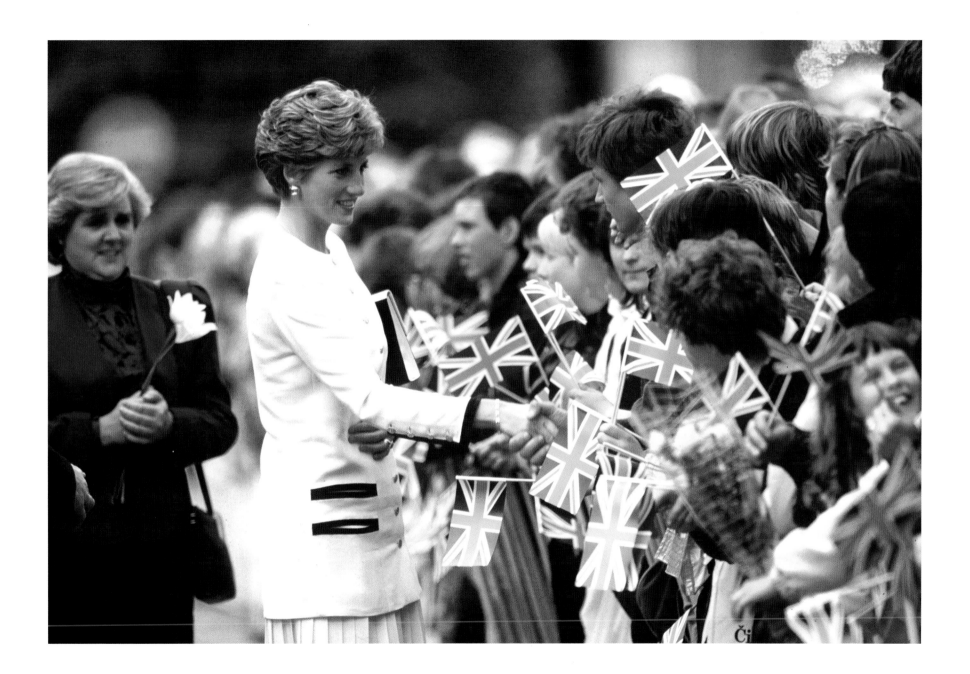

147 Czechoslovakia

In 1787, shortly before the premiere of Don Giovanni at the Estates Theatre in Prague, Wolfgang Amadeus Mozart moved in to Bertramka to finish the last parts of his opera in peace. The house originally belonged to a vineyard just outside the walls of the Czechoslovakian capital city.

This fine, quiet setting surrounded by woodland was the inspiration for Mozart to compose the concert aria and scene for soprano Bella mia fiamma, addio, which he dedicated to his hostess, the outstanding singer Josefína Duková. After Mozart's death the living quarters of the villa became a museum to the life and times of Mozart and now it is immaculately preserved as it would have been at the time of Mozart . . . That is until the British press pack arrived.

Dubbed the 'Ratpack', the 30-strong group of mainly large, overweight men entered the house weighed down with their cameras and bags. We were huddled into one corner of a barrack room when the Princess arrived at our centre. Diana viewed one of Mozart's pianos on which he had performed in Prague. It was white with golden edging, standing majestically on a

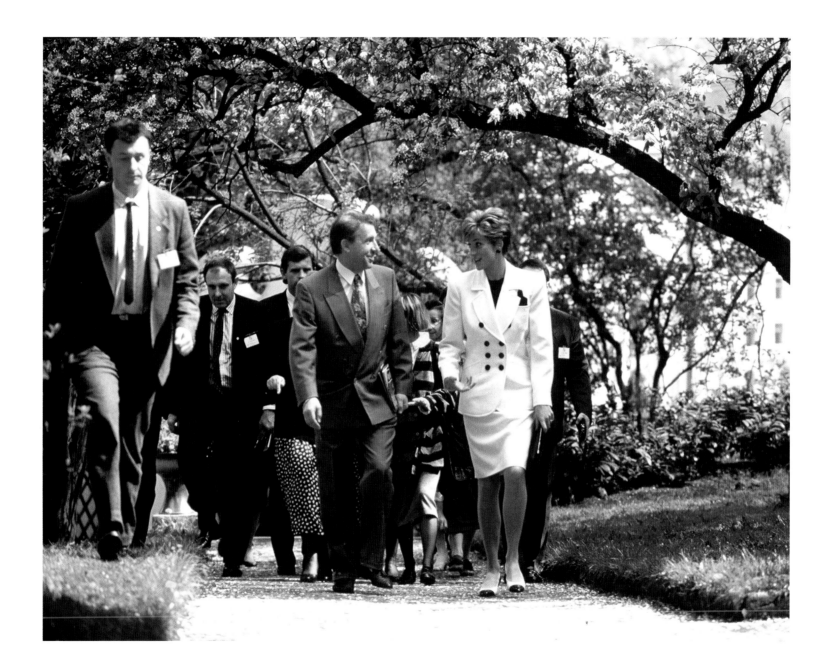

149 Czechoslovakia

raised platform underneath a diamond-encrusted chandelier. The Princess walked carefully and slowly amongst the many items preserved from Mozart's personal collection, which even included a lock of the musician's hair.

Diana then stepped through a door and into the next room which caused a mad scramble from the press chasing through afterwards. There was a large scraping noise from behind me as I hurried from the room. It sounded like metal and wood coming together unceremoniously. I looked around to see a very embarrassed newspaper photographer inspecting the side of Mozart's piano. His 300mm lens had taken a scoop from the paintwork near to the keyboard. Buckingham Palace and museum officials gathered around the shamefaced snapper. An official from the museum wrote down the cameraman's details in his black notebook. For over two centuries the priceless instrument had survived, until the now red-faced photographer had arrived. It would be unfair to name him in this book, but it was only an accident, wasn't it, Brian?

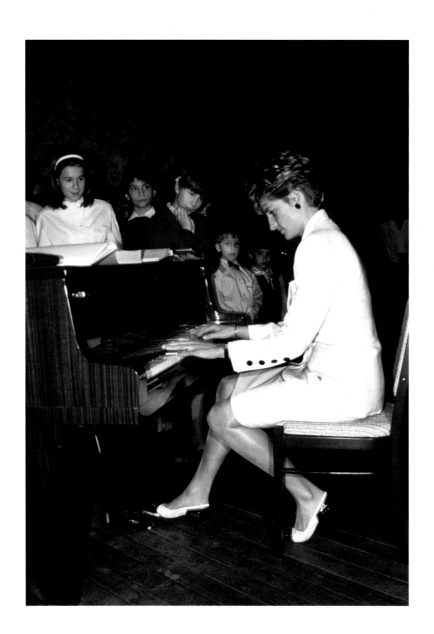

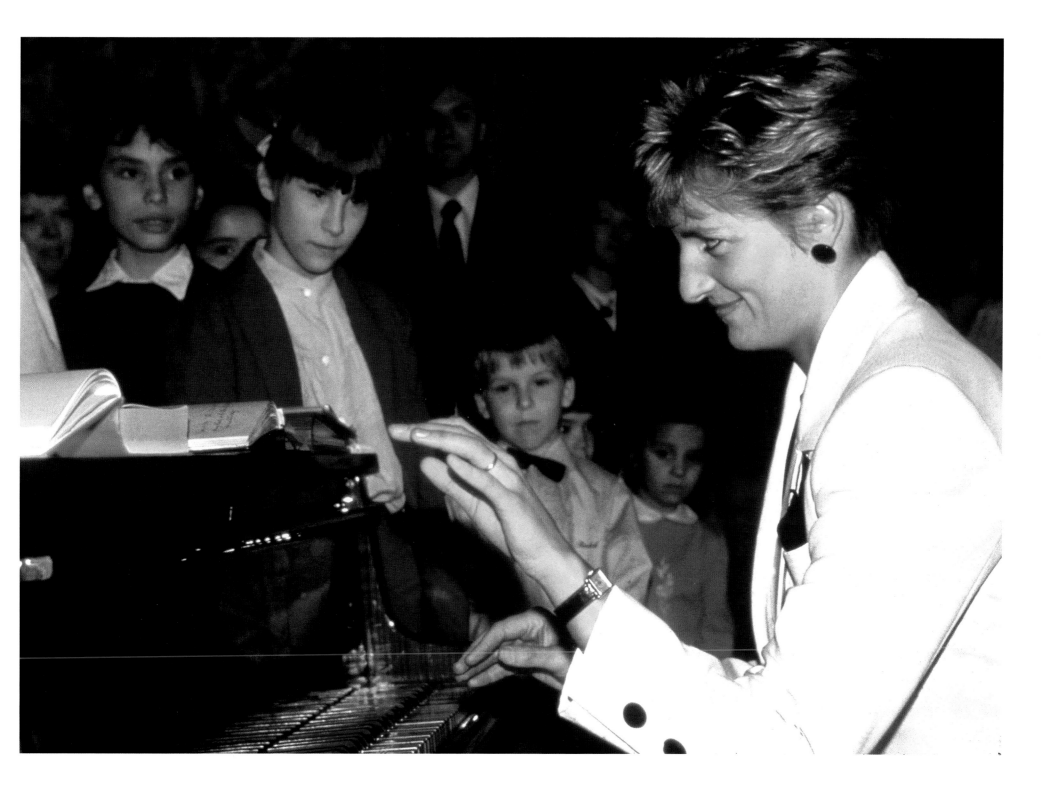

Pakistan

1991

Diana united the world in a way in which few had succeeded before her. The Princess spread the word of friendship, peace and joy across all seven continents with her own inimitable charm. It's now sadly a world without Diana and coincidentally it has become a far more unstable world politically, where war zones and devastating acts of terrorism are sadly the norm. Pakistan is very delicately positioned today.

Diana visited a very different Pakistan in 1991. There was no question that her tour would go ahead, as the region was considered a safe place for a westerner to visit.

She saw it as her mission to build bridges between all cultures, to help us understand each other better and to find new friends, which she attained with much success during her lifetime. It would have been fascinating to see how Diana's role developed in these very difficult and troublesome times had she still been alive today. I believe she would have developed further and more substantially into a global ambassador for peace.

Diana was welcomed into the home of a young family near to Islamabad. Sitting next to the nervous mother of a small baby, she caressed the child's face and casually chatted to the relatives. Next to the mother sat a lady dressed in full burka, probably the child's grandmother. With ease, the Princess blended into her new surroundings and within moments of arriving had made the whole family feel relaxed. Diana gossiped to all for at least twenty minutes; it was as if they'd been friends for many years. Soon it became time for Diana to leave the house but not before she had left a lasting good impression on her Muslim friends.

Diana was a long way from her home but for the Princess home would be wherever she was welcomed and that would also be here in Pakistan . . . even today.

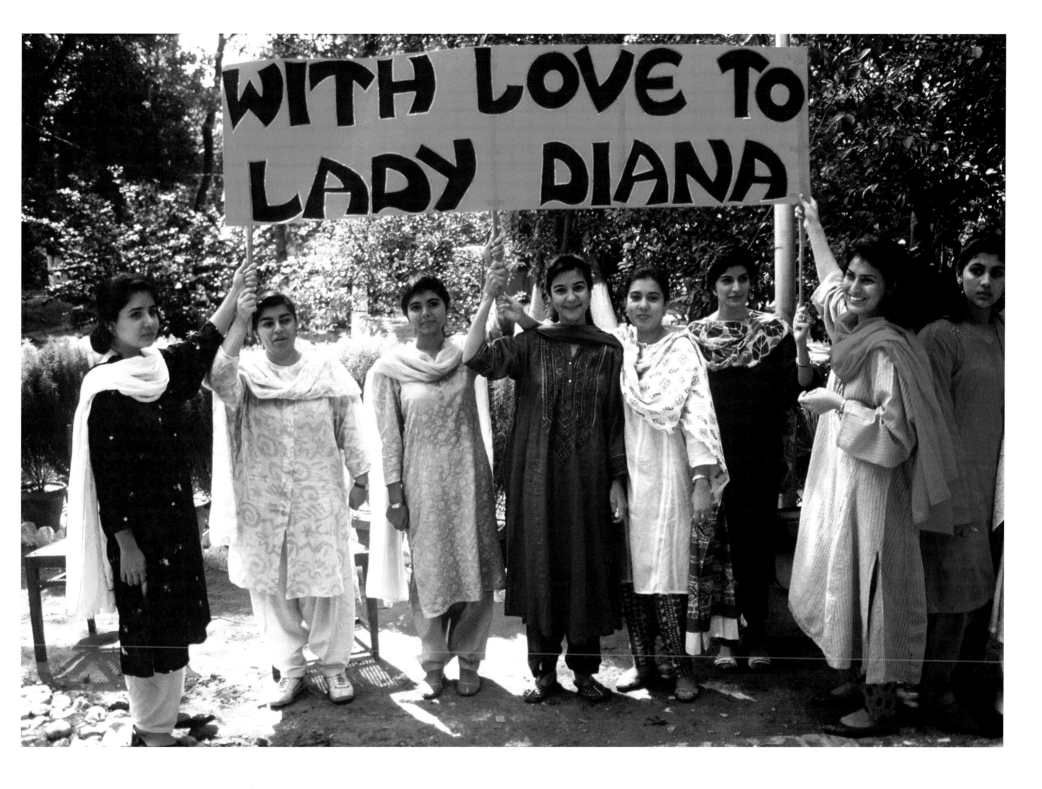

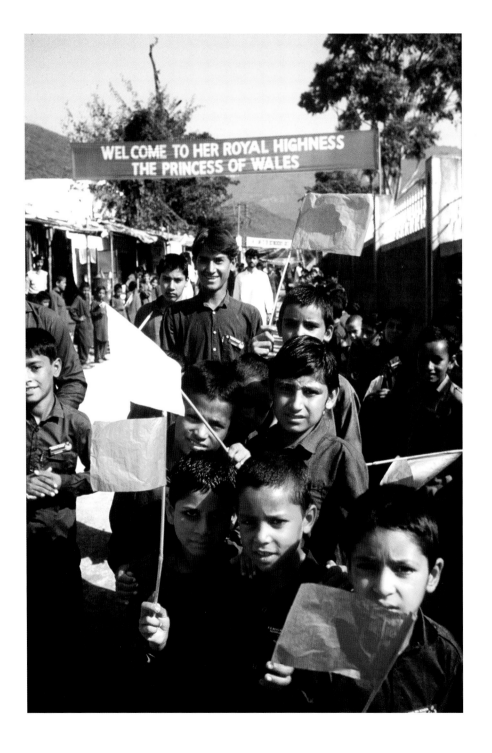

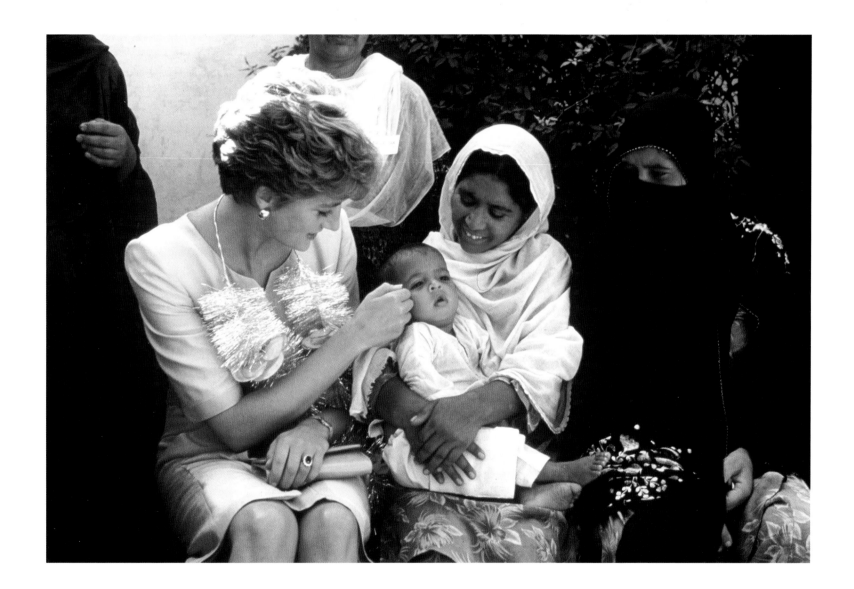

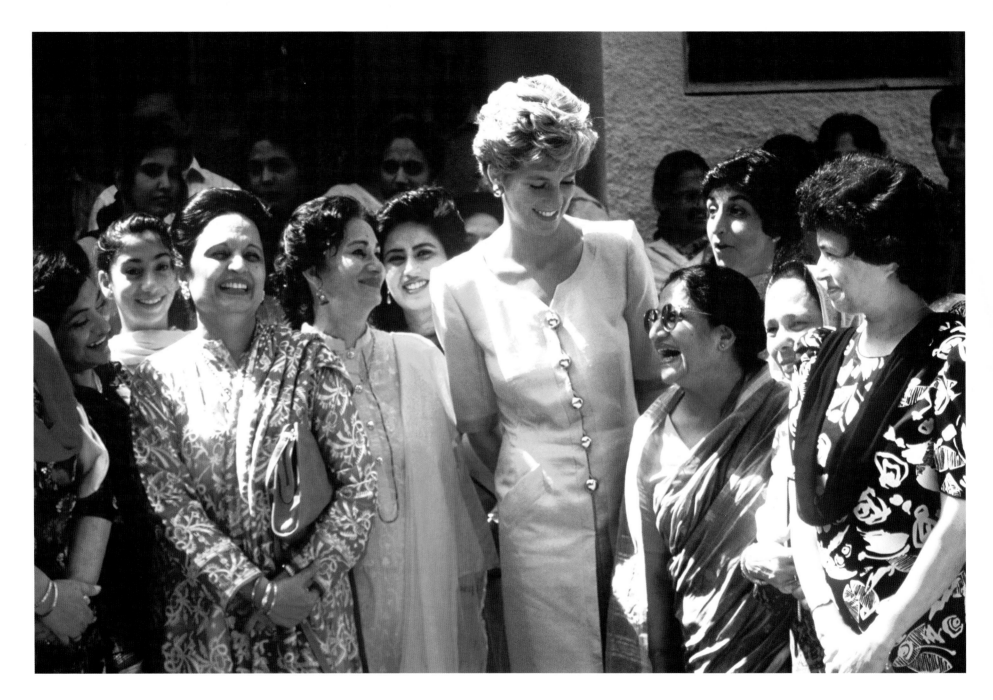

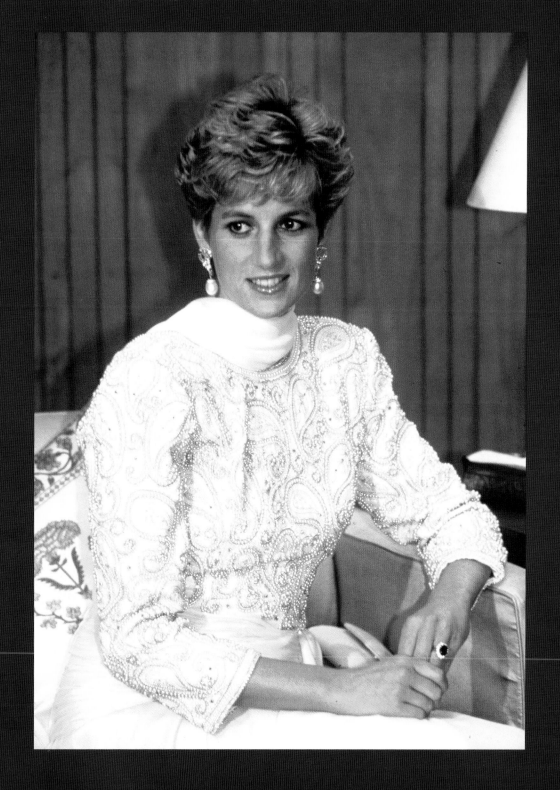

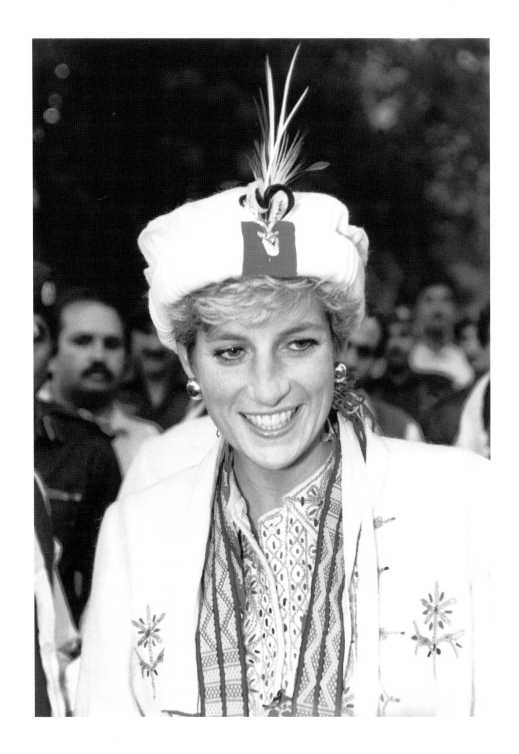

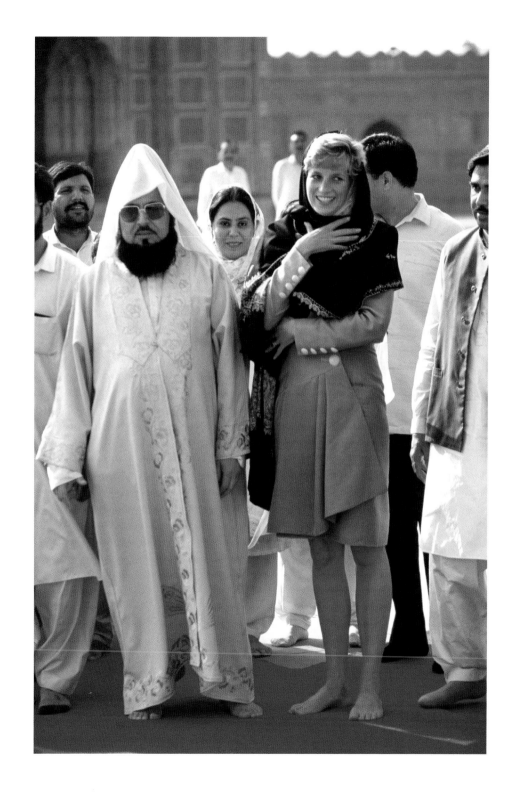

Nepal
1993

Diana had found a new direction in her life. She was to use her global fame to highlight some of the problems of the world. Out went the glamorous dresses and tiaras and in came the work suits and sandals. The Princess embarked on a humanitarian mission as an International Red Cross VIP volunteer.

Although this new mission was very worthy, it wasn't great business for us. Media publications worldwide would rather have seen the Princess dressed in a glamorous outfit, standing next to a Hollywood actor, a picture that would have walked into the hands of all the gossip rumour mongers and splashed onto the front pages. This was often preferred to Diana dressed in a sand-coloured work suit, meeting needy, underprivileged people. The reality of these issues is often a sad reflection on worldwide media demands.

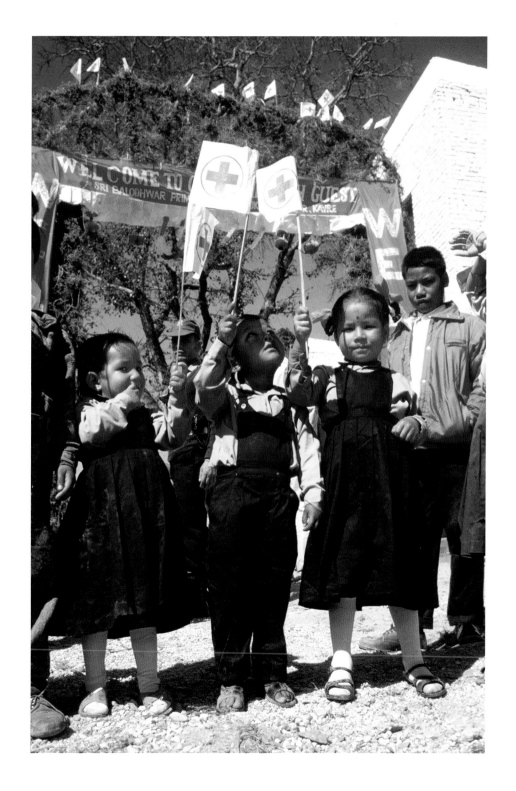

I watched the little children at the Sri Balodhwar Primary School near Kathmandu playing in their break time. The clean, uncontaminated water flowed as the children queued and took turns to taste the fresh liquid at the newly installed, specially built standpipe. Shortly, a real life Princess was due to visit them in their remote mountain village. On her visit, Diana would highlight the great work of the Red Cross clean water campaign, using our cameras to relay the urgent need for aid and support. You could almost feel the anticipation and new hope in the air as the villagers and schoolchildren waited.

I watched the Princess leaving, after a couple of hours happily touring the village and school. Her mission was finished and Diana was going to her next location. Behind me I heard the trickle of the water again. A small girl in her school uniform with red bows in her hair was scooping the water to her mouth, sipping noisily. Watching the child take a handful of fresh, clean water from the newly installed Red Cross tap made me realise how fortunate I was. The child was

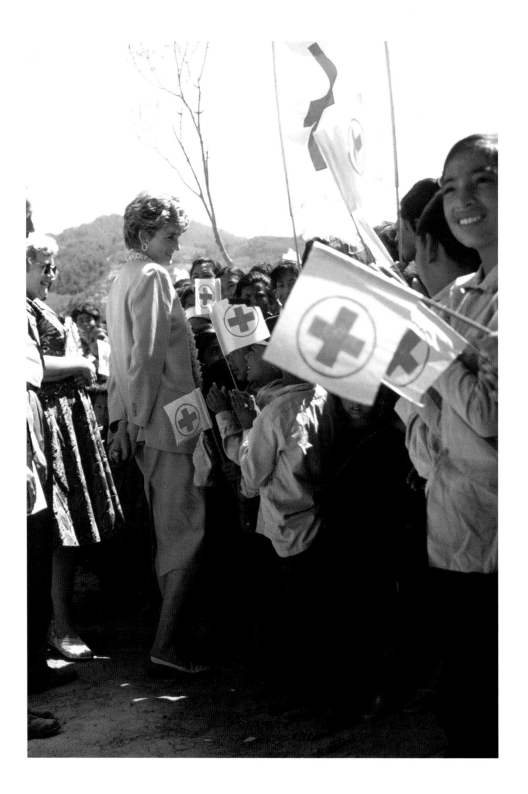

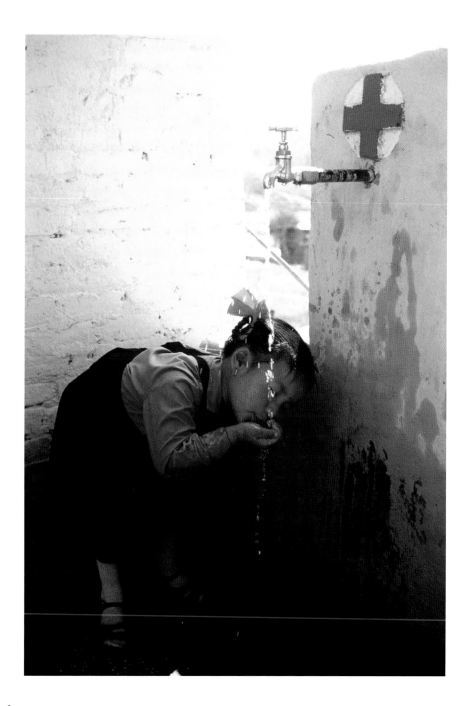

about four years old, and was probably tasting pure water for the first time in her life, a basic need that most of us take for granted every day.

I took a couple of pictures then she took out a piece of paper from her pocket. It was a picture of a tall blonde lady wearing a crown and waving a Red Cross flag. It said simply 'Dear Princess, thank you.' She had not been able to give her painting to Diana but handed it to me so I could pass it on to her, which I gladly did later.

This was not about making money for myself any more; I had arrived in the real world with a thump. The Red Cross, with Diana, were here to help improve and save lives. I was happy to be a part of it, albeit in a small way, and even though I was earning a lot less money it didn't seem to matter any more.

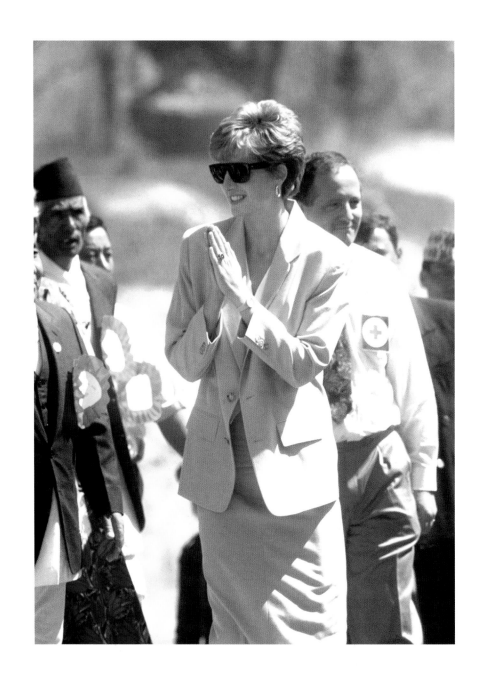

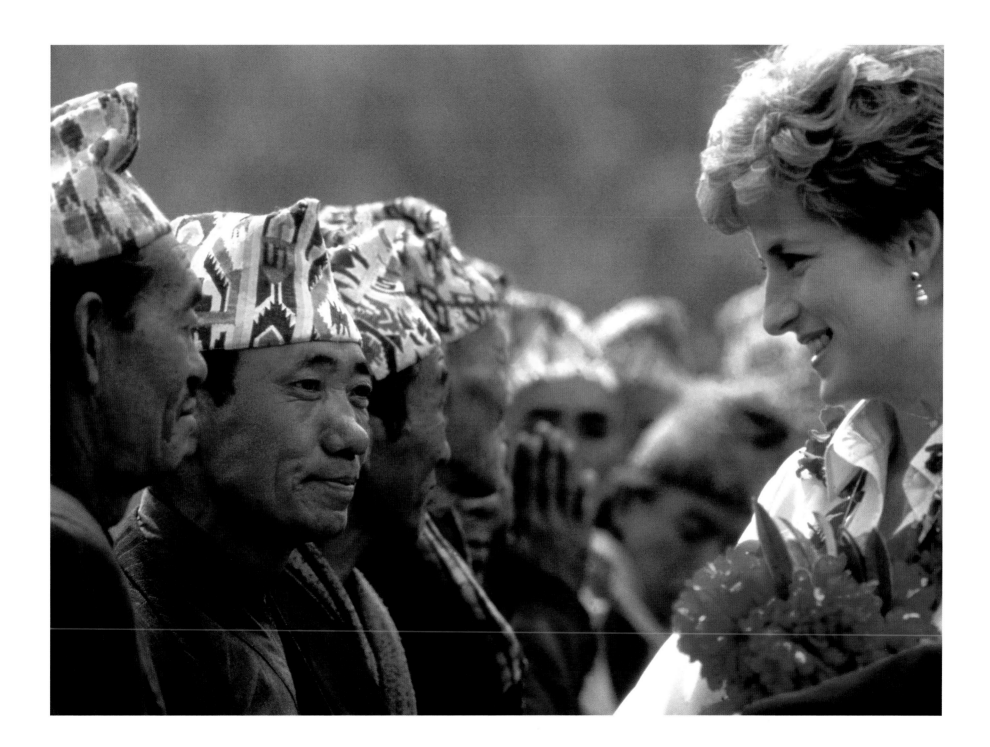

Oman

1986

Our hosts from Oman had very kindly arranged for all of the media on the tour to be their guests at a beach barbeque. On an idyllic beach at twilight we watched the red sun disappear slowly over the horizon. It was rare to have a chance to relax during a tour of this scale as we are always trying to travel one step ahead of the royal party. But for this evening it was different, only two photographers would be allowed entry for the grand banquet held nearby in Muscat at the royal palace as the guests of Sultan Qaboos bin Said. When space is limited the numbers of press allowed access are limited. The photographers with access will then share their photographs with all the other media accredited to the tour. We all took it in turns on a rotary basis.

The media sat and enjoyed the feast on large rugs laid out on the still warm sand. The main topic of conversation amongst the freelancers inevitably came to the price of your airline ticket to get where you were. No one liked to think that they had paid the most for their ticket as that would put you at the bottom of the freelance tree as to who could finish the trip spending the least money. After all, as soon as you regained your expenses from your first photo sales and broke even you would start to begin making a profit.

The winner of the cheapest ticket on this occasion was my good friend David Levenson. He could travel the far reaches of the world on the equivalent to the price of a bus ticket. No matter where you travelled with him, even if he was sitting on the seat next to you, he would have paid half as much as yourself. Dave was easily the 'king' of the budget ticket but he would never reveal his confidential secret as to how he attained it. But by the completion of this tour his secret would no longer be safe.

Diana's successful tour had ended at Muscat airport. The media assembled with all its paraphernalia of camera bags and personal luggage. Dave proudly waved his inexpensive ticket under my nose to show off once again. It was at least £150 cheaper than mine and of course I was still envious of his Muscat to London airborne achievement. The press boarded the flight and we took off, but Dave was nowhere to be seen.

On returning home to London, I phoned David's photo agency, Rex Features, to ask where he was and why he hadn't been on the flight. David's secret that he had held safe for so many years was now gloriously exposed to me in one simple call. Muscat to Riyadh, Riyadh to Beirut, Beirut to Amsterdam, Amsterdam

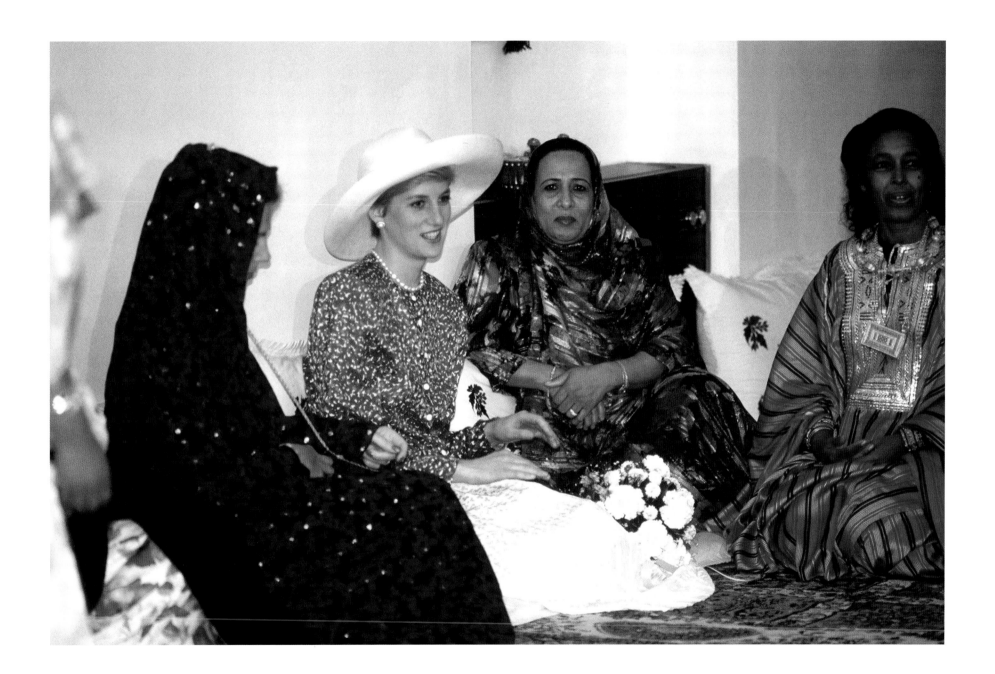

to London. He was travelling to London, all right, but stopping off on the way to visit the inside of airport terminals and arriving back in London over 28 hours later than the rest of the media party.

When I finally caught up with Dave I challenged him on his ticket. 'Great,' he said, 'It was very cheap.' But then I asked about his other expenses, which he started to add up. Transfer fees at Amsterdam, £15.50. Meals at airports including breakfast, lunch, dinner, breakfast, £63.30. Excess baggage at Beirut, £31.41 (one airline wouldn't let him onboard with all the camera equipment). Magazines, paperback book, sweets to relieve the boredom waiting in departure lounges, £8.99. Refreshments to combat the Middle Eastern heat, £7.66. Foreign coin charity collector (who was very persistent), £4.22. Finally, because he'd landed at Heathrow after midnight, there was a surcharge on his taxi fare home, £18.60. When all these expenses were added up, it left Dave with a grand total of 32p saving over my ticket, but at least he had reached the profit threshold before I had, he pointed out to me proudly.

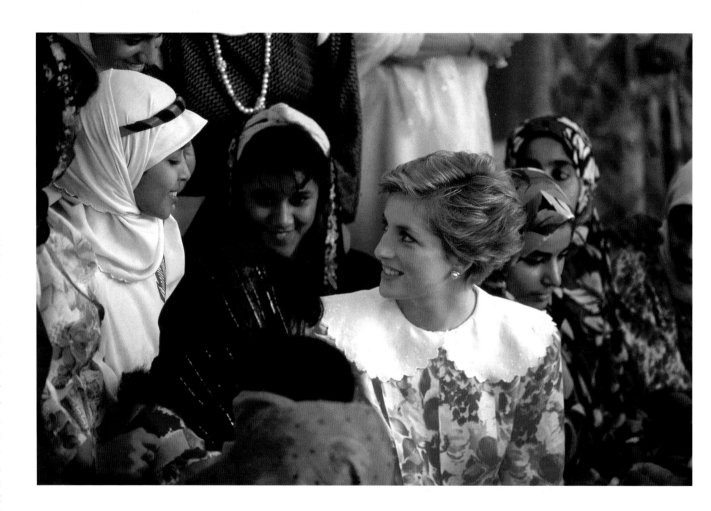

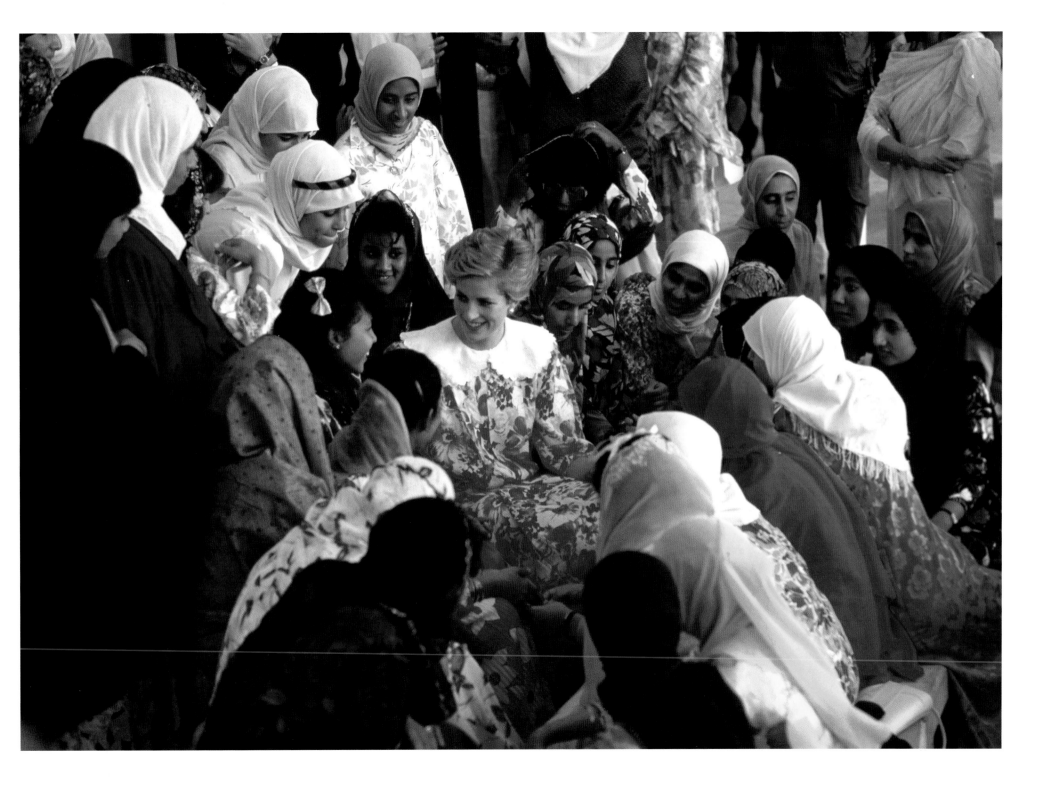

Thailand

1988

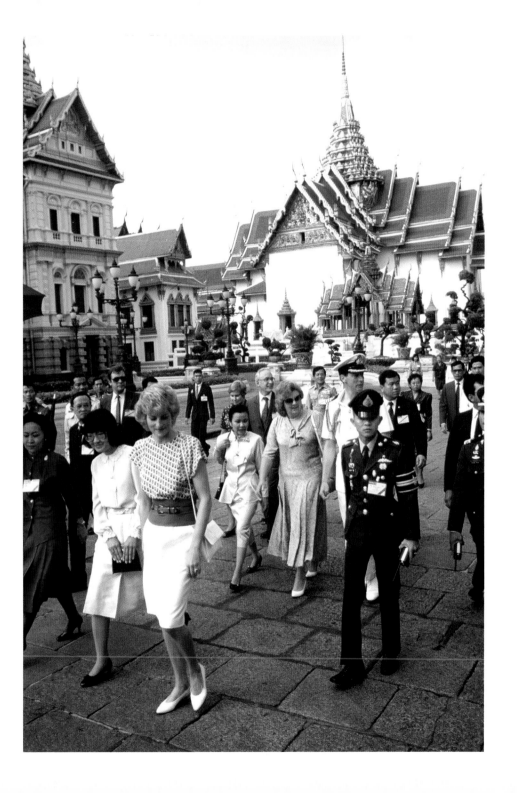

In the beautiful country of Thailand the Princess wasn't the only person graced with the royal treatment. Diana was returning to the United Kingdom after her successful tour of Australia and, as many travellers do on this route, she stayed a few days to visit the kingdom of Thailand.

When Diana disembarked from her aircraft at Bangkok airport the royal party were immediately sheltered from the blazing heat by massive umbrellas held aloft over their heads. The royal umbrellas were carried high by bearers who then escorted the Princess wherever she walked on the red carpet. Not a ray of sunshine reached the royal skin as she was greeted by the dignitaries who were lined up in front of the press. Diana glowed with delight at this novel form of royal treatment.

But this special hospitality was not only reserved for royalty; I, along with other media, was also honoured with an umbrella bearer. Standing waiting in the press area on the runway tarmac, the sweltering temperature was nearly 40 degrees. But thanks to my bearer I could at least obtain shelter from the hot sun. Everywhere I walked he followed as though his very life depended on it. He was a very smartly dressed young man in a white tunic and blue

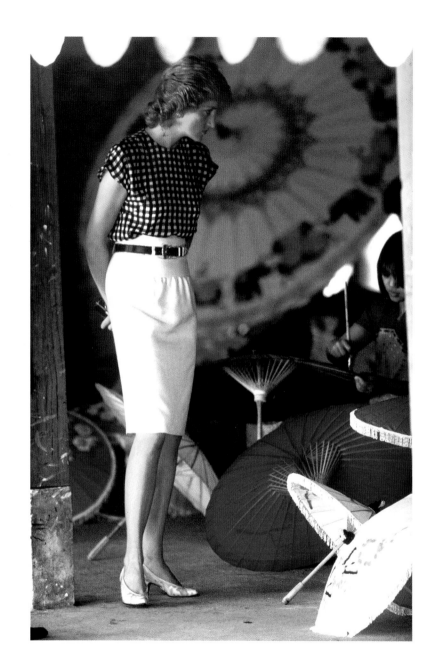

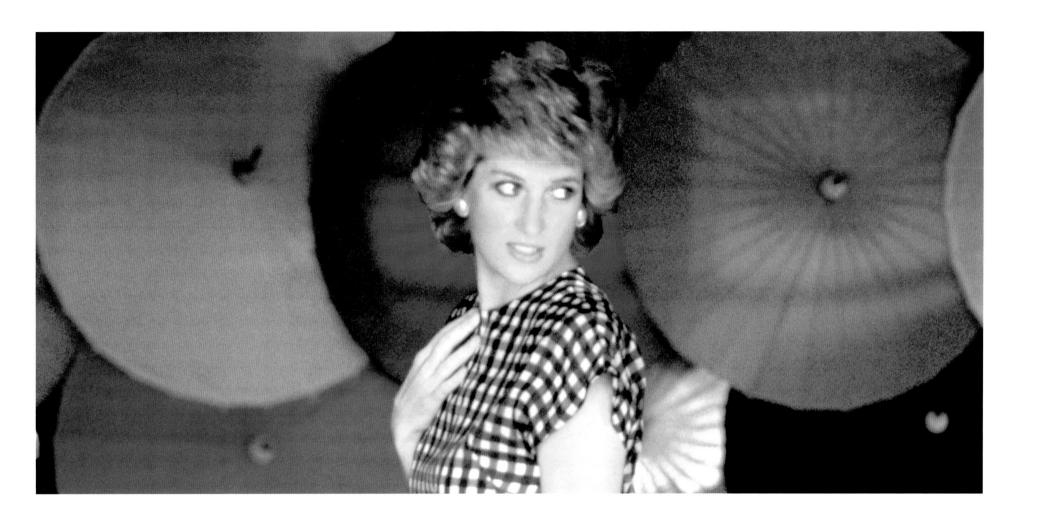

trousers. He expertly and skilfully plied his trade – not a single ray of sun landed on my person throughout the two hour wait at the airport. This was a very welcome kindness; I now knew how Yul Brynner felt in *The King and I* movie.

When Diana walked to her car the press followed soon afterwards. A couple of other freelance photographers and I had hired a taxi to take us to the next venue the royal party would be visiting. The three of us scrambled quickly into the cab so we could tag onto the end of the royal convoy into Bangkok town centre. Although I was now sitting in the back of the taxi, the man stood with his umbrella still shielding the sun from me. He looked confused – I think he was unsure where and when his duty to me ended. His orders were to shade me and shade me was what he was going to do. 'Get in!' I urged him. We were losing time – the convoy had already sped past us and was heading out the perimeter gate. The man quickly downed his brolly, tied it to the roof rack and squeezed inside.

The procession sped into town, followed by us with our 12-foot brolly on the roof. In and out of the congested Bangkok streets we tailed the royal convoy, at speeds of over 60mph. The cavalcade finally arrived at the Grand Palace and I jumped out quickly with my cameras. Jan (I had learned his name on the journey) got out of the cab to retrieve his umbrella from the roof but it was missing. It had fallen off during the frantic journey and had been by now most definitely crushed into pieces by the Bangkok traffic. Jan was devastated – not for the loss of his brolly but for the fact he couldn't fulfil his duty of keeping the sun off me. In his eyes he had lost all honour and he apologised profusely. I gave him some money to cover the cost of the umbrella and thanked him for his kindness.

As with all the Thai people we encountered during the rest of our stay, they were courteous, friendly, respectful of others but mostly very thorough in their work.

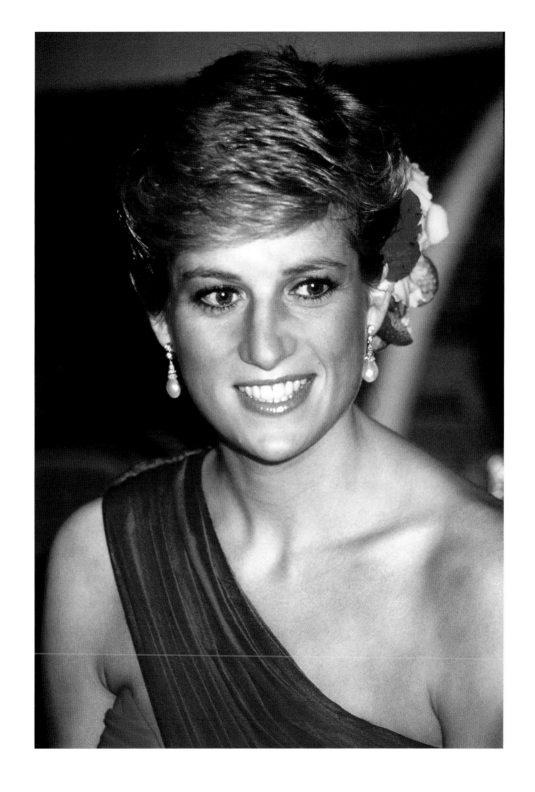

Scotland 1985

I'm not sure if Diana felt comfortable in Scotland, but if she didn't the Princess never seemed to show it. Diana was well known as a typical 'Sloane Ranger', much more familiar with London shopping and doing lunch with her girlfriends. She didn't really fit in with the hunting and shooting fraternity of the wilds of the Scottish Highlands. She would have been more comfortable in Edinburgh or Glasgow, away from the exclusive gatherings in the Highlands.

The Royal Ratpack press loved Scotland. It was a chance to get away from the confines of London and spend a few days in the rugged countryside. Arriving with a hearty breakfast inside at Edinburgh, Aberdeen or Glasgow in the early morning aboard the BA express flight, we were always fit and ready to take in the clean, fresh mountain air, the haggis, the Highland jigs and, of course . . . the whisky.

On this Scottish trip I was to photograph Diana as she visited the remote reaches of northern Scotland, the Western Isles. Having just watched the film *Local Hero*, I knew what to expect from my visit. The royal tour started off in Stornoway and would finish on Barra, nearly 70 miles further south. Diana, with the aid of the royal helicopter, hopped with ease from one island to another. We, the press, having departed by car from Stornoway airport, were facing a scenic journey of a lifetime.

Ours was the only car on the road as Lionel Cheruault, a fellow royal photographer, and I sped from one isolated village to another, dodging the sheep as we raced to keep up with the royal helicopter flying high above us.

Diana was looking as glamorous as usual, despite the fact she was dressed from head to toe in oily water-proofs and Wellington boots. Her huge smile beamed out from inside the jacket hood covering her head as she sipped a cup of tea in the back garden of a crofter's cottage. She was enjoying her visits as were the locals who, I'm sure, would have never expected Princess Diana to ever visit their remote and humble abode.

Lionel drove us to the southern end of the island of Harris when we came across the Sound of Harris, a ten-mile stretch of open water before the next island of North Uist. Up until this point, there had been bridges to cross from island to island but now we were stranded as we had just missed the last ferry crossing of the day. Diana's next visit would begin early the next morning. If we had waited for the first ferry crossing the next morning we would miss half a day's work. We had to get across as soon as possible. Lionel and I retreated to the small pub to discuss our options.

The locals were gathered by the warm, open log fire drinking their whisky quietly. We settled nearby, enjoying the warmth. We were here to stay for the evening, having found a couple of rooms in the main

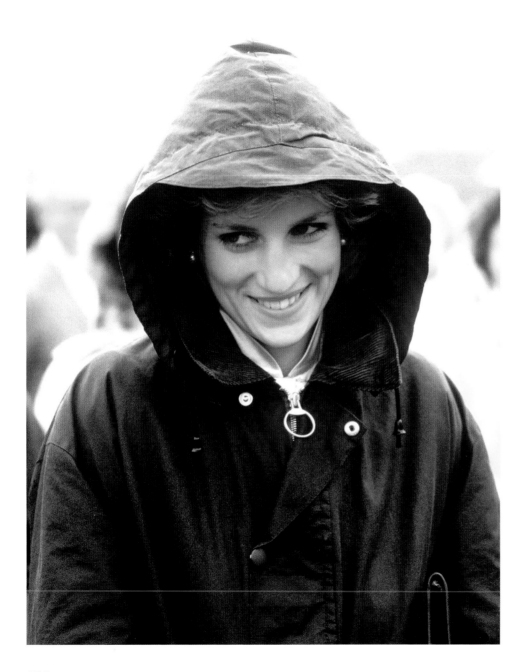

street. I asked the barman if he knew anybody that could hire us a boat. A bearded old man overheard us and offered to get us across early in the morning. Jim led us outside the pub where he pointed across the small harbour towards a large white cruiser. It looked big enough to take ten people in comfort and in some style. We agreed a fee, up front, and arranged to meet the next morning at 5am.

Jim greeted us at the harbour, waving with his pipe and gesturing for us to get in. He was sitting in a tiny red dinghy; the outboard motor was running, throwing out clouds of white smoke. Lionel clambered aboard and stood up in the boat to grab the gear from me. I followed afterwards. Jim turned the throttle with a sharp yank and we were off, through the harbour and out to open water.

'Where are you going?' Lionel asked excitedly. Jim pointed to the faint outline of North Uist on the far horizon. I pointed to the cruiser and questioned him as to why we weren't on it. Lionel and I had both assumed that this was the transit dinghy to the cruiser. But it seemed this boat we were on had been moored next to it when Jim had pointed it out the previous night. After a few malt whiskys our vision may been impaired slightly or I think we were both suffering from wishful thinking rather than paying attention to the finer details. Jim grinned, realising our mistake. I thought I lip-read him say, 'Stupid Englishmen', but I couldn't be sure as the words were drowned out by the engine noise.

We had travelled outside the enclosure of the harbour walls when the engine began to splutter and died, leaving us drifting back inside the harbour. Jim had forgotten to fill up. He rowed us back to the mooring pier and went off to look for some fuel. After an hour and a half he returned with a small can then proceeded to fill the tank. We were not impressed with him as we were losing valuable time. The first of Diana's visits would be starting shortly and we were still on a different island.

Jim finally cranked the boat into action once again and we were on our way, out of the harbour and heading south. About half way across I spotted the ferry closing fast on us from behind. We were now so late, thanks to 'dim Jim', we may as well have caught the ferry anyway and still had our car which we had left behind. The huge ship stood 30 feet above us as it sped past. It was closely followed by its equally high wake. Making up for lost time, Jim revved his engine to full throttle and steered the dinghy into the path of the wave. He jerked the rudder around as we met with the powerful surge. Up on the mountain of water, we were now riding on top at the same speed as the ferry. There was a constant shower of white water spraying over the front of our surfing tub. Some of the passengers laughed, pointing as they spotted the three of us riding on the crest of a wave.

We arrived on North Uist soaked and relieved, but our efforts were to be in vain. The camera equipment had been drenched in the boat, rendering it useless. It took Lionel and I the rest of the day to repair and dry it out. But at least it gave us an excuse to get back in the bar near the warm fire and the whisky.

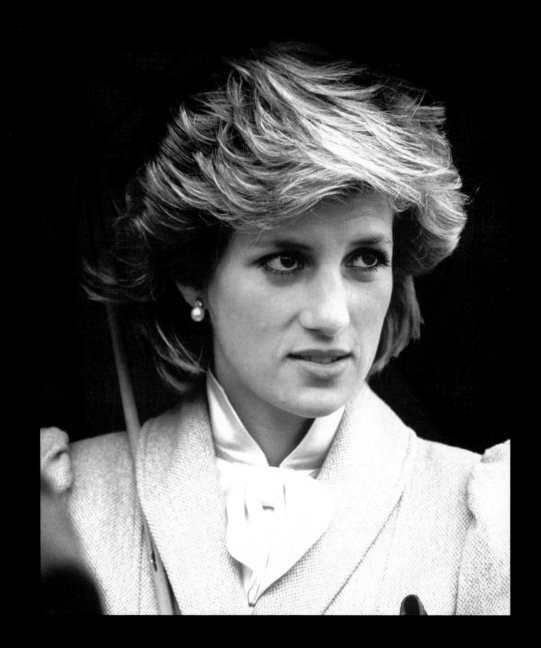

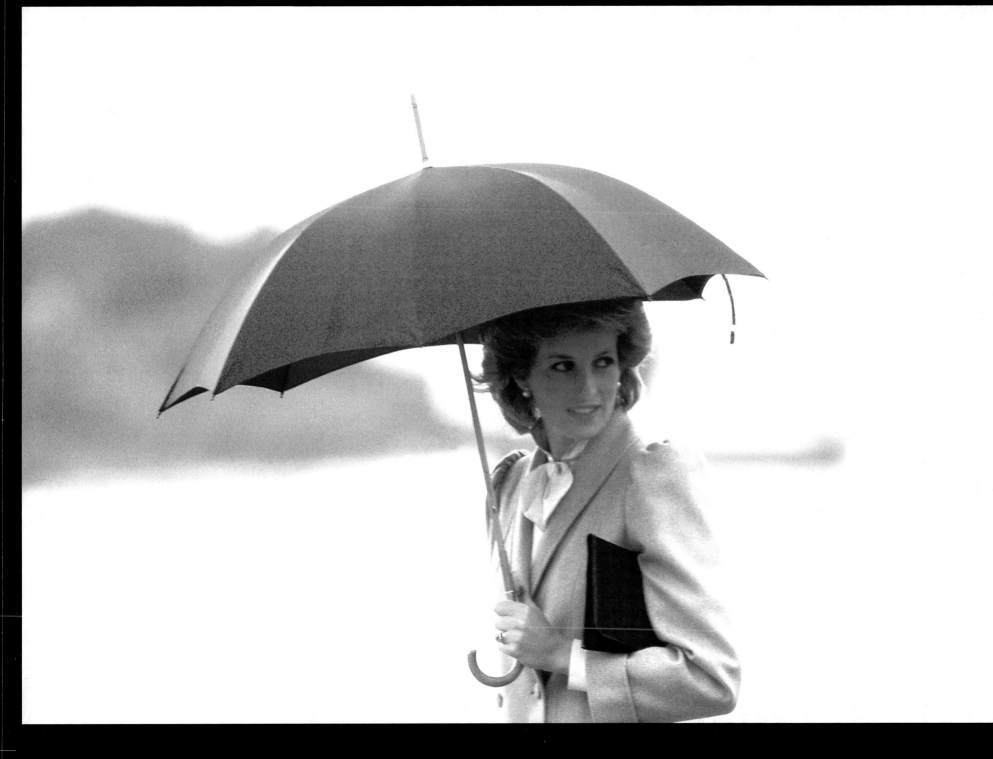

Bahrain

1985

The press were driven on buses across the 16-mile viaduct that linked the Saudi Arabian mainland to the Kingdom of Bahrain. At a cost of 1.2 billion US dollars, the magnificent King Fahid Causeway opened in 1986 and stretched across the Persian Gulf.

Our transport stopped when we finally reached the mainland as our hosts were very keen to proudly show off their newly built wonder to the foreign media. We were surprised to be coming to a halt as we only had twenty minutes remaining to get to Diana's point of arrival in Bahrain. This was still another ten minutes away, but we were happy to oblige our guide as the Middle Eastern tour had, up until now, been all work and no play.

The world's press, numbering at least fifty, clambered off the three buses and stepped over to the beach area, rewarding us with our first real view of the bridge. Curious local people gathered around to see the foreign camera club photographing everything and anything around them. One small girl stood out from the crowd. She was dressed in a traditional Arab outfit and looked truly amazing. I asked her parents who were standing with her if I could take her picture, to which they gladly obliged.

The girl's photo would be a great addition for background shots that could be used in conjunction with the Diana tour pictures. I took three frames, but then over my shoulder appeared another photographer snapping away. Then another. The young girl didn't seem to mind at all and just gazed around her, probably wondering why everyone wanted to take her picture. The group of press became larger as each photographer spotted her. The girl had captured the attention of all of the international media by now. Cameramen formed neat rows in front of her, some on their knees and others standing behind. In those few moments the small girl had become the most sought after and, soon to be, most famous face in Bahrain ever and she had only gone out for an ice cream with her parents.

Our guide gathered us together to return back via the buses as we were now running late for the royal party's arrival.

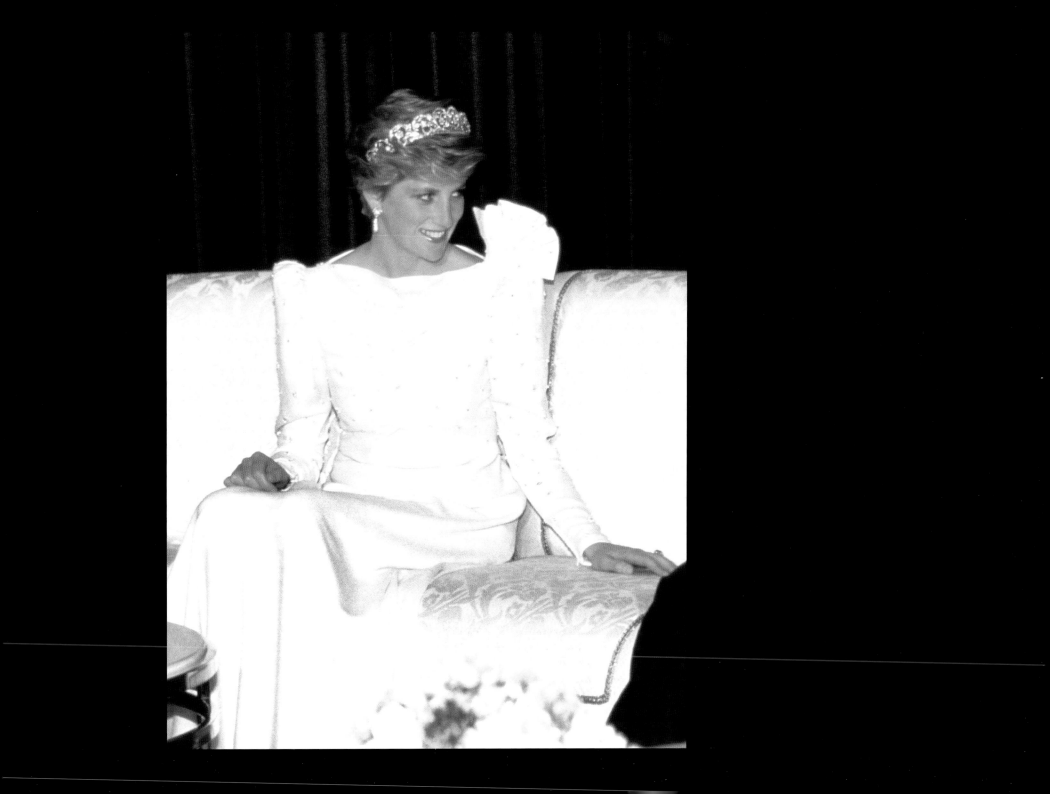

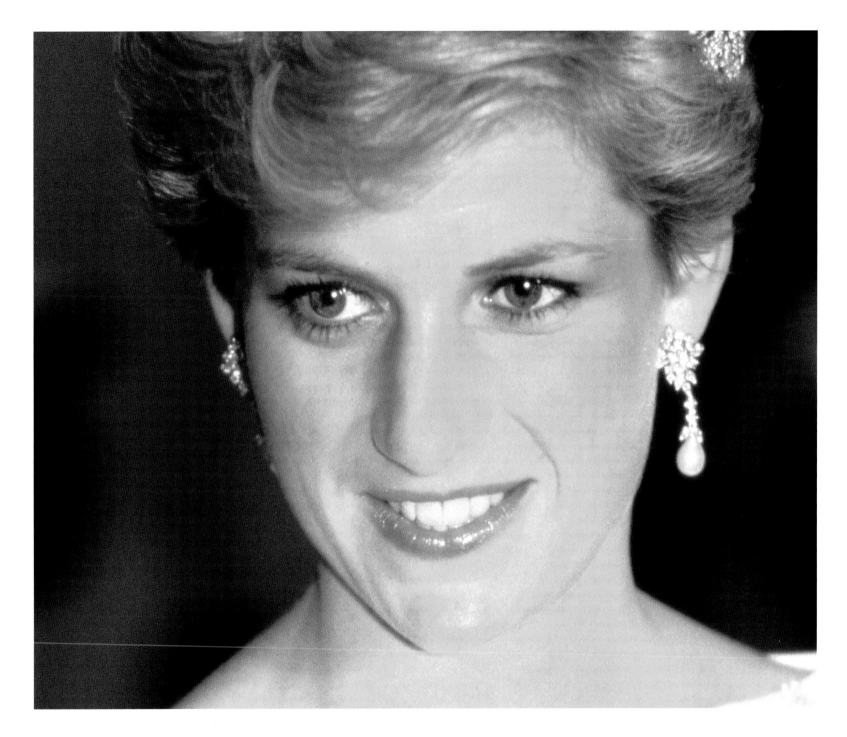

185 Bahrain

Having consumed a red hot chilli pepper during my middle east tour, I was laid low for a couple of days. I didn't have the willpower to lift a camera to my eye. Sick, nauseous, feeble and out of action, I had been incapacitated by a pepper.

Caribbean

We had been invited by Buckingham Palace to photograph Princess Diana with Prince William and Prince Harry on a beach on Sir Richard Branson's island of Necker. The international media had arrived in the British Virgin Islands in the Caribbean to record the royal holiday and by now there were so many of us that we were outnumbering the locals on the small island of Virgin Gorda by two to one.

Four large fishing boats had been chartered by the Buckingham Palace press liaison officer to transport the photographers, television and journalists out onto the aquamarine sea. With the heavy camera equipment we soon overcrowded each boat at the small dockside at Mahoe Bay. The press easily exceeded the legal passenger limits of each vessel as they sank lower in the crystal clear water. We didn't mind though, we were ready on the boat. All our effort and money had been invested in the next half an hour.

The press boats then cast off the ropes and steered out to the open sea.

Ten minutes later we had arrived and the anchors were dropped near to the 'royal' beach about 200 metres from the shore. Boats the size of ours couldn't get any closer to the beach because of the natural boundary of the coral reef. Our boats had been escorted to the positions by three police gunboats which, with their armoury, were very persuasive that we should go no closer than we actually were.

The early morning surf was throwing our boats from side to side as we tried to steady our lenses. Already looking tanned and relaxed, Diana appeared first on the beach dressed in a printed leopard-skin dress, followed by William and Harry wearing t-shirts and trunks. The rocking of the boat made it almost impossible to take photographs. Each time the boat

tipped forward all I could do was point the lens in the general direction of the island, press the release button and leave the motor drive firing as the long lens quickly moved up and down. I succeeded in obtaining eight pictures of the sea followed by three of the beach area, then a further eight pictures of the clear blue sky. Fortunately some of the beach photos sometimes did have an image of a royal included in them, much to my later relief.

The photocall was to last a mere three minutes. Diana had walked out, sat down and been buried in the sand by the children. This was an average set of pictures. We had learned from experience that picture editors of leading magazines and newspapers across the world wouldn't be satisfied with a photo of Diana dressed as she was. We knew that they would require pictures of Diana wearing a bikini, something the Princess, it seems, was unwilling to oblige us with that day.

The order was given by the police chief for the press boats to leave the area as the photo opportunity was now finished. The four press boats upped anchor and turned away from the scene, returning back to the harbour. The Princess stood up straight, brushed the sand from her legs and walked off the beach into the thick bushes of cactus at the rear, presumably returning to the beach hut. We were all satisfied . . . fairly. Diana now was free from the peeping lenses of the world's media. In return for the photocall all the press had agreed to leave the royal family to enjoy their holiday in peace during the rest of their stay. The media had obtained a fairly good set of pictures that we could most probably sell, but not definitely.

Out of the bushes in the far distance walked a blonde -haired figure. On peering through his binoculars, a reporter from the Daily Mirror suddenly bellowed at the top of his voice, 'It's Diana, she's wearing a bikini!'

His loud remarks traversed the sea to the other press boats which were, by now, sharply turning back towards the royal island. 'Turn the boat around!!!' was the cry from everyone on our boat. The captain shook his head but instinctively turned the wheel round, tipping the boat over to the left. The Princess had separated with her dress and was now lying on the beach in a bright red bikini, looking like a supermodel. This was just the photograph everyone on the four boats had been after all along.

Looking like an invading army on the surf, the press boats charged towards the shore at full speed, chased by the police boats which were full of policemen frantically waving in the air at us to stop. We reached the coral reef as a bemused Diana stood up and shielding her eyes with left hand, staring at us with her right hand on her hip. The boat tipped over as 40 or more desperate photographers leant over one side to attempt to take pictures. The captain tried to compensate by steering in the opposite direction. Water poured over the brim onto the feet of the press but we weren't concerned with that. This was our only chance. We didn't even care if the boat turned over upside down as long as we got the photos that we came here for. But a police gunboat had edged between us and the beach, totally blocking our view by now. Our driver had seen enough (as had Diana), and he pushed his throttle hard forward to get us moving. It was the only way he could save his boat from either turning upside down or being blown out of the water by the police gunboat. Diana jumped into the sea then and was hidden by the waves.

I managed to get my bikini photograph as did most photographers on the boats, but despite risking life and limb it was the earlier shots of Diana wearing the leopard-skin dress that were the most widely published in the international media after all.

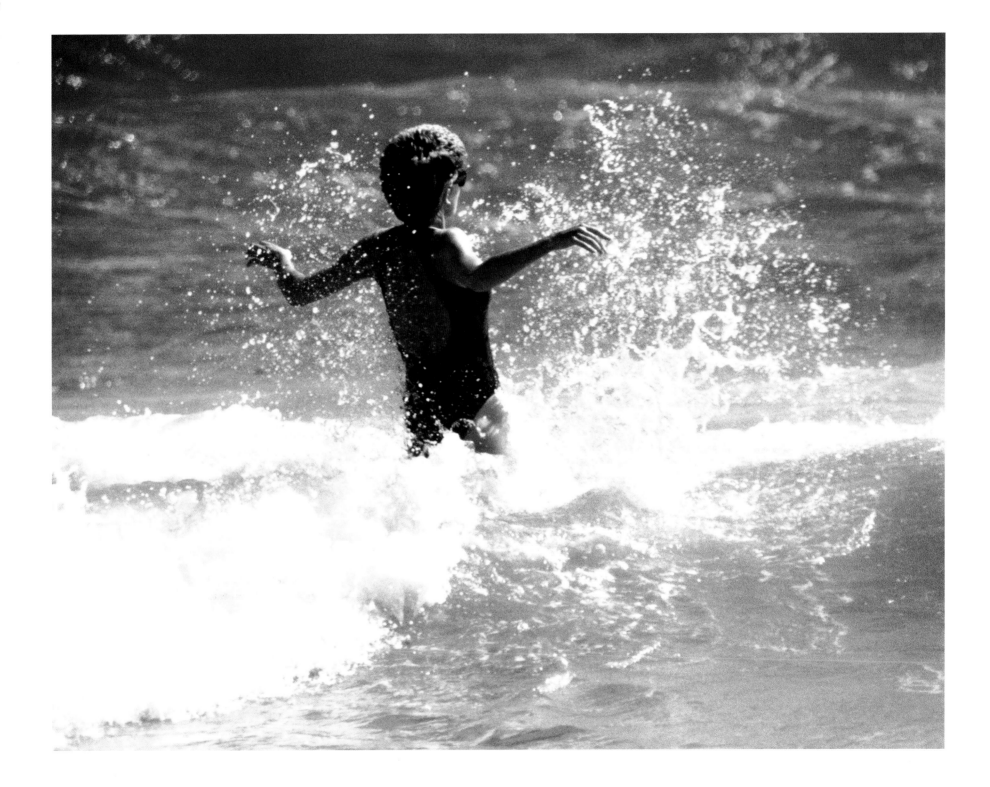

Princess Diana became a global ambassador for peace, a valuable
and greatly missed quality in the twenty-first century.

Diana Princess of Wales
1 July 1961 – 31 August 1997